Francisco Asensio Cerver

# DRAWING
## for Beginners

Ramón de Jesús Rodríguez Rodríguez (text)
Vicenç Badalona Ballestar (illustrations)
Enric Berenguer (photography)

KÖNEMANN

Copyright © 1999 Könemann Verlagsgesellschaft mbH
Bonner Straße 126, D-50968 Cologne

Original title: Dibujo
Managing editor, text, layout and typesetting: Arco Editorial, S.A.

Translation from Spanish: Harry Paul Carey
English language editor: Alison Crann
Project coordinator: Kristin Zeier
Cover design: Peter Feierabend, Claudio Martinez
Production manager: Detlev Schaper
Printing and Binding: Neue Stalling, Oldenburg
Printed in Germany

ISBN 3-8290-1932-7

10 9 8 7 6 5 4 3

# CONTENTS

# Materials

## THE DRAWING AS THE START OF EVERY ARTISTIC PROJECT

Drawing is the base of every artistic expression. Works like the Sistine chapel, Guernica and all the artistic legacy of humanity started out from drawing techniques. All the pieces in museums and all architecture, that is to say, all art, starts out from this humble and straightforward origin, a pencil gliding over a sheet of paper. As is logical, to be able to draw you need, at least, a tool that can scratch and a medium on which to do so.

The materials that can be used for drawing can be as many or as few as the artist desires. In all the other techniques of artistic representation, such as oil, watercolor, or acrylic, it is necessary to have available certain tools. In contrast, to draw you need so little equipment that anybody can do it anywhere with just a pencil and paper. As the enthusiast becomes more familiar with the world of drawing, he or she will discover new options and materials, such as charcoal, chalks, sanguine, brushes, feathers, in short, tools that have only one objective: to draw lines, to etch or to stain.

▼ Paper is the most straightforward medium. However, as we will see later, there are many types and qualities of paper. As your appreciation of drawing grows, so too will your special feeling for the materials.

## INDISPENSABLE MATERIALS

To begin drawing you only need cheap and simple tools such as a notebook and a pencil, or a stick of graphite, or charcoal: everything else is supplementary. The basic materials for drawing can be found in fine art shops or stationers.

▼ To draw, it is necessary to have supplementary materials like cloths and cutting tools.

◀ A graphite pencil and a small notebook are enough to launch you into the world of drawing.

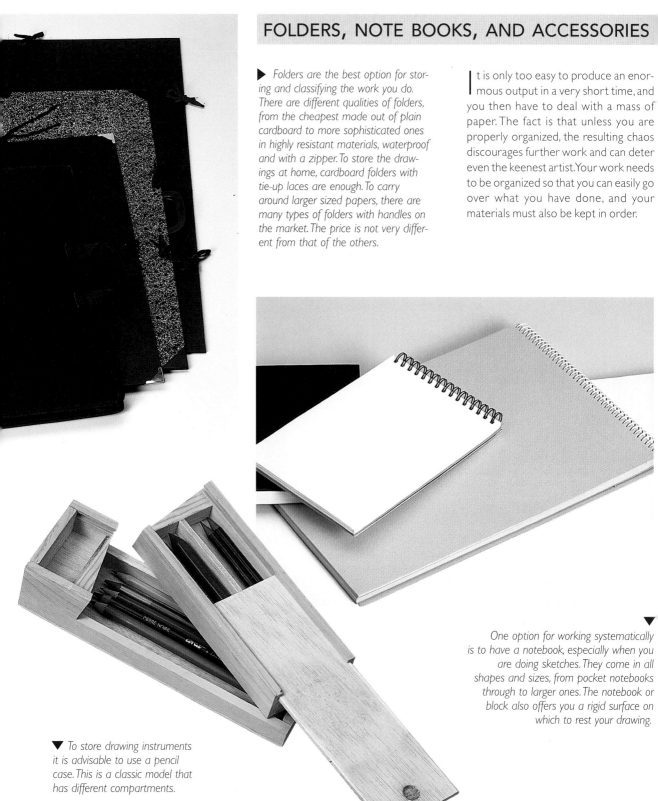

## FOLDERS, NOTE BOOKS, AND ACCESSORIES

▶ *Folders are the best option for storing and classifying the work you do. There are different qualities of folders, from the cheapest made out of plain cardboard to more sophisticated ones in highly resistant materials, waterproof and with a zipper. To store the drawings at home, cardboard folders with tie-up laces are enough. To carry around larger sized papers, there are many types of folders with handles on the market. The price is not very different from that of the others.*

It is only too easy to produce an enormous output in a very short time, and you then have to deal with a mass of paper. The fact is that unless you are properly organized, the resulting chaos discourages further work and can deter even the keenest artist. Your work needs to be organized so that you can easily go over what you have done, and your materials must also be kept in order.

▼ *One option for working systematically is to have a notebook, especially when you are doing sketches. They come in all shapes and sizes, from pocket notebooks through to larger ones. The notebook or block also offers you a rigid surface on which to rest your drawing.*

▼ *To store drawing instruments it is advisable to use a pencil case. This is a classic model that has different compartments.*

## CHARCOAL

Charcoal is the oldest, simplest and most malleable drawing medium that exists. It dates from the first artistic expressions of the human race. As its name indicates, it consists of carbonized wood and, therefore, allows a strong black line to be drawn. When a mark is made on paper with charcoal it is very unstable: It only has to be touched or rubbed with the fingers for it to turn into carbon dust. It is precisely this delicateness that makes it such a suitable medium with which to learn to draw, for it can easily be corrected.

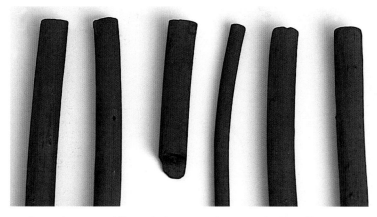

▼ *Charcoal comes in different thicknesses and very varied calibers. The sticks are used up very quickly and, therefore, it is always advisable to have a few at hand. Charcoal is very fragile. In general, the artist breaks up the stick into little bits which are suitable for the type of stroke to be made.*

▶ *To start drawing with charcoal all you need is a stick, paper, and a cloth. Charcoal is so delicate that any contact with the drawing will cause it to rub off.*

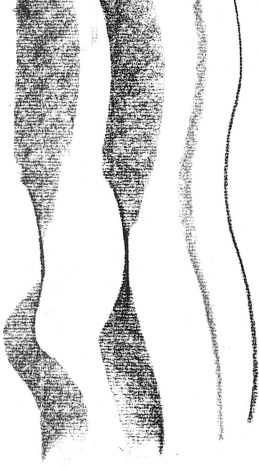

◀ *The entire surface of the charcoal leaves a mark, that is to say, it draws. Here you can see some of the different types of strokes that can be made.*

▶ *The charcoal stroke is completely conditioned by the paper onto which it is drawn. It is wise to practice on different types of paper so that you can begin to appreciate how varied the strokes obtained can be.*

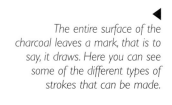

# THE PENCIL: DEGREES OF HARDNESS

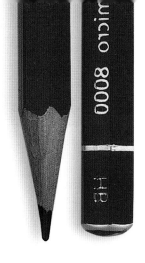

One of the most popular and widely used media for drawing is the pencil. It is made of lead that can consist of several materials (carbon, plastic, sanguine, graphite, etc.) wrapped in soft grainless cedarwood which is easy to sharpen without splintering. The quality of the pencil depends on the two principal components. The lead has to be sufficiently compact so that it does not break. However, try to avoid dropping the pencil, as this may damage the lead. The wood must have the right degree of softness and dryness so that it does not flake when sharpened.

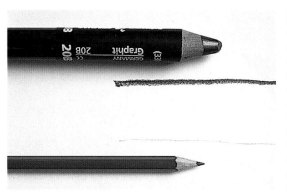

▶ *Pencils are classified according to their hardness. Soft pencils are recommended for artistic drawing; they start at HB and include the whole B range. Those which belong to the H range, which are harder, are designed for technical drawing. On the left, above, a 20B graphite pencil, which is very soft; and left, below a 2H, which is harder.*

*The hardness of the pencil is marked or it near the end. The hardness is determined by the degree of grayness that the strokes make on the paper. Soft pencils allow very dark strokes to be made and they are marked with the letter B next to a number The higher the number, the darker the maximum gray of the pencil. Hard pencils are indicated with the letter H and a number. The higher the number, the harder and finer the stroke will be. In the picture you can see a HB pencil. It is halfway between the two extremes.*

▼

*These pencil cases are very comprehensive. You do not have to buy a whole box. Pencils can be bought one by one.*

# PURE GRAPHITE

Pure graphite is a lead so thick that it does not need a wood covering. Most sketchers are heavy users of graphite sticks for they permit a great deal of versatility in the stroke. As they are not covered by a wooden sheath, drawing with graphite is not limited to the point: a wide variety of strokes is possible.

*Here you can see some examples of pure graphite sticks. The thickness has nothing to do with the hardness; it just allows different strokes. The quality of the strokes with this drawing tool is far better than that of pencils. Moreover, sticks of pure graphite never lose their point and the entire surface can be used to ◀ make marks.*

▶ *Graphite strokes, whether made with a stick or with a pencil, can be smudged or rubbed with the fingertip while still soft. This is called stumping and will be very useful as you study different techniques in the drawing exercises.*

*Sticks of pure graphite have an endless array of uses that, when applied to drawing, can give results that an ordinary pencil cannot match. Take a look at the strokes made with the back of the tip. The width allows a large area of paper to be covered in a moment. ▲*

▼ *Pure graphite allows a lot of versatility in the strokes.*

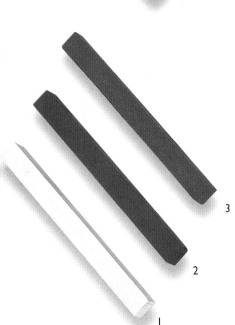

# SANGUINE CRAYONS AND CHALK

▶ *Three earth tones of chalk. Chalks can have very varied color ranges. The most traditional ones for drawing are always based on earth tones.*

You do not always have to draw with the gray and black tones that we have seen so far. Among the different drawing materials, we should not overlook chalks and sanguine crayons. Chalk is manufactured from calcium carbonate prepared artificially and mixed with glue and pigments. It is sold in little sticks that offer a rich variety of strokes. Sanguine crayons are made from mineral pigments also agglutinated with glue. These drawing media allow a wide range of effects and chromatic variations. When combined, they can produce very interesting results for the artist.

*A case of chalks in both stick and pencil form. This collection of materials is of a very high quality, aimed at satisfying every possible need of a professional user. The extensive range of tones can be appreciated.*

▲

3

2

1

▼ *A bar of white chalk (1), sanguine (2), and sepia (3). These three bars are the ones that the majority of drawers use the most. With three colors you can develop ranges of all types.*

# SUPPORTS FOR THE DRAWING

Paper on its own is not stiff enough to support the pressure of the drawing. To be able to draw, you need a hard flat surface on which the touch of the medium on the paper does not produce differences in the texture. Many of the materials necessary to set up a little studio at home are not difficult to find. Some tools make it easier to do drawings from life or nature without having to take your eyes off the model; this is the case with the easel, of which there are many models with different characteristics.

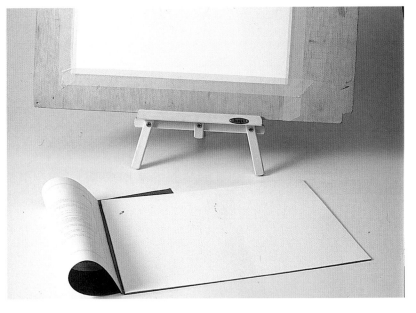

▼

A drawing block on its own is sufficient to give you a stable surface, provided that it is not too big. When you draw on top of loose papers, a plywood board is necessary to support the paper. These boards can be bought and cut to measure at a carpenter's. The ideal size is slightly bigger than the paper which is going to be supported.

▼ An easel allows the paper to be placed vertically on the support. This is especially useful when the block is too soft. To use the easel, it is also necessary to have a board. The easel shown above is designed to stand on a table, thus allowing you to make the fullest possible use of your work space.

It is very simple to improvise your own drawing table. All that is needed are two trestles to support a sturdy board which will provide the surface upon which you work. A table is vital for horizontal work and also to lay out the materials you are going to use.

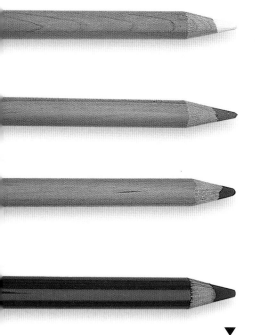

## LINE AND TONE

It is important to be familiar with the different drawing media and the possibilities that each one of them allows on the paper before starting to use them. Some media are very harsh or rasping; the way they drag over the paper does not please some artists. Others, by contrast, are soft, even perhaps too soft. The line produced by the hardest media is always more precise than that obtained from the softer ones, but it is much more difficult to correct and the contrasts are far more subdued.

▼ *Chalk crayons and carbon pencils. In this form, the chalks may be used very much like pencils, allowing the production of very precise lines in a wide variety of tones. The big drawback of carbon pencils is that they are very fragile.*

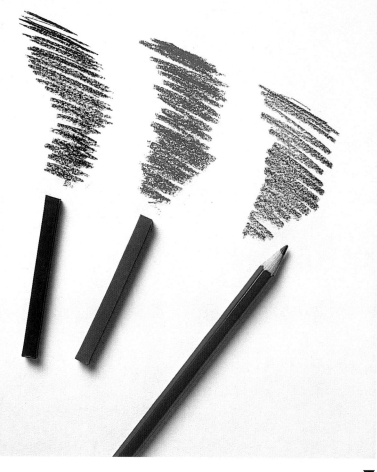

▶ *The felt-tip pen has been a great innovation in the field of drawing. It has a cartridge filled with Chinese ink which permits a continuous stroke. This type of tool can be obtained in specialized fine art shops. The felt-tip pen opens up a wide variety of drawing possibilities, although the tone is always an opaque block.*

▼ *Pressed carbon, on the left, has a soft silky feel. It allows a wide range of tones that range from pitch black to a subtle gray, if it is stumped. The sanguine stick, in the center, has a sandy feel. However, it also permits a wide range of tones. The soft graphite pencil, on the right, enables you to make a gentle stroke in a great variety of tones.*

## FROM MONOCHROME TO COLOR

Despite what many enthusiasts think, a drawing does not have to be monochrome. It is difficult to know where to draw the line between drawing and painting, although some of the materials that provide color are undeniably drawing tools. A drawing can be done in a single color, giving a monochrome result. You can combine different colors so that the finished work will be polychromatic.

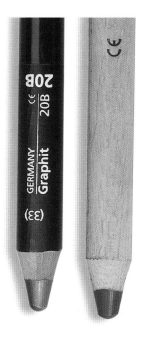

▼ *With special pencils like these, a drawing of great expressiveness can be realized. Their width allows thick strokes to be made and all types of tone intensities. This type of pencil is found in shops specialized in fine arts.*

▼ *Colored crayons are very useful in drawing. They allow you to create a detailed layout, without having to turn your back on all the expressive possibilities of the stroke and line, but enabling you to take advantage of all the colors you may require. There is a wide variety of these pencils on the market. It is best, however, to acquire a high-quality assortment.*

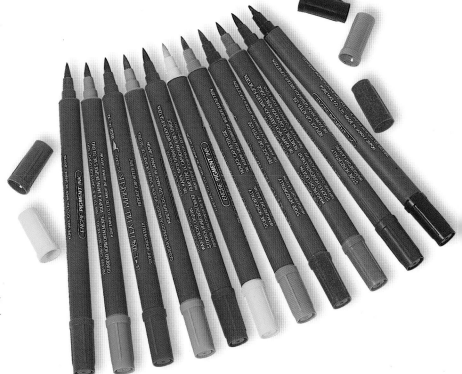

◄ *Felt-tip pens are also considered to belong to the world of drawing. The higher their quality the better; those used in schools wear out rapidly, no longer producing even the smallest stroke.*

# Materials

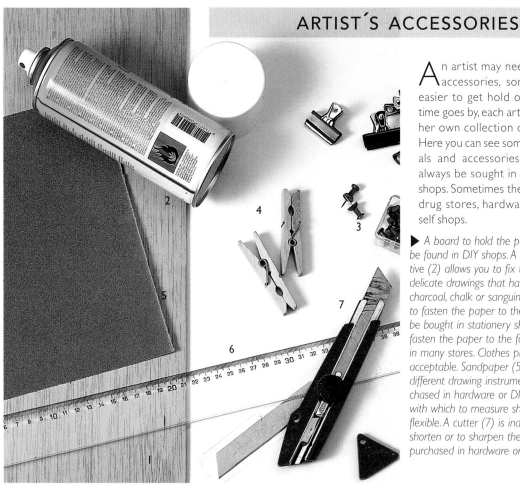

An artist may need many different accessories, some of which are easier to get hold of than others. As time goes by, each artist builds up his or her own collection of personal tools. Here you can see some of these materials and accessories. They need not always be sought in specialist fine art shops. Sometimes they can be found in drug stores, hardware or do-it-yourself shops.

▶ A board to hold the paper (1) which can be found in DIY shops. A spray can of fixative (2) allows you to fix the most delicate drawings that have been done in charcoal, chalk or sanguine. Drawing pins (3) to fasten the paper to the board can be bought in stationery shops. Pegs (4) to fasten the paper to the folder are sold in many stores. Clothes pins are also acceptable. Sandpaper (5) to sharpen the different drawing instruments can be purchased in hardware or DIY stores. A ruler (6) with which to measure should be long and flexible. A cutter (7) is indispensable to shorten or to sharpen the pencils. It can be purchased in hardware or DIY stores.

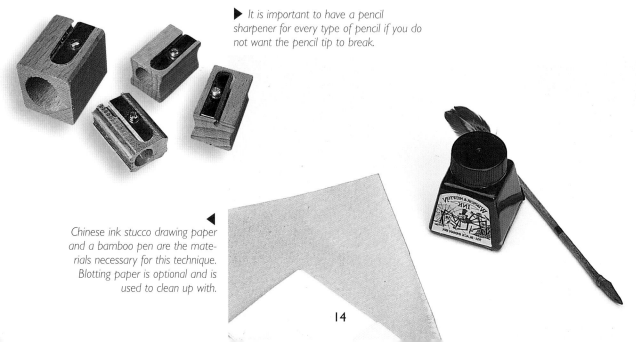

▶ It is important to have a pencil sharpener for every type of pencil if you do not want the pencil tip to break.

Chinese ink stucco drawing paper and a bamboo pen are the materials necessary for this technique. Blotting paper is optional and is used to clean up with.

## THE PAPER

Paper is the principal drawing medium. This is why we must pay special attention to it. There is a great variety of paper on which we can draw. The grain or texture of the paper has an important effect on the mark, or trace, that the different drawing media leave. The thicker the grain of the paper, the stronger the mark will be. Besides the grain, paper is also defined according to its weight; the heavier it is per square meter, the thicker and more resistant it will be.

▶ Some companies manufacture high-quality colored paper. These different types of paper enable you to work with all kinds of drawing media. On these colored papers, it is also possible to work with reliefs in white chalk.

Paper of different grains and weights. Paper with a brand name is the best for drawing. The quality of its texture guarantees a homogeneous and stable surface. The brand-mark of high-quality paper is usually water-marked in one of the corners. It can be seen when you hold it up to the light.

Here are two examples of how you can work with white chalk on colored paper. ▲

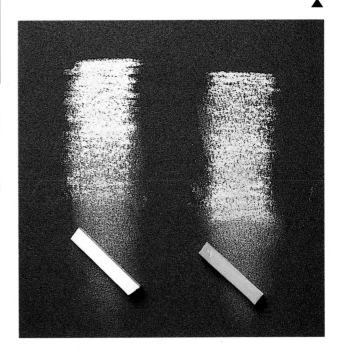

▶ More economically priced paper. This type of paper is used principally for doing sketches. It is bought by weight and is quite cheap. If you want to buy a large amount of this paper, you can go to a stationery warehouse or discount store.

# ERASERS AND CLOTHS

Cleaning materials are fundamental whatever the drawing technique employed. While drawing, the paper becomes quite dirty and every type of medium must be rubbed out or corrected with an appropiate material. Erasers allow lines, stains and smudges to be eliminated and the paper to be left clean. Besides erasers, there are other types of implements to modify or correct the strokes.

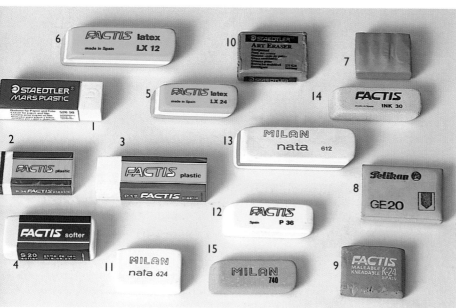

▶ Here we can see a wide assortment of erasers. Each one is suitable for a particular type of drawing medium. Plastic erasers (1, 2, 3, 4), latex erasers (5 and 6), putty erasers, especially suitable for charcoal and sanguine (7, 8, 9 and 10), very soft crumbly erasers, especially suitable for pencil marks on delicate or satin paper (11, 12, 13 and 14), and a hard eraser for ink (15).

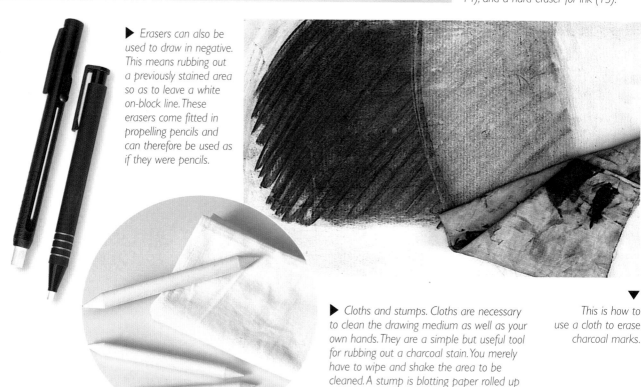

▶ Erasers can also be used to draw in negative. This means rubbing out a previously stained area so as to leave a white on-block line. These erasers come fitted in propelling pencils and can therefore be used as if they were pencils.

▶ Cloths and stumps. Cloths are necessary to clean the drawing medium as well as your own hands. They are a simple but useful tool for rubbing out a charcoal stain. You merely have to wipe and shake the area to be cleaned. A stump is blotting paper rolled up to form a blunt tip with which to diffuse your line with varying degrees of subtlety.

▼ This is how to use a cloth to erase charcoal marks.

# 1

# Charcoal

## CHARCOAL STROKES

Charcoal can be used as a very versatile drawing medium. Depending on how it is held, you can draw with all the width of the stick, with the tip, or flat between your fingers. Each way of holding the stick allows a different type of stroke to be made, which added to other drawing techniques can produce a great variety of options and results.

**Charcoal is one of the most highly recommended media for an initiation into the world of artistic creation. A charcoal stick can vary in thickness and any of its surfaces can be used for drawing. It leaves a mark so unstable that it can be rubbed off just by touching it with one's fingers or with a cloth. It is important to pay attention to the basics of this technique, as the most insignificant details, such as rubbing or the way the stroke is made, will be indispensable to the understanding of more advanced processes.**

▶ *The charcoal stick has to be broken with the fingers to the necessary length. Just a light pressure is sufficient to break the stick to the required length. This must be neither too long nor too short: five or six centimeters is about right This size enables you to make all types of strokes on the paper.*

▼ *When it is held like a pencil, a charcoal stick is enclosed in the palm of the hand. This form of drawing will become very familiar to all enthusiasts. However, learning to master the stroke is complicated since, in contrast to a pencil, the upper part of the charcoal is hidden by your hand. The movement of the stroke is entirely controlled by your fingers.*

▼ *To make a stroke like this, hold the charcoal as shown in the picture. This way of drawing enables you to create precise lines and firm strokes since the entire length of the charcoal is in contact with the paper.*

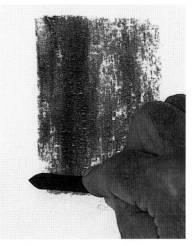

▼ *By dragging the charcoal transversely, as shown in this photo, you can make strokes as wide as the stick is long. It is thus possible to cover a wide area with charcoal very quickly.*

## CHARCOAL LINES

The different faces of a charcoal stick allow you to use a variety of strokes to mark and outline all types of forms. To draw, you only need charcoal and paper. With these simple tools it is possible to create all kinds of work, but first you have to learn the ins and outs of this drawing process and the basic principles of drawing.

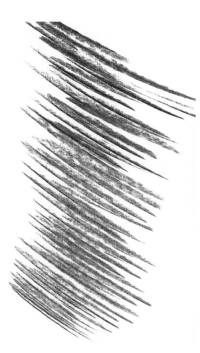

▶ *If you hold the charcoal stick near the point as if it were a pencil, it is possible to do rapid strokes guided by the movement of the hand. Here, it is a question of tracing various lines in order to compare the effects of different pressures. Be careful not to smudge the lines with your drawing hand.*

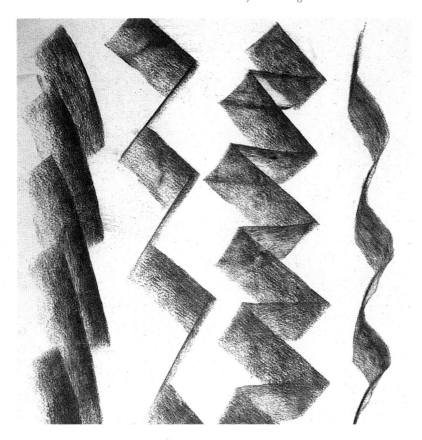

▼

*When a charcoal stick is held horizontally, using its length to make the stroke, the result is very firm since trembling is effectively ruled out. The charcoal stick is its own guide as it is dragged over the paper. This process does not allow for fine details. However, it is useful for outlines and adjustments, for the first steps of any drawing or picture.*

▶ *With the charcoal held horizontally, lines as wide as the stick can be drawn. As can be seen here, this style offers a rich variety of combinations in the some stroke. It is only necessary to make a small movement to change a fat stroke into a transverse one.*

## CORRECTIONS AND HOW TO USE THE ERASER

If you have tried the exercises on the last page, you will notice that the charcoal is not fixed on the paper and that your fingers are stained. Because of this quality, it is possible to make all manner of corrections to the work in progress. Corrections can be made in various ways: with the putty eraser or with your hand or fingers. Before starting to draw even the simplest subjects, you must practice correcting and smearing the charcoal on the paper.

◀

*Make a stroke with the stick flat. Gently go over this line with tiny circular movements of the hand using the fingertips. The charcoal spreads out and stains the paper. This process is called stumping the stroke.*

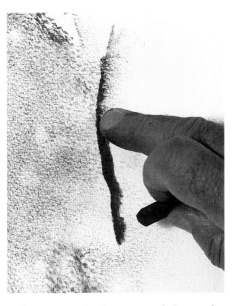

▼ *Stumping can be done on top of all sorts of lines. All that has to be done is make a stroke with the point of the charcoal, and then run a finger along one side of the stroke so that it merges into the background. If you press too hard, the charcoal may combine with the skin's natural oils to produce an irreversible stain. If the pressure is faint the merging will be very gentle.*

The hardest erasers can damage the surface of the paper, and, of course, they get much dirtier. When another type of eraser is used, it is a good idea to wash it whenever it becomes grimy. Of course, before you use a redently cleaned eraser, it has to be completely dry.

▼ *A putty eraser can be kneaded with the fingers to give it the desired shape. Depending on the shape of the eraser, different types of corrections and rubbing techniques can be made. This exercise is very straightforward: it consists of shading all the paper with the charcoal stick flat. Using the eraser, several white spaces are opened up by rubbing softly on the surface darkened by the charcoal. When the eraser becomes grubby, the soiled part is pushed inwards, so that a new surface can be used to continue erasing or to open up other white spaces.*

# COMBINING LINES

Once the rudiments of charcoal drawing have been learned, they have to be put into practice. All the shapes and forms of nature can be reduced to very straightforward elements so that they can be better represented on the paper.

By combining the different ways of making strokes with charcoal explained so far, seemingly complicated forms can be drawn. Pay close attention to this exercise and you will see that it is not too difficult to start drawing.

Drawing requires a suitable type of paper, otherwise it is possible that the charcoal will slip on the surface and spoil the line. The paper must have a surface that lightly abrades the charcoal. This is why paper with a smooth finish is not suitable.

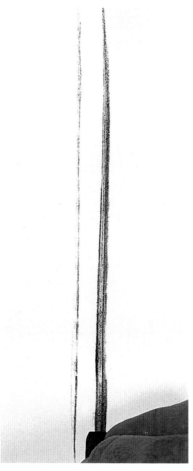

▲ 1. *To produce straight lines without the stroke trembling or wobbling, hold the charcoal stick flat between your fingers and make a stroke with its entire length. First a very faint line is drawn, not applying too much pressure. The body of the charcoal stick is the guide for the line and prevents it from deviating. Next to this line, another one is drawn, but this time pressing harder, which will give it a darker tone.*

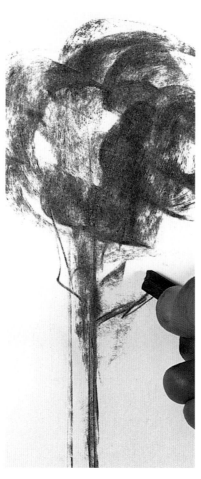

▲ 2. *Starting from these two lines, different strokes are going to be made with the stick held transversely so that its whole surface is in contact with the paper. This allows you to produce very thick lines and curves. You can vary the thickness by changing the angle at which the charcoal moves.*

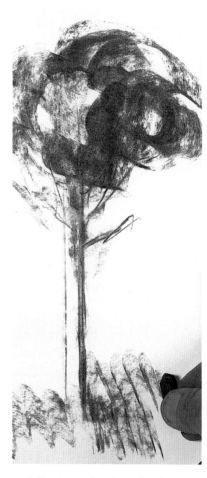

▲ 3. *The harder the charcoal stick is pressed down on the paper, the darker and more intense the stroke will be. On the left side of the paper, use strong pressure. In the lower zone, draw new strokes alternating flat with vertical. With the stick flat between your fingers, draw fine vertical zigzag lines.*

# *Step by step*
# A tree

The aim of this exercise is to familiarize the beginner with charcoal, the possibilities that it offers for different strokes, and its practical application. The exercise should not present any problems. A tree has been chosen because it is a form that is simple to analyze and because landscape elements allow much more freedom of representation than other, more sharply delineated objects. The proportion of your drawing may differ from those of the example, but the end product will certainly be a tree. In the early exercises, the beginner is not expected to obtain the same result as in the photo: it is only a point of reference.

| MATERIALS |
|---|
| Paper (1), charcoal (2). |

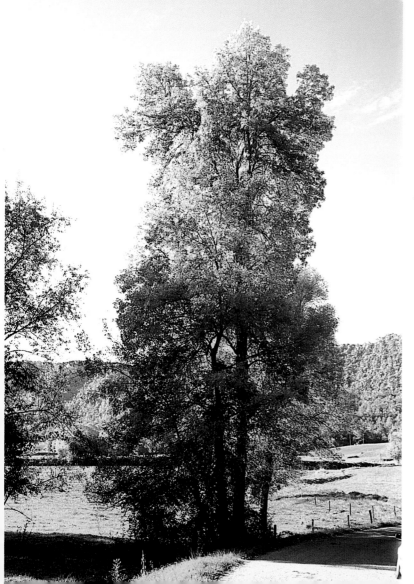

**1.** *The shape of the tree may be fitted into a rectangular outline. Within this shape, the outline of the top of the tree is drawn with the point of the charcoal. This enables much looser and freer strokes to be made. This exercise does not require very precise forms. However, the tree trunk does call for greater exactitude, and therefore, in this area the charcoal must be used flat and lengthwise, thus giving a firm stroke line.*

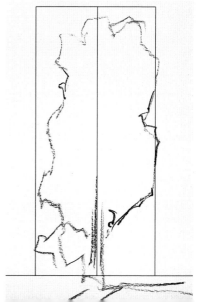

# STEP BY STEP: A tree

**2.** *This exercise can be completed in a very short period of time, as it requires only a few strokes. It is the right type of stroke in each area of the drawing. Start drawing the left of the tree with the charcoal stick held flat and transverse, so that dragging the stick stains all the paper along its width. The stick will have to be broken, enabling you to shade only where necessary. These first strokes are not too close together and, therefore, produce a soft gray. As can be seen in this close-up, the background of the paper shows through the strokes.*

Sometimes the charcoal stick may contain areas that are not the typical color of this medium, but show a brown seam that could even scratch the paper. When this happens, the wisest course of action is to change the charcoal, or rub it with sandpaper until the black reappears.

**3.** *The right-hand side of the tree is drawn with a flat and transverse stroke, going over the drawing made previously with the point of the charcoal. First, draw with a soft stroke, avoiding a strong mark. Afterwards, on the profile of the tree, increase the pressure so as to produce a slightly darker gray. Notice that not all of the tree top is stained, some parts are left white. They are the lightest areas.*

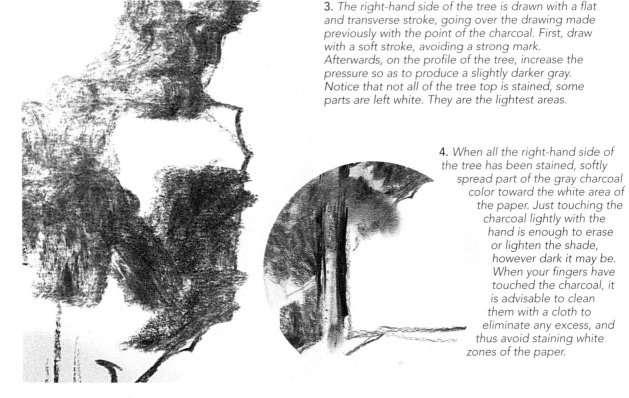

**4.** *When all the right-hand side of the tree has been stained, softly spread part of the gray charcoal color toward the white area of the paper. Just touching the charcoal lightly with the hand is enough to erase or lighten the shade, however dark it may be. When your fingers have touched the charcoal, it is advisable to clean them with a cloth to eliminate any excess, and thus avoid staining white zones of the paper.*

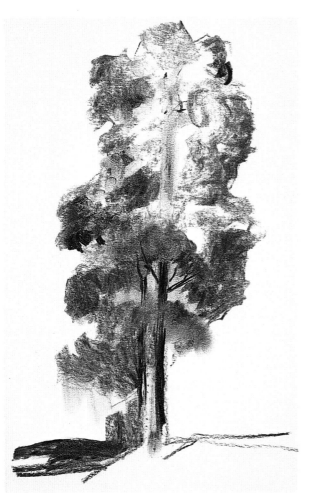 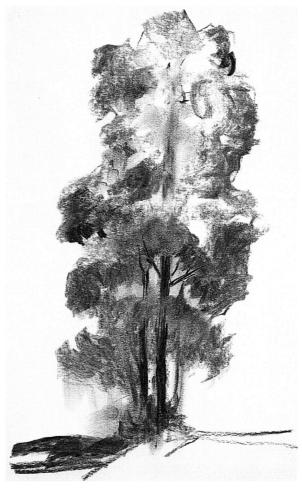

**5.** *Continue progressively darkening the tree top. Charcoal pieces of different sizes are used so that it is possible to obtain flat and transverse strokes of various widths. The areas that represent denser shadows require a heavier stroke. To make the intense shadow on the ground, the point of the charcoal is used in the same way as when the right-hand side of the tree trunk is emphasized. Use a finger stained with charcoal to draw a vertical line in the middle of the tree.*

**6.** *The tree trunk is drawn with several strokes of the point of the charcoal, holding the charcoal stick as if it were a pencil. In this way it is possible to emphasize the dark zones with fine lines that leave sufficient space so that the background appears clearer. The charcoal tip is used to start drawing some of the tree branches. Once again the charcoal is held flat and soft dark strokes are made for the foliage on the right-hand side.*

If any area needs to be erased, a cotton cloth can be used, rubbing it gently over the drawing without pressing too much. However, to restore the paper to its original white, it is best to use an eraser to clean the area.

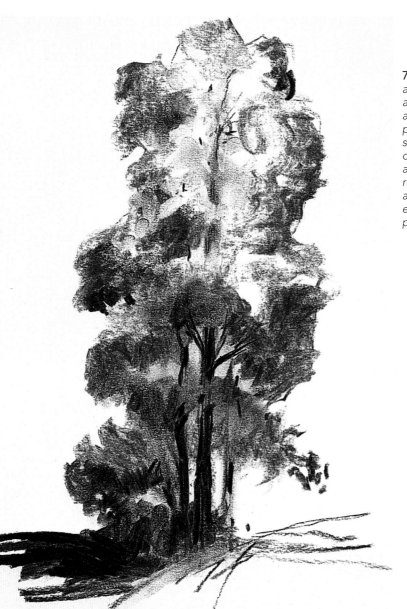

7. *Once all the elements of the tree are in place, the contrasts of the top are intensified with the stick held flat and transverse. The lower shadowy part is emphasized much more strongly with firm strokes with the charcoal tip. Finally, some very clean and separate lines are drawn on the righthand side of the picture. These are the final details of this first exercise, which has enabled you to practice charcoal strokes.*

Since at this early stage you have little experience with the different strokes, it is advisable to practice them on a separate piece of paper before starting an exercise.

## SUMMARY

**On the top of the tree** a flat, transverse stroke is used.

**The tree outline** has been done with the charcoal tip, thus producing a clean and individual stroke.

**To outline the trunk** the stick has been used flat and lengthwise. In this way the lines are straight and firm.

**The shadow on the ground** has been made with the tip of the charcoal.

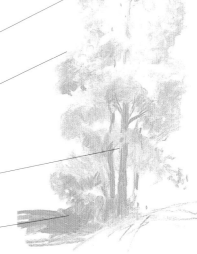

# Drawing lines

## THE USE OF LINES

A line, whatever its form, is the result of the charcoal acting on the paper but the charcoal can produce more than fine lines. If strokes are made widthways, the line can become a stain. To understand forms, you must begin with simple outlines using a minimum of strokes and lines. Any object, however complicated it may be, can be reduced to these basic and elementary lines.

**Correctly constructing the lines allows you to create all types of drawings. Moreover, charcoal allows a process of gradual elaboration as the drawing progresses, beginning with a few simple strokes on which to build up more complex forms. After studying the following pages, you should have no difficulty in producing quite complicated drawings.**

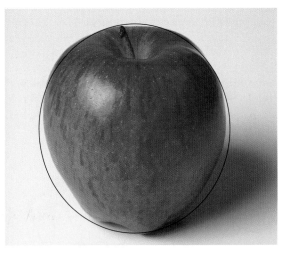

▶ Any natural element, for example, this apple, can be reduced to simple geometric forms. This is a good exercise with which to start studying the basic forms of any object.

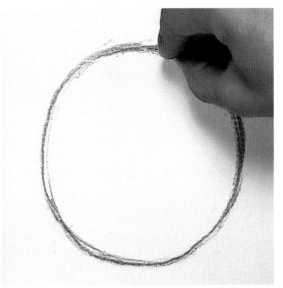

▶ To make the lines need not be difficult. Just hold the charcoal stick flat between your fingers and go all around the form with longitudinal strokes.

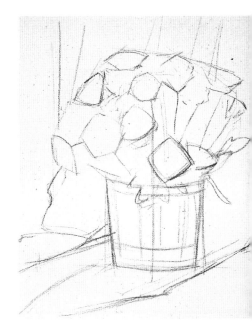

▼

In the same way that a natural shape, like an apple, can be fitted into a circular outline, with a little practice much more complicated forms can be produced, like this bunch of flowers. This straightforward exercise begins with a circular shape. The stroke is made with the charcoal held flat, and the lines become firmer once the basic shape is laid down.

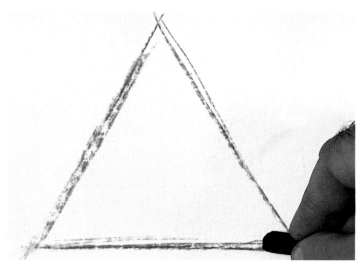

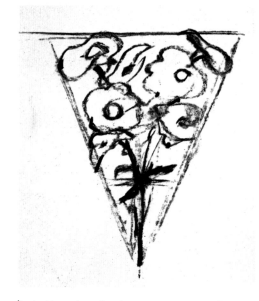

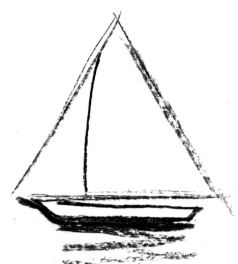

▶ 1. *It is not difficult to draw a triangle. With the charcoal held flat between your fingers the three lines that form it are schematised. Afterwards, use the tip of the charcoal to go over the stroke. If it is necessary, rub out any line, just a flick of your hand or a cloth will suffice. This first phase is very important and the outline must be precise for the posterior strokes depend on this initial work.*

## ESSENTIAL LINES

On the previous page, you were introduced to the concept of outline. Starting from a figure as straightforward as a triangle, it is possible to draw forms that are apparently more complicated. The forms that have straight lines are drawn with the charcoal flat between the fingers, using lengthwise strokes with a very steady hand. The exercise of this section involves a somewhat more complicated approach, although it will not be too difficult if proper attention is paid to the initial structure.

▶ 2. *Starting from the triangle, a simple trapezoid shape is drawn in the lower part. This bottom part will be intensified with a second, harder stroke. Finally, a free-hand zigzag stroke will indicate the reflection of the boat in the water.*

Analyzing something into simple geometric forms is the first step in doing any drawing. A clear understanding of the structure of the forms involved is a great advantage when tackling the representation of the object.

▶ *Inside a triangular shape a great variety of objects can be fitted, like a bunch of flowers. Their forms are complicated but inside a simple outline that marks the limits they can be drawn in much more detail. It is important to draw the first steps with soft lines that can be easily corrected, if necessary.*

# GOING OVER THE STROKE

You have seen how the simplest forms give rise to more complicated ones. While on this topic, we shall also look at how variations in this stroke allow the outline to be elaborated in different ways.

It is always important to make a rough sketch beforehand, the strokes of which will become firmer as the drawing develops. The more advanced the drawing is, the more definitive the strokes will be and the more variety they will have.

In the example shown on these pages it is important to pay attention to each of the phases of the drawing, without omitting any.

> Starting from the basic forms it is easy to finish this drawing. The accessory lines, once they are no longer required, can be erased effortlessly by simply passing a cloth over them.

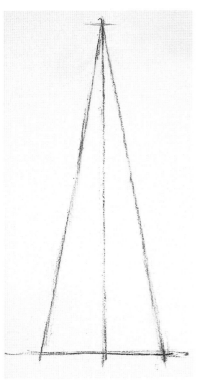

▼ I. *The first phase must always be very schematic. With the charcoal held flat between your fingers, lengthways strokes are made with the surface of the stick. Thus, the first strokes, which are the ones that will allow the model to be correctly constructed, will be made very clearly, with hardly any corrections. A straight horizontal line forms the base of the drawing. Perpendicular to this line, a vertical one provides an axis of symmetry. First, one side of the triangle is drawn, and then at the same distance from the axis the other side is added.*

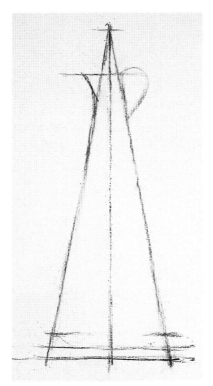

▼ 2. *Starting from the first triangular structure, it is easy to draw the complex form of a vase. Observe the simplicity of the new lines that are superimposed on the previous forms. These lines are drawn so neatly that there is no possibility of later errors.*

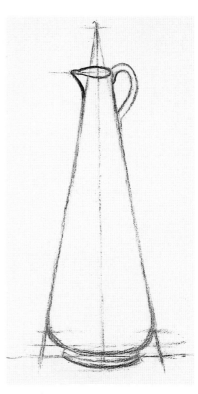

▼ 3. *The work done on the outline allows the stroke to be gone over more solidly as new strokes are added. It is much easier to put in firmer lines on top of on earlier structure. As the initial strokes have produced a very exact construction, those that are made now can be done with the tip of the charcoal stick. Only the lines considered definitive should be gone over. In this way the principal elements of the drawing will appear bolder.*

> The elements with the most complicated form can always be fitted into simpler forms. Once the general form has been outlined, others can be fitted into it to give the definitive picture.

# ADJUSTING THE LINE

A line is first sketched, then it is schematized, and finally it is adjusted according to an initial structure that is intended to be a guide to the whole drawing. On the basis of this definitive structure, different strokes can be superimposed on earlier ones, gradually building up the forms so as to define and complete the drawing. Continue in the same way as the drawing was begun, with soft strokes of increasing intensity. The first sketch lines will be soft strokes. As the drawing progresses, the strokes will become firmer and more intense as they define and delineate the forms more precisely.

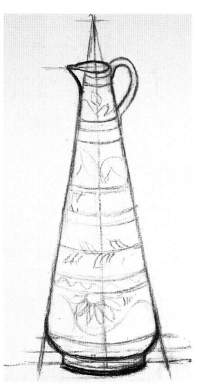

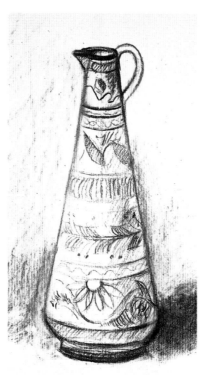

▼ **4.** *You can now add more details to the sketch, using the tip of the charcoal to produce soft lines conveying the decorations on the vase. The outer form of the vase is completely finished. Now, a much freer type of line is going to be used: it will not be so rigid. Any mistake can be wiped out with your hand or a cloth, although if there are too many smudges an eraser should be used.*

▼ **5.** *In this step, the initial lines of the decoration are gone over, but first, with the eraser, all the lines that were used to construct the drawing and are no longer necessary are eliminated. Once these superficial lines have been rubbed off the important strokes are made bolder, both interior and exterior. The interior ones are drawn with the charcoal point. The dark strokes that go round the vase are done with the stick flat and in a transverse direction. The denser dark zones on the right-hand side are made with greater insistence.*

▼ **6.** *The strokes become more intense and definitive. Softly sloped lines are used to darken the sides of the vase. The dark shadow is blackened as much as the charcoal permits. Finishing off the decoration details requires much attention and care. Once the dark lines of the interior have been emphasized with the point of the charcoal, the dark areas on the base and handle are reinforced. Finally, the eraser is used to open up a white space on the left of the vase.*

# Step by step
## A still life in charcoal

To start the drawing it is necessary to lay down a good linear structure. Each stroke must start from a firm base. To achieve this, it is essential to begin by constructing a simple outline to serve as a scaffolding for the lines of the drawing. Starting from a very simple basic scheme, complicated forms can be constructed. The aim of this exercise, apart from practicing the different types of strokes, is to enable you to become familiar with the basic structure of the objects, in this case a bunch of flowers.

### MATERIALS
Paper (1), charcoal (2), and a cloth (3).

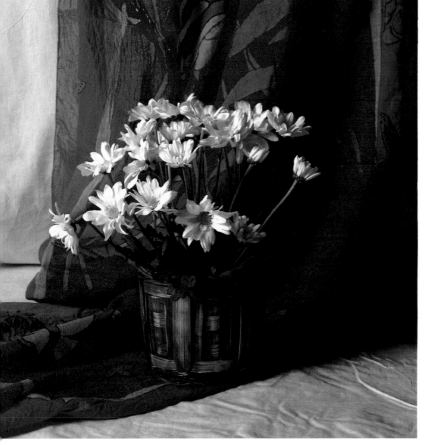

**1.** To start constructing the drawing, the charcoal stick is held flat between the fingers. The strokes must be done lengthwise, so that they will be long and firm. If you look closely at the model, you will see that the flowers are situated within a fairly straightforward form: this will be the first thing put down on the paper. A soft vertical stroke is made which will aid the visual division of the paper into two. With the charcoal still flat, an almost square form is drawn; this will be the outline of the flowerpot.

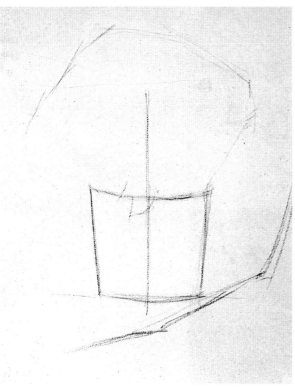

**2.** *Softly mark out the lines that complete the skeleton of the model with lengthwise strokes of the charcoal. Observe here how the flowerpot is corrected. The lateral lines are redone to narrow the base of the flowerpot. The center must be equidistant from both sides. The symmetrical axis will help you to gauge this correctly. Once this correction is made, the excess lines on both sides are erased with a cloth. Now the flowerpot is no longer square. The flowers are begun with strokes that outline the entire form, but without going into details.*

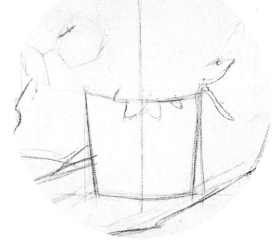

**3.** *The earlier structure has provided guidelines on which to construct another and more detailed version. You should always follow this procedure when drawing, progressing from outline to detail and always moving from the general to the specific. Now go over the outlines of the flowerpot, using the flat of the charcoal to produce a clear, solid line, making sure you show the curve at the base. Still holding the charcoal flat, use lengthwise strokes to suggest the principal flowers and the folds of the cloth.*

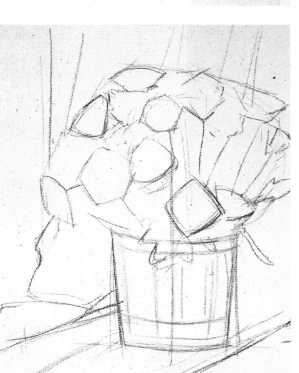

**4.** *Having duly elaborated the basic linear structure, you can now make the other forms more explicit. Without the preliminary outline it would be impossible to place the flowers accurately, now, however, each can be sketched first in outline and then in detail. This series of progressions will gradually complete the drawing. Begin by drawing a closed shape to represent each individual flower.*

**5.** *Once the initial scheme is well defined, it is possible to start developing the details, this time with the tip of the charcoal, as if it were a pencil. The schematic outline of every flower enables us to define the exact space where the petals have to be drawn in. When you are drawing them, the pressure has to be gradually increased so that the guiding strokes underneath will fade away.*

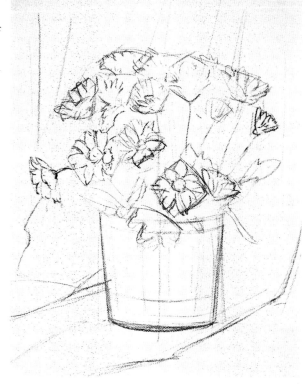

Charcoal gets used up very quickly so plenty of sticks should always be kept at hand. As the charcoal stick draws with all its surface, it should be used up evenly, so that there will always be a suitable surface for drawing clear, fine lines.

**6.** *Use the cloth to remove the accessory lines with which you have constructed the still life. Be careful not to press too hard, or the charcoal will become ingrained in the paper. A light wiping should remove all traces of the softer lines. It doesn't matter if a line cannot be completely eliminated; the essential point is that the most important lines should stand out. Some of these will probably have been erased along with the accessory lines, so they must now be redrawn as you go over the entire picture. This stage involves emphasizing the defining lines of the flowers and the pot and strengthening the outlines of the background.*

When drawing, you should avoid making a series of truncated strokes. This is one of the principal faults of beginners. The stroke has to be continuous, displaying an energetic texture all along the line.

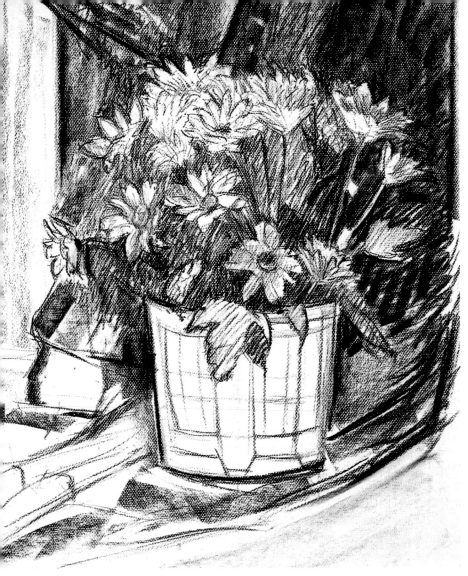

7. *The drawing is now almost finished. The most important parts of the still life have been completed. Some work that still remains to be done is the darkening of the background, both between the flowers and behind them. For this addition, the tip of the charcoal is used, producing very dark, rapid and straight lines. Then the charcoal is used flat and widthways to produce grays of different intensities which define the curtains in the background.*

In any drawing the steps of the process must go from smaller to bigger, both in the precision and details of the strokes and in their intensity.

## SUMMARY

**The flowers,** having been outlined in a very simple, general form, are drawn with the point of the charcoal.

The drawing starts out from a very **simple outline,** based on the division of the space with the charcoal held flat and a lengthwise stroke. The form of the flowerpot is enclosed within a square outline.

**The background** is produced by a combination of flat, widthways strokes and criss-cross lines made with the tip.

After erasing the accessory lines with a cloth, **the lines of the still life are made bolder,** this time with steady strokes using the charcoal as if it were a pencil.

# Composition and planes in the layout

## COMPOSITION

Composition consists of finding a balance between the different elements of the picture. Composing is part of the layout for it is in this first process that every part of the drawing is structured. When composing individual elements, the different proportions of every part of the model must be kept in mind. When composing a group of objects you must also observe their relative proportions.

In the previous topic we saw how objects can be represented schematically with simple lines, and how to build up more complex forms on the basis of such outlines. The placing of objects within a group must be carefully studied in order to produce an aesthetic balance. This balanced placement of objects within the picture is known as composition. Good composition needs a fair amount of practice, although it is not the most complicated aspect of drawing. As well as the placement of the objects, composition also involves separating out the different planes of the model; these levels are established during the layout process.

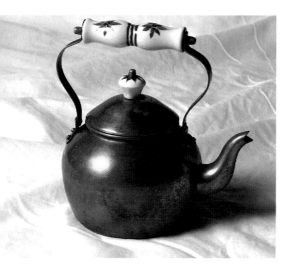

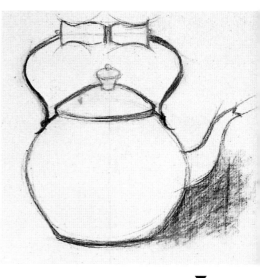

▶ 1. The composition of a drawing begins with the individual elements. Here the exercise is to draw a teapot, paying close attention to the proportions of the different parts.

▶ 2. When drawing the body of the teapot, many beginners fit it into a circle. However, if you look closely, you see that its form is not circular, but a little flattened. The next stage of constructing the teapot is fitting the spout: it must be almost in the middle. The opening must be higher than the body of the teapot.

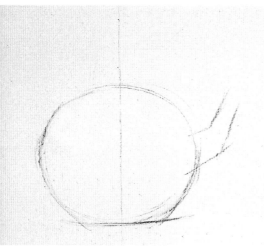

3. Just as the distance between the spout and the bottom of the lid must be studied, the same must be done with the upper part of the handle and the base, allowing the lid and its knob to be fitted in and the right amount of space to be left blank. For this exercise, you can try out sketches and measurements on a separate sheet of paper. You could take the measurements from the example above.

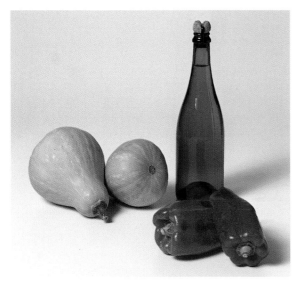

▶ This model can be fitted into on almost triangular form, the vertices of which are perfectly established by the elements in the comers. A triangular type of composition is very frequent and allows complicated themes to be resolved quite easily. As can be seen in this image, it is not advisable to lay out the still life or model that we are going to draw with exact symmetry. A little bit of asymmetry always gives the picture an edge, making the composition more interesting.

## PLACING THE ELEMENTS

To situate the elements correctly, you must first learn to see the separate parts as if they were one. The layout process is a great help in developing this skill. As with the individual elements, construction of a group layout means studying the relative proportions of each feature. This page contains three simple exercises, each composed of a variety of objects. Each image includes an outline of the overall shape of the composition. Try copying these outlines. If you compare the three, you will see that they all have two points in common: they are all asymmetrical, and none of them is perfectly centered on the paper.

▶ When elements of a similar height are combined, as in this case, the composition is no longer triangular, but takes on a more complicated polygonal form. The scheme of the composition becomes harder work, and at the same time the number of reference points increases they are the different vertices of the composition. When the measurements are transferred to the paper, it is important to bear in mind both the distances between the outer limits of the objects, and also the distance between these points and the edge of the picture.

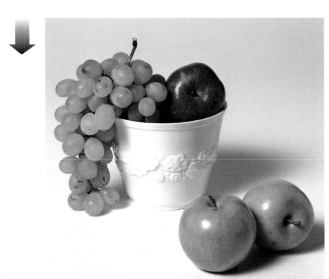

▶ As can be seen in this example, any composition, however complex it may seem, can be schematized in lines that permit a rapid comprehension of the general form.

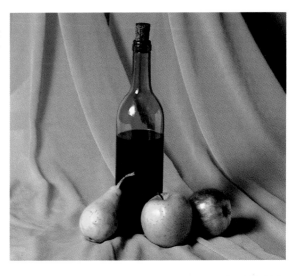

1. *A layout is the representation of a theme with straightforward lines that leave the model perfectly marked off. In the process, it is necessary first to observe the model carefully and then try to structure its form. Being a good observer is one of the principal foundations of drawing.*

## THE DIFFERENT PLANES AND PROPORTIONS

In the last section we looked at some compositions and their basic schemes. The composition of the objects in a picture is not limited to the layout of the external forms: this is only the start of the structure of the drawing. It is useful to remind ourselves of the first point of this topic where the composition was structured within a concrete object. This same system must be used for the group of elements as a whole. We will now look at how to calculate the proportions of each one of the objects and planes of the composition.

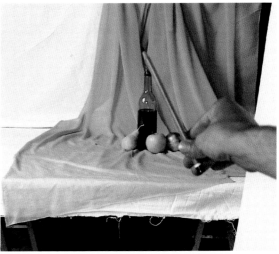

2. *The space can be divided up in several ways. It can be done using the real model, rearranging the forms of the simple elements. Once the model has been arranged, you can draw the framing, the composition and the layout, thus enabling you to pick out the composition lines. To appreciate this effect one eye must be closed.*

3. *If you stretch out one of your arms and take the pencil or charcoal stick as a reference, it is possible to place the measurements on the paper with considerable precision. In this way the proportions between the different objects can be compared. This is how the distance between the base of the bottle and the top of the wine is established. In fact, the wine level is exactly halfway between the cork and the bottom.*

▶ **1.** *In this example, the scheme of the composition has a clearly defined triangular form. The base is not completely flat because the apple in the middle produces a new vertex that increases the dynamism of the overall form. The height of the bottle marks the vertex of the triangular form. This first stage is carried out with a flat lengthways stroke to enable the straight lines to be drawn as precisely as possible.*

## LINES AND STROKES IN THE COMPOSITION

Once the model has been studied and you have been able to discover the structure of its composition and how the different planes are distributed, you must lay down the structure before you actually start doing the drawing itself. In the construction process, the general form has to be considered first, and then the elements and the proportions. This page contains an exercise based on the model of the previous page. All you have to do is build up a schematic for the composition.

▶ **2.** *Starting from the initial layout, you can establish the forms of all the objects. This time the drawing is made with the point of the charcoal to help you master the short stroke. Follow this method to outline the fruits. Once the scheme is set up, the lines that have been used for the layout and to compose the still life are no longer useful. Rub them out. Whenever forms or planes are superimposed on top of one another, they must be drawn as if they were transparent. In this way you can observe where every line starts and finishes.*

> As the composition scheme of the model is
> a step that is quickly rendered superflous
> as the drawing progresses, it must be done
> with soft strokes, without pressing,
> so that it can easily be rubbed out when
> its function has been fulfilled.

▶ **3.** *Once all the objects have been fitted into the layout, the lines have to be made bolder and the now unwanted guiding lines must be erased. All that remains to be done is to define the form of the curves and the interior lines of the bottle.*

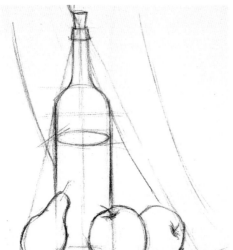

# Step by step
# Fruits and a bottle

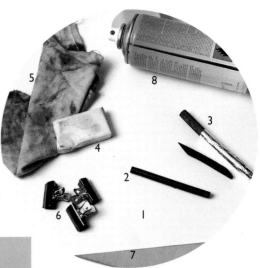

Throughout this topic you have studied different aspects of composition and layout. If you pay sufficient attention to the first steps in the model, a lot will be gained. The composition of the elements that make up the model and the form of each one of them are more easily understood as they become more structured. This experiment goes further than the previous exercise on this topic. Although the elements are similar, the structure of each of them is studied in more detail, as is the superimposition of the planes that they occupy.

### MATERIALS

*Drawing paper (1), charcoal (2), pressed charcoal stick (3), putty eraser (4), cloth (5), clips (6), board (7), and charcoal fixative (8).*

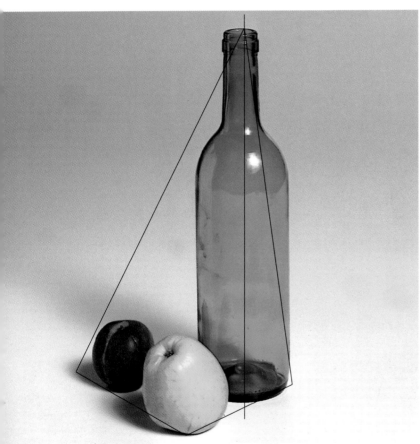

**1.** *The basic composition of this still life is triangular. The bottle, slightly displaced to the right, marks the height that will serve as a reference for all the elements. Once the triangular composition has been absorbed, it is advisable to outline each of the forms separately, bearing in mind their location and the distance between them. The base of the plum on the left is slightly higher than the bottom of the bottle. The apple on the right is interposed between the plane of the bottle and the plane of the plum in the background.*

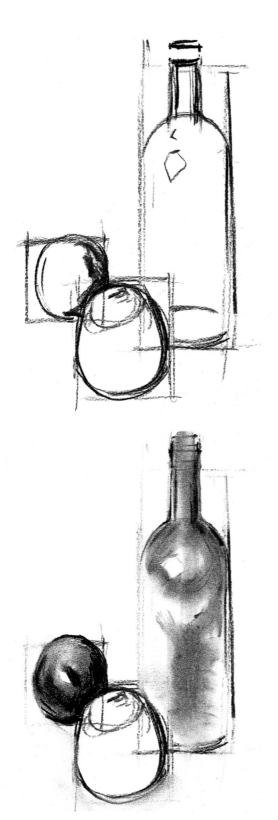

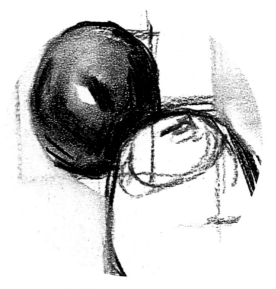

*2. The scheme of square forms used here gives a good approximation of what will be the definitive forms of the drawing. The fruits are easy to do, starting from the squares that frame them. To draw the bottle, the semi-circular shape of the base of the bottle neck is outlined and then the entire neck is drawn.*

*3. Once each of the elements of the still life has been outlined, the dark areas and the details are drawn in. In the area close to the plum in the background, draw with the point of the charcoal. An energetic stroke gives a very deep black. A finger is rubbed over softly until all the form of the plum is filled in. Once again, the shadow zone is shaded to darken it. The eraser is used to create the shiny part of the plum.*

*4. The outline of the bottle is made bolder, this time with much more definitive lines that make the neck longer and give it shape. A few strokes with the point of the charcoal are sufficient to darken the outline of the bottle. The inside of the bottle is smudged with charcoal-stained fingers, leaving clear the areas that must appear brighter. In the midst of the dark area, the eraser creates a highlight.*

**5.** *The staining of the apple in the foreground is completed with the fingers still covered in charcoal. This time it is preferable that the tone should not be too dark in order to achieve a contrast with the plum on the left. In this type of exercise the eraser is extremely useful as it enables areas that have been accidently dirtied to be cleaned up. Also, it can create highlights on a surface stained with charcoal.*

The composition aims at achieving a harmony between the forms and the space that they occupy. The elements must be placed in such a way that they are not too centered or too close together, nor too far apart.

**6.** *If you do not want the drawing so far achieved to be spoiled by any accident, a fixative spray can be used to set it. Before doing this, you have to be completely sure that all accessory lines have been rubbed out, for once fixed, they cannot be changed. Once the drawing has been fixed, the strongest contrasts can be brought out on top of the previous work, on both the neck and the base of the bottle.*

The framing of the composition is of great assistance in settling the distribution of the elements of the model on the paper.

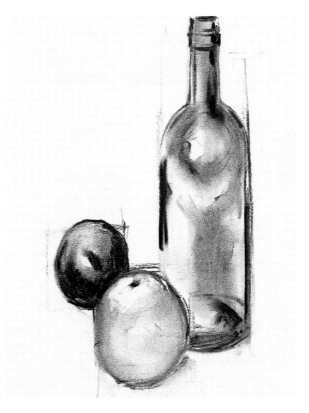

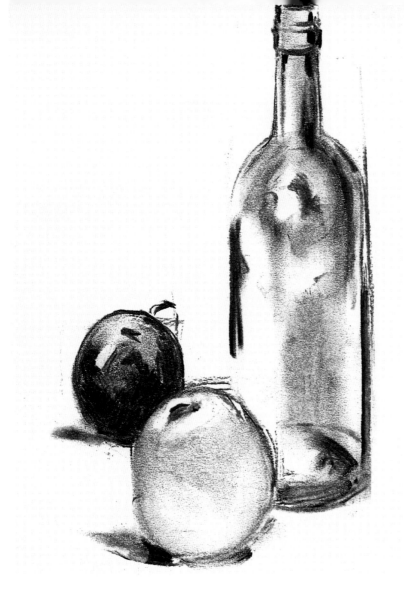

**7.** *On top of the apple in the foreground, some very dense dark patches are drawn so that it is perfectly separated from the plane of the plum. These last very dense strokes are done with pressed carbon, which produces much darker blacks than charcoal. Some dark spots are also made on the bottle by gently stumping with your fingers. Stain your fingers with carbon to do contrasts on the apple in the foreground and then open up some shiny highlights. After drawing and stumping the shadows on the table, you will have completed this exercise.*

> If you wish to prevent your charcoal drawings from becoming smudged or losing definition, you should spray the finished work with a fixative. This will preserve the charcoal and therefore the drawing.

## SUMMARY

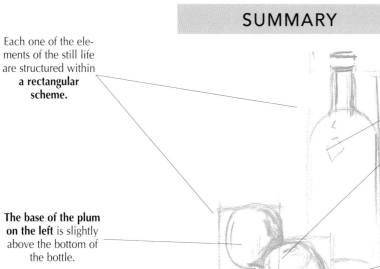

Each one of the elements of the still life are structured within **a rectangular scheme.**

**The base of the plum on the left** is slightly above the bottom of the bottle.

**The eraser** allows you to create selected shiny areas or highlights.

**The strokes are superimposed** on top of each other while the composition planes are being constructed.

# 4 Drawing with sanguine

## SANGUINE: ANOTHER VISION OF DRAWING

A sanguine stroke will complement any of the other dry media. We are going to try a simple exercise to practice integrating sanguine and charcoal together.

Sanguine opens the door to endless tone possibilities, and its use is practically the same as charcoal. However, the results that can be achieved make it appear to be a different medium. A drawing in sanguine is one of the most beautiful possible. The warmth of the sanguine stroke cannot be compared with any other drawing medium. Moreover, both the mark of sanguine and its gradations combine perfectly with other drawing media such as charcoal.

▶ 1. The shape of this fruit is basically a circle, slightly deformed in its upper and lower zones. When the definitive line is started, with a fine but steady stroke, draw the little dip on the upper part. After outlining the nectarine, make the dark stains with the charcoal stick held flat between the fingers. In the left-hand area, the charcoal stick is not pressed very hard: it is only the start of the first tone. On the right, in contrast, the pressure is much harder. With a piece of sanguine, the same size as the charcoal, flat between the fingers, stain the left-hand side. As you can see in this example, charcoal and sanguine are two media that can blend perfectly.

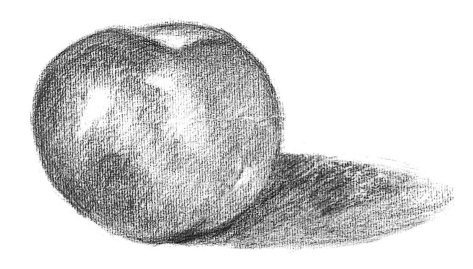

2. You can shake the paper gently in the zones where the contrast is too strong. Stump the darkest charcoal shadow with your fingertip. Finally, make the form more definitive using the sanguine stick and leaving the highlights white. The sanguine is used to intensify the reddish zone with softly insistent strokes.

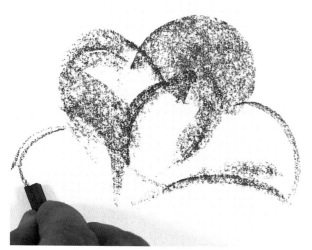

## THE POTENTIAL OF THE STICK

Just like the individual elements, the overall effect of all the forms joined together has to be constructed observing the proportions between each and every part of the objects. You will do three exercises which are composed of several objects, on top of which the general form of the composition has been schematized. First, draw this outline on the paper.

▶ **1.** *Break the sanguine stick. If it is new, break it roughly in the middle. In this way you have two pieces. Take the stick flat between the fingers and start to draw transverse to the stroke. As can be observed, the contact with the paper is different to that of charcoal. Sanguine covers it with greater density and overall is slightly more sandy.*

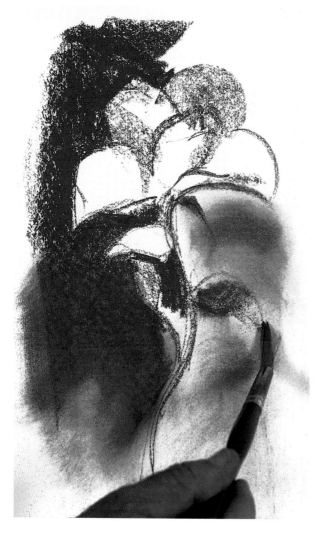

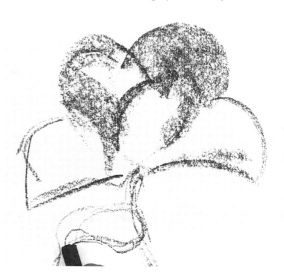

▼

**2.** *The stroke of the sanguine point is more precise than can be achieved with charcoal. Now draw the lines that outline the leaves and the petals on the left. The stroke has to be made in one movement, without any breaks. If you use the tip of the sanguine stick you can achieve an effect quite similar to that of a pencil stroke.*

▶ **3.** *Depending on the pressure of the sanguine stick on the paper, you con completely cover a zone and even close the pores of the paper. On the left-hand side of the drawing, all the background is covered with strong pressure and the stick flat. Sanguine can also be put on with a paintbrush. With a thick bristle brush, smudge the right-hand side of the drawing to produce a very special stumping effect.*

## COLORED PAPER AND SANGUINE

Sanguine has a warm and opaque appearance. It offers the same stumping possibilities as charcoal. This characteristic can be added to the tonality of colored paper to achieve a very strong integration of the drawing media. The tones of the paper can be perfectly combined with those of sanguine, In this exercise you are going to use sanguine and charcoal once again, but this time on colored paper. Although the process is as straightforward as the last exercise, the difference in the finish and in the texture is evident.

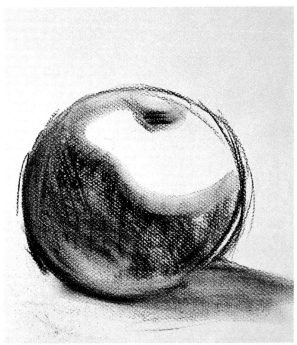

*1. This simple exercise consists of drawing a fruit with two tones, one in charcoal and one in sanguine. The initial outline is done in charcoal. The stick is used flat to do the shadows. The shadow stroke is easily done with the charcoal stick flat. Afterwards, drag a finger over the outline to blend the stroke into the paper.*

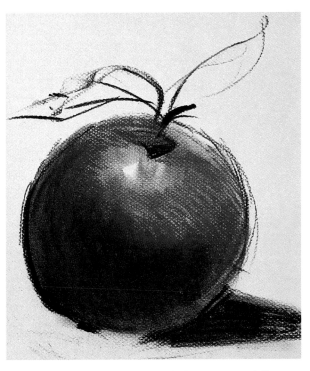

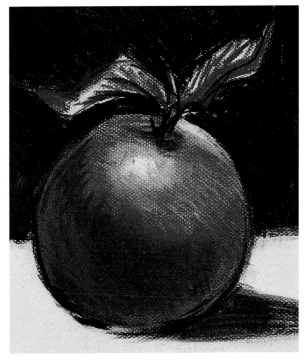

▼ **2.** *Draw on top of the charcoal with the sanguine stick. The highlights of the fruit are left blank, meaning that the color of the paper remains visible. Use a fingertip to stroke the sanguine on top of the charcoal until the two tones are blended together. If the highlight has become covered, open it up again with the eraser.*

▼ **3.** *The background is completely drawn over with a dense, closed black stroke. Now the fruit and the table on which it rests take on considerable luminosity and volume. Darkening the background completely with charcoal makes this fruit stand out perfectly and gives it a more realistic volume.*

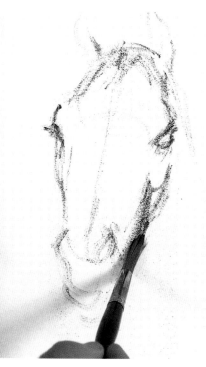

## SANGUINE POWDER AND THE BRUSH

▶ **1.** *Sanguine can be laid down in a number of ways without losing the character which it bestows on the drawing. In its manufacturing process, gum arobic is dissolved in water to make the paste that once dry becomes sanguine. If a stick is scratched or pressed strongly, it will crumble into powder. This exercise consists of working with sanguine powder and a brush. To ensure that the powder sticks to the paper it is necessary to dip the brush in water.*

One good method for getting very fine sanguine powder is to rub the sanguine stick gently with fine-grained sandpaper. The resulting powder can be piled up on paper and then picked up with the brush.

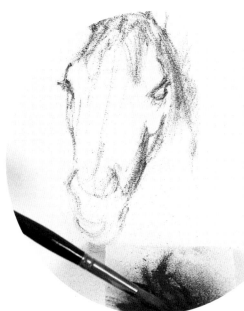

▼ **2.** *Use a bristle brush which you have dampened slightly so that the sanguine powder will stick to it. You can now start your drawing; begin by roughly sketching the horse's head, using very fine lines. The point of dampening the brush is neither to dilute the powder nor to moisten the paper, but to ensure that it will pick up the sanguine, This means that any corrections can be made simply by wiping the drawing with a cloth.*

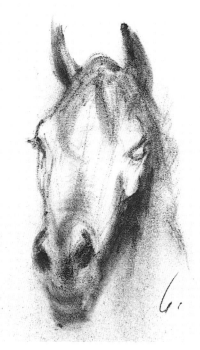

▼ **3.** *Lastly, the lines that contrast the darkest areas are finished. These strokes can be made with a somewhat wetter brush so that the sanguine is denser on the paper. In any case, when the work is finished, it is advisable to use a spray fixative to stabilize the drawing.*

# Layout with sanguine

Sanguine is a drawing medium with very varied potential. It allows the artist to make all types of strokes and stands out sufficiently even when the paper is colored. The range of possibilities that sanguine offers make it a particulary suitable medium for the following exercise, in which you are going to try figure drawing. As always, you must first sketch the layout, producing simple geometric forms which will then gradually take the shape of the model.

### MATERIALS
*Colored paper (1), sanguine (2).*

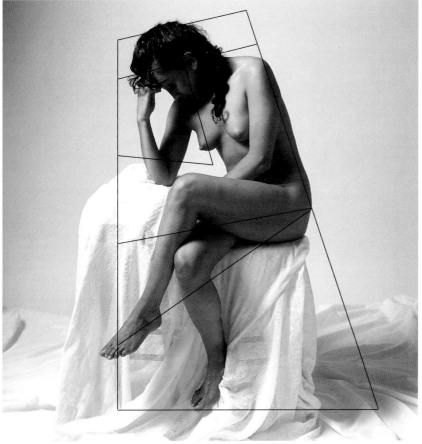

*1. Before starting to draw, you should try to visualize the general shape in the simplest possible geometrical terms. What sort of outline would best enclose this figure? A straight line down from the arm appears to meet the foot; a straight horizontal line gives us the base of the figure; and the right side is closed off with a sloping line, giving us an almost tri-angular shape. These first lines are made with the edge of the sanguine stick. Once the external outline has been laid down, the internal forms are sketched in the same way; first the space between the arm and the right breast is schematized, and then the sloping line of the leg.*

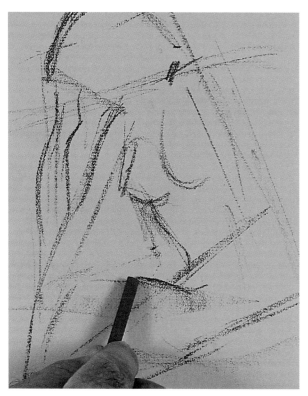

**2.** *After drawing the slope of the leg, do the same with the line that places the arm. In the upper part of this triangular layout, sketch in the shape of the head. As is evident, it too has a geometric shape. Having marked out the gap between the body and the arm, it is now easy to place the breasts and fit in the arm, which in turn will support the head. Now, using the point of the sanguine, outline where the thigh begins.*

The lines that are put down on the paper are exclusively for construction purposes. Before making any other stroke, it is well worth going over the whole exercise and trying to match every line you have drawn with those of the photograph.

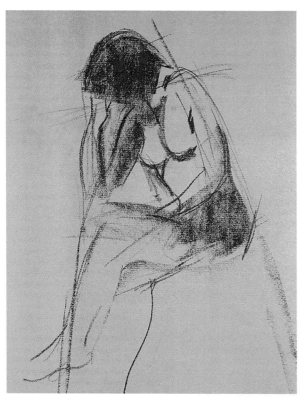

**3.** *The outline of the shape of the left arm is finished off, using as guides the inclined line that ends up at the thigh and the one which schematizes the right-hand side. The line that connects the beginning of the thigh with the arm marks the extension of the leg. Use a clean stroke to situate the leg that is resting on the floor. Use a bit of sanguine held flat between the fingers to lay down the main areas of darkness.*

**4.** *The dark areas that have just been drawn in the last step separate the different planes in the drawing, besides giving more body to the figure. With the stick flat, give more contrast to these dark zones, leaving the lighter zones unmarked. Observe how the legs are resolved. The knees are left as highlights. With the sanguine stick held lengthways to the stroke, finish off the leg touching the floor.*

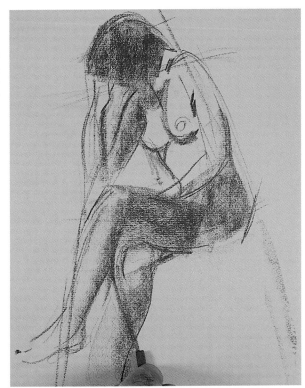

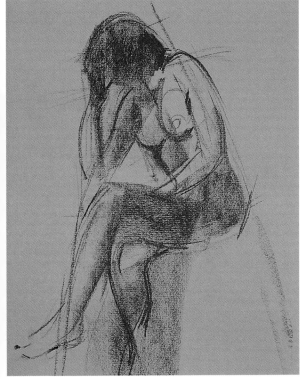

**5.** *The figure slowly takes shape. Any corrections necessary can be made as you go along rather than left until the end. It does not matter if different lines are superimposed on each other as long as this improves the general scheme and avoids confusion. By now the principal lines are defined. With the stick held flat, some soft contrasts are drawn on the torso and the shadow beneath her body.*

**6.** *This is how the point of the stick is used to create the dark zone on the crossed leg. When you do the darkest bits, the medium tones and the lightest appear even brighter thanks to the contrast thus established.*

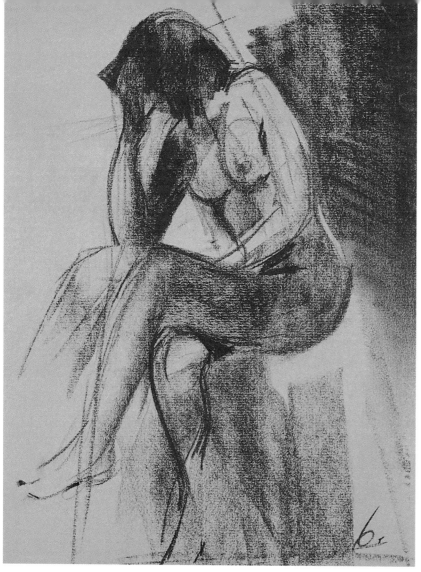

**7.** *The scheme of the figure is now completely finished. You can now make the lines that outline the arms and legs bolder with a much freer stroke. Use the point of the sanguine to intensify the darkest areas and contrast the background strongly. This rounds off this figure sketch. As you have seen, the details have not been worked out. Throughout the whole process, the central idea has been schematization and construction starting from simple forms.*

As with any drawing medium, when using sanguine the basic work scheme must concentrate on the drawing as a whole. The details and nuances are left until a later stage in the process.

## SUMMARY

**The initial scheme** fits the figure into an almost triangular form. This is made with the sanguine stick held flat, in long strokes.

**The first lines are always the most schematic.** The lines of the leg, of the arm, and the gap between the arm and the torso allow the form of the figure to stand out more.

**The maximum contrasts of the shadows of the figure** are drawn with the tip of the stick to achieve a better outline.

**The shadows are marked with the sanguine stick held flat.** Different pressures give varying intensities to the different zones.

# Highlights in white chalk

## SANGUINE AND WHITE HIGHLIGHTS

A highlight is nothing more than adding a tone that is much lighter than the paper and the other media used. In general, when one is drawing on colored paper, the tones that can be developed in charcoal and sanguine are limited by the color of the paper. Nevertheless, this drawback can be overcome if white areas are added. The contrast is so strong that the drawing takes on a new interest.

So many tones can be drawn on paper that any subject, however complicated it may be, even if it is composed of a great variety of forms and colors, can be represented with the different gradations permitted by the drawing media. In the last topic we looked at how to use sanguine on colored paper. If the highlights are reinforced with white chalk, the effect against the background of the paper becomes much more noticeable.

▶ 1. The color of the sanguine will hardly be perceptible against a paper as dark as this. Therefore, we are going to draw with the two media that offer the greatest contrast on earth-colored paper: charcoal and white chalk. First, the landscape is sketched in charcoal. The line of the horizon is sketched in and the dark part of the sky is stained quite intensely, leaving the cloud zone unmarked.

When doing a piece in sanguine, if the lightest areas are picked out with white chalk a very impressive effect can be achieved.

2. The cloud zone is done entirely in white chalk. Then pass your hand over the white chalk to stump the background of the paper. Give form to the clouds with your fingers. Some zones are stained with charcoal, and once again you stump with your fingers. This blending produces different tones of gray. Finally, the lightest areas are drawn directly with white chalk. They are left unstumped. White chalk can be used for all types of stroke work or blending.

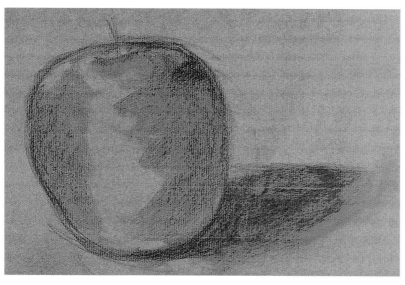

▶ **1.** *The layout of the form is always a fundamental question in drawing. It is a process so straightforward and elementary that it is all too often neglected. This omission is the origin of many badly proportioned or constructed drawings. Without a correct layout; it is impossible to do a high-quality drawing. The shape of the apple is outlined as cleanly as possible: without shadows, only the principal lines. Use a small piece of charcoal flat and in a crosswise direction to darken the main areas of shadow. The lightest area is left unstained. The shadow cast by the apple is also drawn in.*

# USING WHITE CHALK

We have already seen how white chalk can compensate for the lack of luminosity on colored paper and even exceed white paper in this respect Here an apple has been chosen as the model for the exercise. The elaboration process is identical to that of the previous exercise, but in this case there is hardly any fusion of the tones.

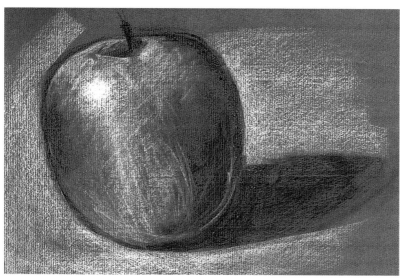

▶ **2.** *The area around the apple is stained with the white chalk held flat. The apple appears to be on a different plane to the background. The relief of the interior is started lightly, marking only the shiny areas and being more emphatic in the lightest parts.*

▶ **3.** *The area around the fruit is stained more intensely with white chalk, thus making it appear more isolated. The color of the paper merges into the interior of the apple as if it were just another tone. Inside the fruit, the highlight is augmented with white. In the intermediate light areas, the pressure with the chalk is minimal. Finally, charcoal is used to bring out the darkest shadows.*

# THE ORDER OF THE DRAWING

ust as in other pictorial procedures, when the paper color is to be integrated with the other colors, it is necessary to create reserves of the forms that are going to contain the color of the paper. A reserve is merely a space that is deliberately set aside. Inside it there will be the color of the paper or a tone that must be neither stained nor blended.

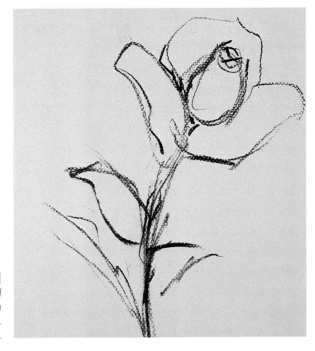

1. *This is a very straightforward exercise in which we will practice reserves and highlights in white chalk. The form is sketched with charcoal as accurately as possible. Any corrections must be made in this first stage.*

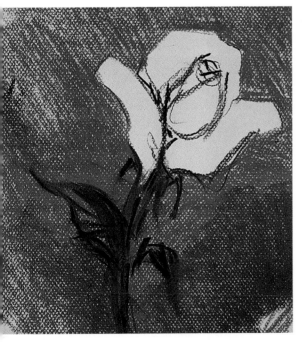

▼ 2. *With the sanguine stick all the area around the flower is filled in until the paper is totally covered except for the interior of the petals which are left in reserve. Now it is the paper that gives the drawing its principal color as the sanguine has completely obliterated the original color of the background.*

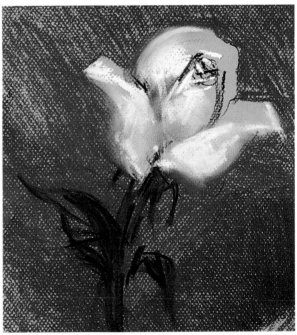

▼ 3. *Once the flower has been worked with the sanguine tone, the paper tone becomes incorporated with the other tones of the drawing. White chalk is used for the highlights necessary to give shininess to the petals. Once all the colors are in place, stump them with your fingers until the sanguine color is blended into the background of the paper color. When the white is merged into the cream colored paper different pinkish tones are obtained.*

## STUDYING THE LIGHT

Combining the three basic procedures of drawing allows the study of all types of light effects. Highlights can often be very useful aids in this process. The following exercise is quite straightforward. You will be able to observe how a few touches of white chalk give much more volume to the whole image.

▶ 1. *Draw the bottle and the bowl semi-hidden behind it. The background is filled in with charcoal, marking out the forms of the two elements. The interior of the bowl is also drawn with charcoal. Before blending the charcoal, use the tip of the sanguine to draw a series of straight and inclined lines in the background, and horizontal ones in the bowl. Once these areas have been filled in, pass your hand gently over them to merge the sanguine with the charcoal.*

In work done with sanguine, the areas of light must be reserved so that they can be defined with white chalk, stumped to varying degrees according to the intensity of the light in that area.

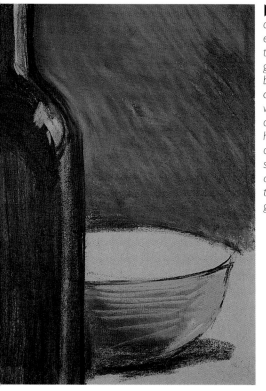

▶ 2. *The previous blending of tones produces an earthen color different from that of the paper and the gray of the charcoal. The bottle is again shaded with charcoal, and a finger is wiped over the side to open up a long, continuous highlight. The strokes on top of the bowl are made with sanguine. Once again, it appears as if the grey of the charcoal has been integrated with the paper color.*

◀

3. *Finally, to finish off this still life, white chalk is used for the highlights. These will be limited to defined areas, on the bottle and inside the bowl, with the stick held flat. Do not overdo the chalk, use it only when absolutely necessary.*

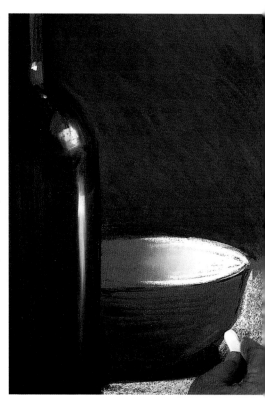

# Step by step
# A still life with flowers

The highlights produced by white chalk on colored paper may be among the most surprising drawing effects. When dark tones are used to draw on colored paper the variety of contrasts is limited to the lightest tones used, whether of the sanguine or the paper, supposing that you are drawing on dark paper. However, when the drawing incorporates white chalk highlights, all the tones have the white chalk as a light reference point. Thus, a considerable tonal variety can be obtained without the color of the paper being a limiting factor.

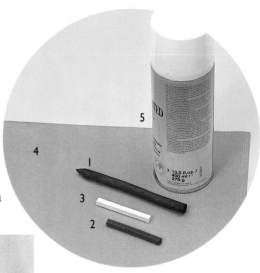

## MATERIALS

*Charcoal (1), sanguine (2), white chalk (3), colored paper (4), and fixative (5).*

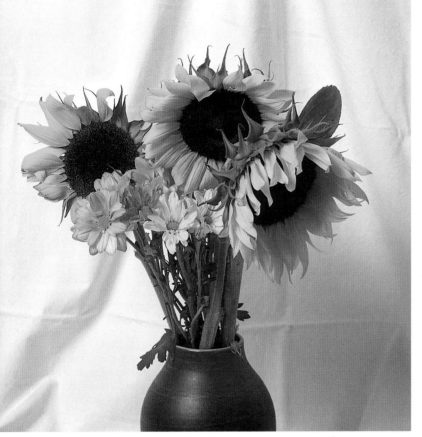

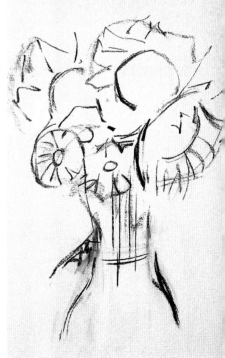

1. *The flowers are begun with charcoal inside an inverted triangular shape. The first forms are synthetic and they are sketched with very simple strokes. For example, observe how the flower on the left has a completely elliptical form. Each flower starts out as an elliptical or circular figure that places its form inside the bunch. Afterwards, the petals are drawn with very elementary strokes.*

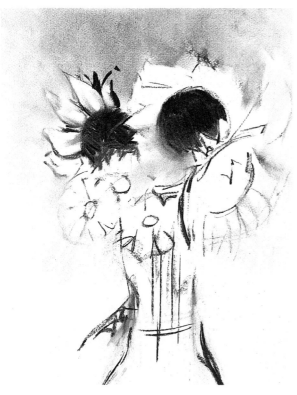

**2.** *Once the flowers have been fitted in, use charcoal-stained fingers to smudge the area around the bunch. The contrast effect means that the bunch is separated from the background: it is the first separation of planes. The centers of the sunflowers are drawn with charcoal, and their brightest parts are done with sanguine.*

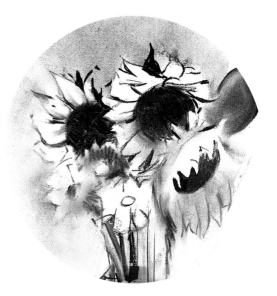

**3.** *The background is smudged once more with fingers stained in charcoal. Do no press too hard or the charcoal will become ir grained in the paper. Draw the petals c the two upper sunflowers with the tip c the charcoal, marking only the stronges lines. Use charcoal again for the leaf on th right, and stump its interior. Use sanguine t outline the petals of the lower sunflower an for a heavy stain on the central one. Go ove the right-hand flower with sanguine an stump it with your fingers to blend the san guine tone with the paper colo*

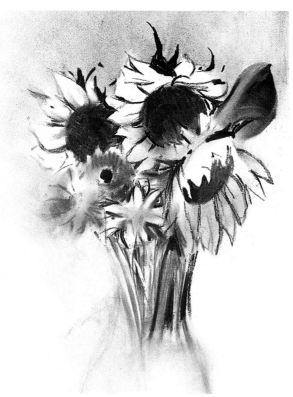

**4.** *Emphasize the contrast of the entire upper part with charcoal. Repeat the stumping of the leaf on the right. Use a clean finger to create a highlight in its lightest area Now draw the sunflower on the right and the petals of the tiny central flower. To increase the contrast and defini tion of the petals of the large central flower, put in some dark patches around it.*

**5.** *As colored paper is being used instead of white paper, the chalk is turning out to be an important source of brightness. Now put in the highlights of the central sunflower. You only need to draw a few lines on one of the upper petals, as a tiny amount of chalk can produce a brilliant contrast. In the little flower on the left the petals can now be defined.*

Drawings of a certain complexity must be laid out first with charcoal. It is easier to correct the errors and redo the forms with this medium than with sanguine.

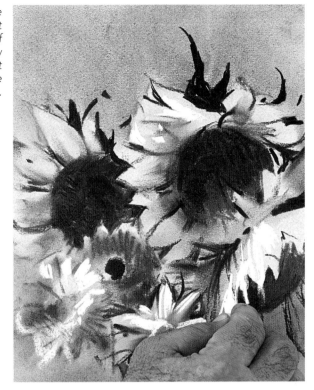

**6.** *The little flower on the left and the contrasts of the stems are redrawn in charcoal. The white chalk is used to heighten the light contrasts on the sunflower in the center. This notably sharpens the contrasts between the dark and light areas. Draw a soft line around the vase with the white chalk held flat between your fingers. This white will be blended with your fingers, thus giving greater volume to the vase.*

The darker the color of the paper, the lighter the white chalk highlights will be.

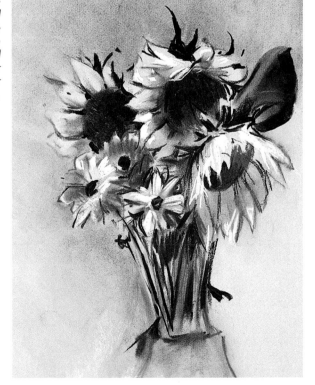

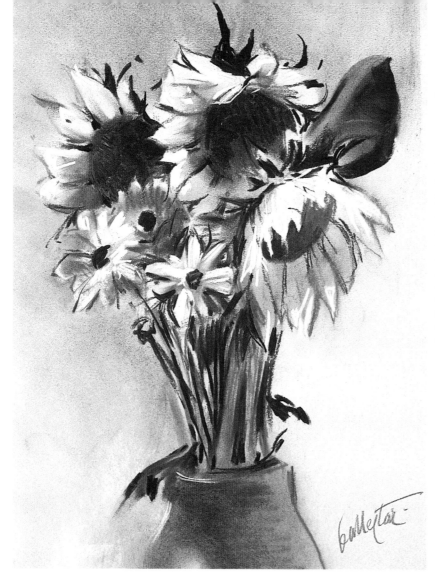

**7.** *The last contrasts with white chalk are drawn on the petals of the sunflower on the left. These little touches of brightness allow the flower to be completely separated from the background. The dark parts of the stem are defined, and the vase is redone with charcoal and sanguine in the darkest zone. Finally, the drawing is fixed with a fine layer of spray fixative. There is no need for highlights all over the drawing; they should be confined to those areas where they are necessary for a greater impact.*

## SUMMARY

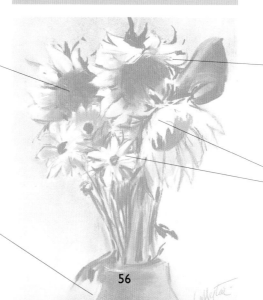

Sanguine is drawn on top of the darkest charcoal parts. **Charcoal is easier to correct.**

**On the side of the vase,** draw and stump with white chalk. This gradation allows the background to be separated from the vase.

**On top of the charcoal background,** open up a highlight with a finger. The clear parts that can be opened up with the fingers are very varied in tone. However, it is prudent not to press too hard.

**The white highlights are started with small lines.** White comes into its own when it is contrasted with darker colors.

56

# 6     Perspective

## BASIC CONCEPTS

This topic does not set out to be a technical analysis, nor to enter into the fundamentals of technical drawing. Moreover, it will not even be necessary to use a ruler, although you can use a sheet of paper as a guide. To make the explanations more systematic, we are going to use a series of very elementary lines that will be revised and repeated on the drawing paper.

> **Perspective allows objects to be represented in three dimensions. To use perspective it is advisable to learn a few rules which, although they are not too complex, require a lot of attention from the beginner. It is possible that at the beginning these notions could seem a little dry; however, there is no need to lose hope. If one learns to master perspective, it will pay off significantly in its effects on the drawing.**

▶ 1. *The horizontal line (1) places the horizon. On it a point is marked: the vanishing point (2). All the parallel lines that are drawn going away from the viewer towards the horizon (3) converge at this point.*

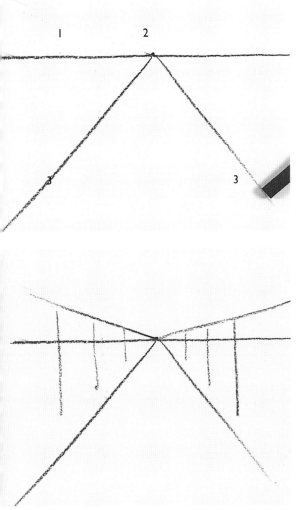

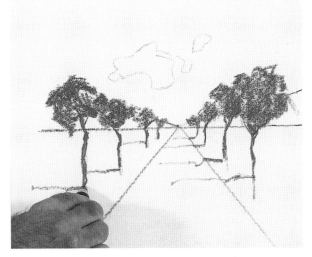

▶ 2. *You must distinguish between the lines that are drawn below the viewpoint of the observer, here the horizon, and those that are drawn above it. If the point of view coincides with the horizon line, it is assumed that the observation is made from a normal height in the street. If vertical lines are drawn between the vanishing lines, these will be smaller and closer to each other the further away they are.*

▼ *Use an exercise in perspective as a basis for this simple landscape. You will see that it turns out to be quite easy.*

▶ I. *This exercise is made up of two clearly differentiated parts. The first is similar to the previous exercise: it is the technical elaboration of the lines that make up the landscape. Firstly, the horizon line (I) is sketched in. As you can see in the image, it is drawn much lower than in the last exercise. This line is going to coincide with the vanishing point (2) and, therefore, the point of view will have a much more accentuated perspective. Here the vanishing point is placed to the right of the picture.*

## VARYING THE VANISHING POINT

The vanishing point indicates the place at which all perspective lines converge. In the previous exercise, we presented a simple landscape in which the perspective was completely centralized. However, we shall rarely use a completely symmetric perspective. It is more common to displace the vanishing point so that the perspective becomes more engrossing and the image has more movement.

▶ 2. *Various perspective lines are sketched. Naturally, they end up at the vanishing point. The lines go from below the horizon line and above it, too. As one can appreciate, the spaces between these perspective lines vary because the displaced vanishing point means that the angle on the right is widened and on the left it is narrowed. This scheme changes the entire construction of the last perspective we did.*

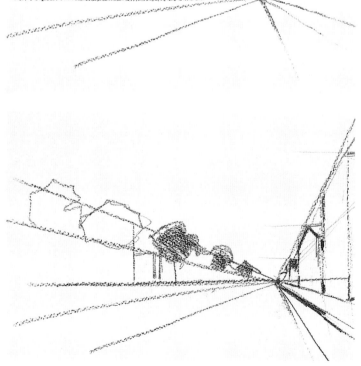

▶ 3. *Two lines below the horizon are established to mark the base of all the objects that are to be placed. All the forms will be correlated and will be arranged according to the perspective. The highest line above the horizon is taken as the reference point for the different heights. As the objects are put in between these two lines, the perspective will become visible. The height of the houses is marked off with lines parallel to the horizon.*

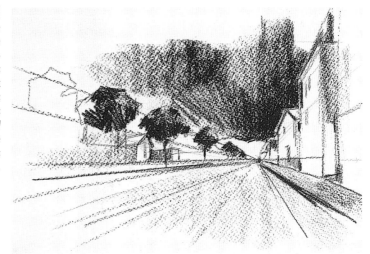

**4.** *The lines on the ground, on which the objects are based, are made bolder. Observe, on the right of the drawing, how the two lines mark off perfectly the pavement and the base of the houses. The line that was used to establish the horizon can also be used to mark the base of the row of houses. The entire sky section is darkened with the charcoal stick held flat, and in this way the upper part of the houses is made to stand out. An important detail to be noted is related to the gutters on the roof: the cut-off point of the two planes has to coincide with the line of perspective.*

## PERSPECTIVE AS LAYOUT

Once the perspective layout has been decided on, it will be the basis of the drawing. It is necessary that the drawing scheme be set out as accurately as possible if you want the objects to have a real perspective. The last example is now going to be developed according to an artistic point of view.

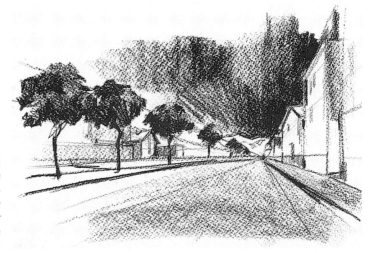

**5.** *To place the trees, their tops are drawn inside the space marked off by the two perspective lines. The trunks come down to a new line just below the horizon. Another line, slightly more inclined, marks off the pavement on this side of the street.*

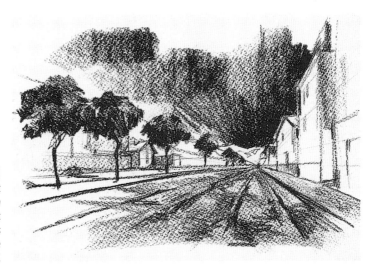

**6.** *Doing dark areas with the stick held flat enables you to differentiate to planes of each section of the landscape. The areas left brightest are on the side of the drawing. The flat stick is used again for the pavement, and some perspective lines are made bolder with the tip of the charcoal.*

# Topic 6: Perspective

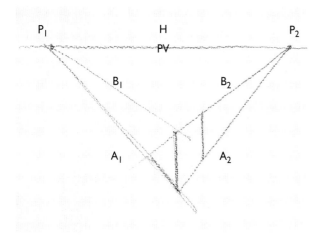

## PERSPECTIVE WITH TWO VANISHING POINTS

Up until now we have looked at perspective with a single vanishing point. This is the simplest way of approaching perspective. However, there are other perspective techniques that are more complicated to learn, although, if you can master them, drawings of great realism can be achieved. Of course these schemes must be only the structure into which to fit the different objects. This exercise is about perspective with two vanishing points. Pay attention to the text and to the drawings.

▼ 1. The horizon line (H) is drawn. On it the point of view is placed (PV). This time we put in two vanishing points (P1 and P2). They must be neither too close together nor too far apart, otherwise the perspective will be overly distorted. The two lines that mark the base of the cube are sketched ($A_1$ and $A_2$). Their intersection point marks the beginning of the height. By drawing in the other two lines, ($B_1$ and $B_2$) the base of the square and the vertical planes are closed off. On the right-hand side, starting from the cut-off points, the lines that mark the side of the cube are drawn in. These lines are completely vertical.

> Objects become smaller as they recede from the viewer and approach the horizon. This effect is not always easy to attain, although with the aid of perspective it is simple to situate the objects at the correct distance.

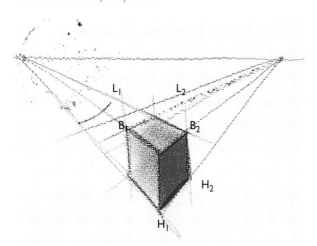

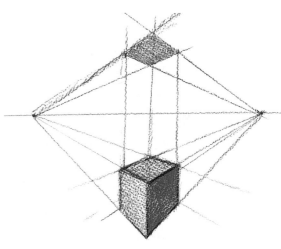

▼ 2. The vertical lines of height ($H_1$ and $H_2$) cut the perspective lines ($B_1$ and $B_2$). From these intersection points two new lines are drawn ($L_1$ and $L_2$) to the vanishing points. The lines that have just been drawn form the upper plane of the cube. In the same way that this cube has been drawn, so can any other object. Remember that all shapes can be schematized inside simple forms.

▼ 3. In the exercise that we have just done, the cube was situated on the floor. A floor can be situated in any of the space planes; all that has to be done is vary the direction of the lines of perspective. In this case, lines above the point of view of the spectator have been chosen. This permits the lower part of the cube to be shown. If the vertical lines are projected and made to coincide with the new perspective lines, a vertical projection of the shadow is obtained.

# Step by step
# A road with a tree

Perspective helps greately in constructing all types of drawings, both still ~~es~~ and landscapes. However, it is with the latter that the basic notions of ~~erspective~~ can be of most assistance to the artist. It is not necessary to ~~ave~~ any knowledge of technical drawing: all you need to remember is that ~~arallel~~ lines tend to coincide in a point on the horizon. Once the scheme ~~as~~ been decided upon, the rest is executed like any other drawing. For this ~~ial~~ run we have chosen a landscape where close attention needs to be paid ~~o~~ the perspective of the road.

*1. The horizon line is drawn more or less at the height at which the road disappears. This line coincides with the point of view of the spectator: this implies that the viewer sees nothing that is below the end of the horizon. There are two perspectives: on one side there is the point marked off by the fence and the highway, and on the other, the point where the road appears to coincide with the line of the trees, beyond the horizon line. This line is cut by the plane on the right-hand side of the landscape and coincides with the off-center perspective point.*

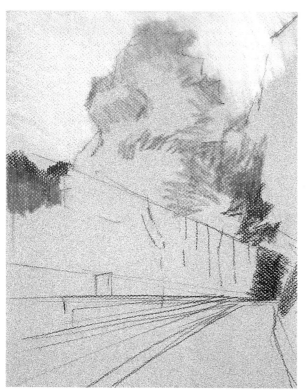

**2.** *Once all the landscape has been schematized around the principal perspective, the drawing can be started. Color the sky with white chalk and lightly stump it with your hand. The chalk crayon offers a very soft stroke and, therefore, perfectly separates the tree line from the sky. The sanguine stick is used to start outlining the top of the principal tree. On the left-hand side the vegetation is thicker. The sanguine strokes completely close the pores of the paper. On the background you work with sepia. The charcoal stick is used to start on the dark areas in the background of the road.*

**3.** *In the background the dark areas of the vegetation are intensified. The tree is strongly illuminated. Moreover, its leaves are much brighter than the rest of the greenery of the landscape. To give texture to the bark of the tree, use the white chalk crayon to do the tiny details. As can be seen, the white chalk produces a strong contrast with the white of the sky.*

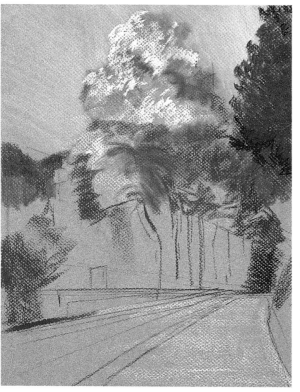

**4.** *Once the white highlights of the tree have been drawn, you can work with sepia and charcoal, blending them together by dragging with your fingers. The vegetation on the right is sketched with charcoal. The stroke is firm but stops short of closing the pores of the paper. The same type of stroke that was used to draw the whites of the tree, but this time in sanguine, is used to draw the highlights in the vegetation. The dark parts on the left are begun with sepia.*

**5.** *The darkest parts of the vegetation are stained before drawing in sanguine on top of them. The sanguine stroke will vary according to the area you are drawing. The planes furthest away are blended with charcoal, while the nearest, like the vegetation above the road, are drawn with short, strong strokes. The ground in the foreground is darkened with charcoal and is then softened with the hand to integrate this tone with the color of the paper. The white lines between the road lanes should be strongly contrasted, as are the profound shadows cast on the highway.*

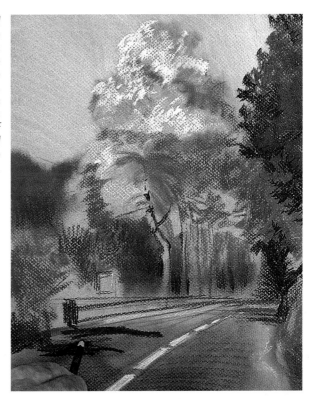

To ensure that the drawing maintains an equilibrium in the lines of perspective, the initial scheme must be well planned, with every element in its place, and it must be adhered to throughout all the drawing process.

**6.** *Now the densest dark parts of the landscape are intensified. Black is used for a general darkening of the deepest shadows: it is blended into the sanguine in the outline. The brightest parts must not be stained with charcoal. Rework the tree in the middle with white chalk. Now the highlights are brighter and some areas have as a base the dark tone produced earlier.*

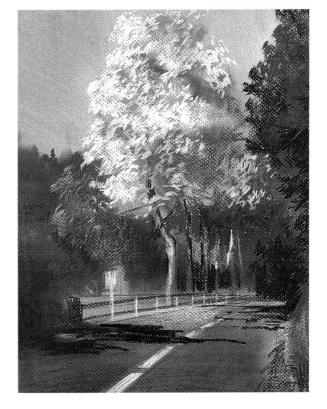

A thorough study of the brightest zones, and of the most intense shadows, will always give us a guide to correct placement of light and dark areas and to establishing the points with the most light.

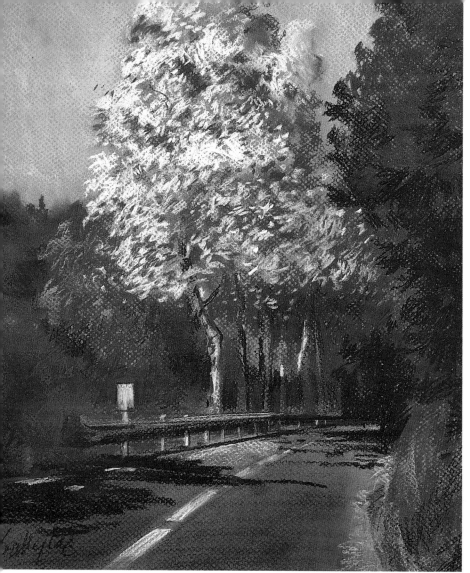

**7.** *The fence is drawn with charcoal. The color of the paper can represent the metal tone. A very direct, dense drawing finishes off the shadows cast onto the road. On top of the lighted tree, some very dark contrasts are produced i the greenery. The areas that have remained somewhat bare are com pleted in sanguine. Finally, a few touches of white by the side of th road finish off this exercise in lanc scape and perspective.*

> The depth of a picture and establishing the foreground and background are always controlled by the laws of perspective. These laws also constitute the basis of the range of colors that divide the different planes.

## SUMMARY

**The intense luminosity of the tree** is produced with detailed work in white chalk on top of the stumped gray areas.

**The contrasts are applied according to the plane that they occupy.** The further away they are, the greater is the blending of different tones.

**The horizon line** coincides with the point of view of the observer. The trees on the left do not coincide with this point of view.

**The vanishing point** is the point towards which all the lines of perspective converge. In this case it is at the end of the highway.

# The eraser

## WORKING WITH THE ERASER

The eraser is a versatile instrument that allows a very constructive type of work. Drawing with an eraser at hand is advisable for several reasons. Corrections are easily made: all that is necessary is to quickly rub a hand over the newly opened area. This enables you to obtain a critical view of the development of your work. You learn to consider the dark areas as valuable elements of a drawing, which facilitate the placing of the areas of light and shade.

> When drawing, the eraser is frequently used, not so much to correct mistakes as to perform a function that only it can do: draw in negative.
> This means to go over a colored smudged surface to create lines or white stains, or areas where the color of the paper shows through.

▶ 1. *The entire surface of the paper is covered with the flat charcoal stick. Although it is easy, this phase is important. All of the background has to be completely covered with charcoal. You must apply uniform pressure, but without scratching the surface of the paper. Remember that charcoal sometimes has seams, or veins, that can scratch rather than draw.*

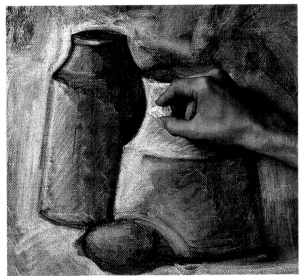

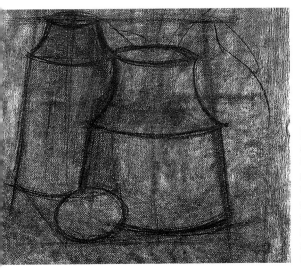

▶ 2. *A scheme is laid down starting from very simple geometric forms. Within the scheme, the basic forms of this straightforward still life are drawn. The initial work is done with the charcoal held flat and lengthways. To ensure that the line is accurate, go over it with the tip of the charcoal.*

▼

3. *With the eraser, begin the process of opening up highlights by rubbing along the edges of the forms and then lightening the right-hand side of each one. The stroke with the eraser can be backed up by a few finger touches to reduce the excessive brilliance of the white of the paper.*

▶ **1.** *The landscape is schematized starting from the horizon line. This gives three clearly differentiated planes: one for the sky, that is completely covered in charcoal without pressing too hard. Another plane is for the mountains in the background, where you draw strongly so that it is separated from the sky. The final and brightest plane is the foreground, which corresponds to the earth.*

## PRESSURE ON THE PAPER

In the same way that different tones can b obtained with charcoal, graphite, or sanguin depending on the pressure on the paper the eras er allows the same process, but in reverse. Th harder you press down, the whiter the stroke o the paper will be. In this exercise we will practic using the different tones of white produced by th eraser. It is a simple exercise which does not pre sent any complications: the forms of the landscap and of the clouds can easily be changed.

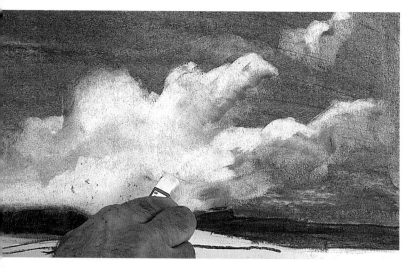

▶ **2.** *The forms of the clouds are outlined with the eraser, but without pressing hard. When you only rub gently the whites opened up are not very pure. The charcoal is dragged, giving very faint grays that are ideal to sketch the first, least luminous tones. Work these rather soft grays over again with the eraser, this time with more pressure. This opens up pure highlights. The quality of the paper plays a key role in the highlighting process. It is best to use paper neither too granulated nor too satiny. With the former, the charcoal becomes ingrained in the pores. With the second, it does not stick properly.*

▶ **3.** *If the earth area is lightly smudged (this can be done with your fingers), the whites that are opened up will contrast much less than those opened up in the dark sky. In this case the whites are produced like strokes that are incorporated into the drawing, blending in with the texture of the earth. As can be seen in this illustration, the white strokes hint at the perspective of the ground strokes that lead towards the vanishing point on the horizon.*

*1. After placing a horizontal line at a higher level than in the last exercise, start drawing with pencil. The lines are much finer than with charcoal, which means that to cover a large surface the pencil must scribble repeatedly across the paper. Even if there are lots of different strokes, what is important is that the majority of them go towards the background, in perspective. The pencil does not press hard, thus avoiding scratching the surface of the paper which makes it easier to rub out later.*

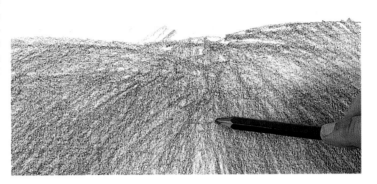

## SIMPLE EFFECTS WITH THE ERASER

The effects that can be achieved with an eraser are manifold and not especially complicated. In fact, the complexity never comes from the stroke, but rather from what the stroke can represent. In the exercise on this page we propose a straightforward landscape in which the pencil stroke and the opening up of clear areas are combined to produce areas of extra brilliance.

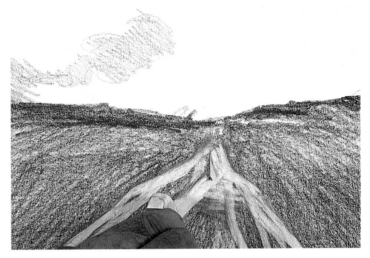

*2. The contrast in the mountains in the background is made more forceful, which gives us separate planes. As we have seen in this exercise, and in the last one, this is a good method of doing landscapes. In the middle of the ground, start to open up irregular stretches with the edge of the eraser. These whites, even though they zigzag, follow the lines of perspective towards the imaginary vanishing point. The intensity of the whites can be made to stand out more if you press harder with the eraser, or if you repeat the stroke.*

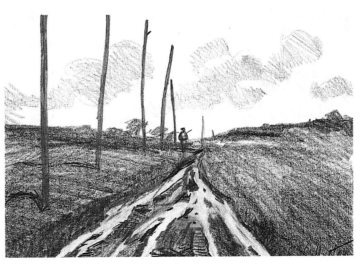

*3. Intensify and define the lines you have opened up with respect to the grays which surround them. This means that the whites are much more definitive. In the foreground, the textures of the ground are contrasted with different strokes. To finish off the perfect definition of the muddy path, draw some dark vertical lines along the side. Finally, to add more depth to the drawing, a line of telegraph posts is put in.*

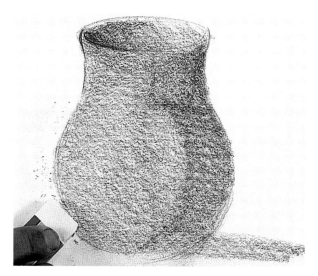

▼ 1. *For this exercise you have to start by drawing this vase. If you look closely, the lower port is practically a sphere, while the upper part has a rectangular form. Where they come together, the form has been softened and rounded. When putting in the gray strokes on the inside, the drawing of the form gets mixed as the stroke has gone beyond the limits marked out by the shape. The eraser restores its shape to the outline of the drawing.*

## USES OF THE ERASER

One reason why the eraser is so heavily used is that it ca outline forms. Once the drawing is completely stru tured, the eraser can finish the cleaning of the outline so th the white of the paper perfectly outlines the object. Beside this very obvious use, the eraser can open up very define highlights that cannot be obtained in any other way.

> The putty eraser is only useful with unstable drawing media like chalk, sanguine, or charcoal. In contrast, the plastic eraser can be used for all the drawing media.

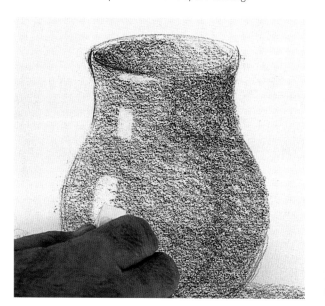

▼ 2. *Once the shape of the vase has been outlined, the highlights can be put in. Nothing is easier than using on edge of the eraser. Just passing an edge over the stained paper will suffice to open up an intense highlight Of course, this highlight must follow the plane of the drawing. On the neck of the vase, a very clearly defined curve has been opened up. Now these two highlights are made much thicker with the edge of the eraser.*

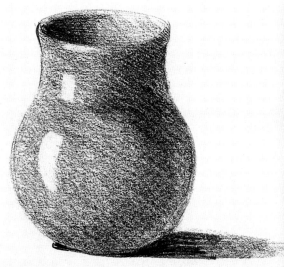

▼ 3. *Such highlights are extremely precise, more so than if they were reserved, since there is a tendency for the stroke to stop short of the reserved area, which diminishes the work's spontaneity and freshness. This point will be fundamental from now on in adding highlights to all types of subjects.*

# Step by step
# A still life with fruits

Here is an interesting still life exercise. It will not be too complicated if the necessary attention is paid to the different steps. However, special care must be taken with the form of one of the objects: the plate is complicated because symmetrical shapes are always more difficult to represent. In this exercise the principal tool is the eraser. As will be demonstrated, it can be used in so many ways that it is the perfect complement for any of the drawing media practiced up until now.

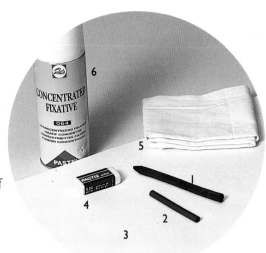

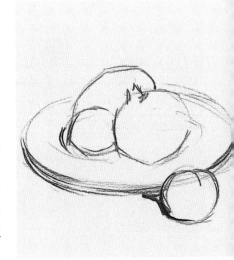

*1. The drawing is started by arranging the forms into the still life. It is important to pay careful attention to this phase of the drawing because all the later steps are based on the results obtained. Firstly, the form of the plate is sketched. The charcoal is held by the tip to obtain a looser movement. The elliptical form is not easy to portray: the balance is hard to achieve. You must persist with the charcoal until you obtain a reasonably approximate form. It is easy to sketch the rest of the fruit on the plate as the drawing of these forms does not require so much precision.*

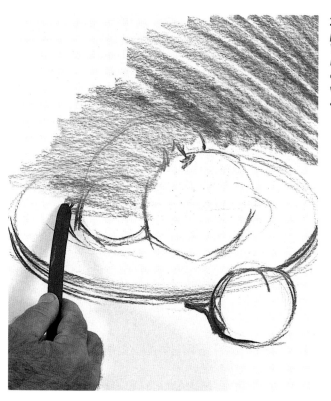

**2.** *A thick charcoal stick is used to fill all the drawing paper, including the outline previously done in charcoal. When you cover the drawing area, the charcoal does not make the outline disappear completely. It remains visible despite the strokes that fill the paper. Although you draw with its tip, the charcoal makes fairly flat strokes because at the start of this phase the tip was beveled.*

**3.** *Once all the paper has been covered, rub it gently with your hand so that the traces of the stroke in the charcoal are removed. This must not be done with too much pressure, otherwise the charcoal may cake or even disappear completely. The initial drawing also fades away, but it does not disappear altogether. Just a small trace is sufficient to go over it later with the eraser, and in this way to recreate the drawing on the basis of the whites you have opened up.*

**4.** *The drawing has not been rubbed out completely. There is still a trace that allows you to draw with the eraser. Start with the form of the plate, which is the most complicated part of this still life. When you erase, follow the forms of the fruits and the outline of the plate. The eraser gets grubby easily. Therefore, it must be cleaned frequently by rubbing it with fresh paper until it is back to its original white. If you are using a putty eraser, you have to mold it until the grimy area has been pushed inside.*

**5.** *By rubbing thoroughly you can open up a white area that includes all the plate surface. After blowing on the drawing to get rid of any trace of eraser, go on to open up the highlights on the fruits. These highlights are carefully placed. On the pear in the background, the highlight occupies all the upper zone. It is made with a long continuous stroke. The strokes on the pomegranate are more radial and move towards the top of the fruit. A small highlight suffices on the plum. It can be made with a quick stroke of the eraser.*

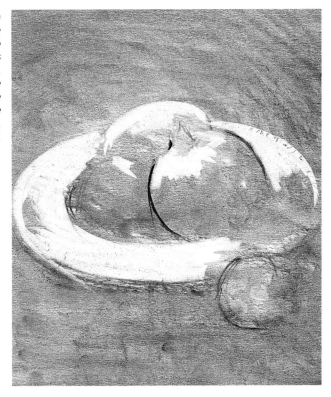

*When the principal highlights have been opened up, you can redraw the darkest shadowy areas with charcoal. Once the charcoal work has been done blend these dark tones into the background with your fingers.*

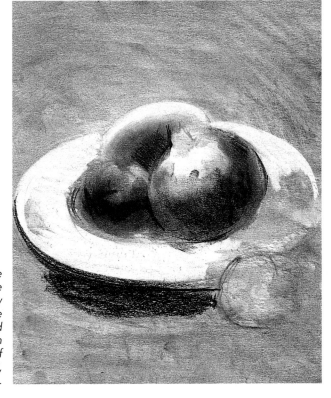

**7.** *The darkness of the fruits is increased by using the point of the charcoal and then it is blended in with the fingertips. This is repeated as many times as necessary until the right density of darkness is obtained. Once the shadows have been placed, draw directly with pressed carbon. It allows you to produce blacks that are much more intense than charcoal blacks. With a little bit of pressed carbon held flat, and not pressing too hard, draw the dark shadow of the plate on the tablecloth.*

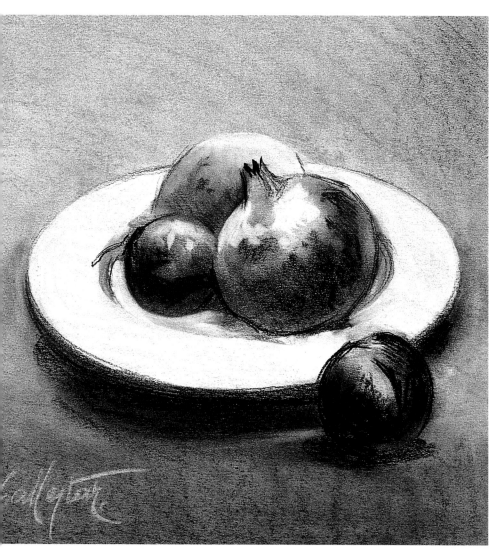

8. *The outline of the shadow on the tablecloth is blurred with the fingers. The darkness on the plum in the foreground is finished off with the tip of the pressed carbon stick. All that remains to be done is to draw a few lines to perfect the forms of the fruit. Finally, the highlights are cleaned up with the eraser in case they have become slightly dirtied with carbon. To preserve the drawing, spray it with fixative from a distance of 30 cm.*

## SUMMARY

**The drawing is begun with charcoal.** On top of this the entire surface of the paper is stained with the charcoal stick.

The background lines underneath can still be seen through the stained drawing. This allows us to **clean accurately, with the eraser,** all the zones that must be white. Start with the plate.

**The highlights of the fruits** are picked up according to the luminosity of each one. The pear in the background is rubbed along the curve of its surface.

**The highlights opened up on the pomegranate** are radial, made with fine strokes of the edge of the eraser.

# Light and shade

## PARTLY LIGHT AND PARTLY SHADOW

When a beam of light falls on an object, the latter displays a patchwork of light and shadows. Experimenting with this effect is the first issue that the artist must deal with. Simply placing one or two objects in front of a light source will demonstrate the varying tonalities of the plane.

**One of the most important questions in drawing is the matter of lighting. A drawing may consist entirely of lines, ignoring any shadows, but it is these that produce a closer likeness to the real thing. The more information you gather from the model, the more realistic your representation will be. The study of light and shade allows a closer approach to realism in drawing.**

▶ *The study of light deals with the darkest and most illuminated zones. As we have seen, each light or shadow area corresponds to a real physical effect.*

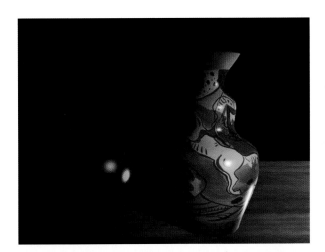

*The length of the shadows depends on the location of the principal light source. Here we can see how this light should be directed onto the objects to be represented and from what distance. Depending on the plane of the object, the light will fall directly on one spot which will be the brightest. As the beam is dispersed over the rest of the object and the plane changes, the light will vary in intensity, as is shown by the curved plane in the example. A straight plane on which light falls obliquely produces a different effect. Look at the base plane here; the light spreads evenly, until it encounters two objects of the still life, which cast shadows in the same direction as the light.*

# DRAWING DARK AREAS

The first thing that must be kept in mind when working with subjects in which the lighting has an important role is that light does not fall equally on the whole object. There is a part of the object that is exposed to the ray of light: this is the illuminated zone. The other part of the object is in shadow.

Later we will study how shadows gently change until they blend into the lighted plane. What is important now, however, is to study the synthesis of the two planes. In other words, we shall temporarily leave aside the half tones and practice with dark tones as if they were one.

> When considering how to draw any sizeable object, it is necessary to look at it in terms of intense or faint stains, depending on the way the light falls on the different zones.

▼ 1. *This drawing can be perceived as one line, without any type of shadow, it can be used as the basis for elaborating a more detailed study. Use on ordinary soft graphite pencil for this exercise; a 4B should give a sufficiently dark stroke. Make sure your preliminary sketch is complete before starting to place the lights and shadows, so that these can be correctly located.*

▼ 2. *Start to distribute the shadows in a uniform manner, outlining the areas that correspond to the lighted planes. In this exercise the shadows are made with a radial stroke that starts from the principal light source. This is also a way to study the curved plane of the model. As can be seen, the outline of the shadow is not straight but curved. The rapid strokes that lay down the shadow simultaneously indicate the lighted area.*

▼ 3. *As the shadow of the fruit is sketched, the lines that make it up adapt to the plane of each zone. On the lower part of the fruit, the highlight is situated proportionally in the same position as in the upper part. Around this highlight, the shadow is drawn radially. In the darkest part, the strokes go across the previous strokes thus intensifying the effect. As can be seen in this example, the separation between light and shadow is very clear and is perfectly adapted to the form of the object.*

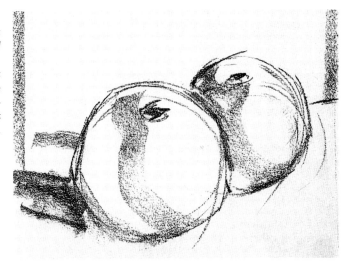

**1.** *The last exercise was carried out in pencil, but this one will use charcoal. Charcoal is very easy to use and allows a rapid stroke that can be corrected straight away. The initial sketch includes the forms of the apples quickly drawn. You then schematize the form of the shadows, holding the charcoal stick flat between the fingers and not pressing too hard, since these same strokes will separate the planes and establish a half tone.*

## DENSE SHADOWS AND HALF SHADOWS

As a second exercise in the separation of shadows, we suggest one in which new tones are established that are halfway between light and shadow. These halftones allow a gentle transition between light and shadow. To do this, it is necessary to start with the approach used in the last exercise. It is not a complicated drawing, but, it must be executed carefully, following the steps indicated.

**2.** *This step allows us to see the principal tone differences. To establish the brightest tones, which will reflect the color of the paper, all that has to be done is to apply a dark covering to the background. If we compare the different contrasts that are now visible on the paper, we can appreciate the three tones: the darkest, the brightest, which corresponds to the color of the paper, and the intermediate, which corresponds to the soft strokes of charcoal.*

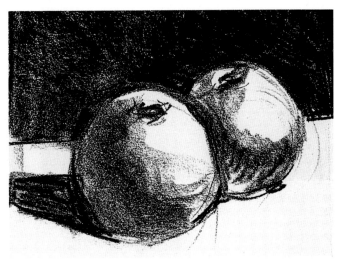

**3.** *Once all the background has been darkened, the rest of the dark areas on the apples can be drawn. This tone is produced with the charcoal stick held flat. The line must be somewhat darker than the lower shadows, but not as somber as the background. This is the way to start applying the dark tones to the shadows of the drawing.*

# Topic 8: Light and shade

▶ **1.** *The layout allows a good approximation of the areas of the model to be made so that the areas of light and shadow can be correctly situated. In this example some simple flowers have been drawn. The petals have been schematized on top of the oval forms. The lines are drawn very simply with the charcoal. When the drawing is completely enclosed in its outlines, the principal elements are clearly distinguishable from the background.*

## CHIAROSCURO AND CONTRASTS

Up until now we have practiced the contrasts that can be established between lighted and shadow zones. The darker areas bring out the brighter ones: it the darkness that enables us to study the tones an decide which are the densest attainable. In other topic the eraser was used to draw and to open up white spaces on top of black. This time the eraser will have a important role in producing the lightest zones.

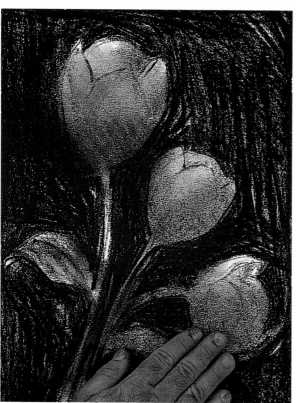

▼ **2.** *To separate all the main forms from the background, the latter is completely stained with pressed carbon. Once this has been done, gray is introduced inside the flowers by smudging with your fingers. Although this gives a dirty effect, it is necessary so that you can later work with the eraser.*

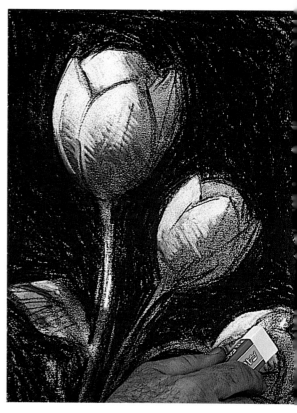

▼ **3.** *The eraser is used like a pencil to open up lines that, when observed as a whole, become very luminous and contrasting white stains. The eraser opens up the brightest highlights on the gray of the flowers. These highlights are only opened up in the lighted areas.*

# Step by step
# Books, an apple, and a vase

In this exercise we are going to practice the ideas studied throughout the whole lesson: the separation of light and shadow together with the correct use of contrasts between these different tones. The exercise is quite straightforward. The most demanding aspect is not so much the distribution of the tones, but how to schematize accurately the still life elements. Out of all the elements, the ones that require the most attention are the books, when doing the initial drawing. We have especially opted for a strong lighting to enhance the shadows. In this way it will be easier to differentiate the planes of light from the shadow planes.

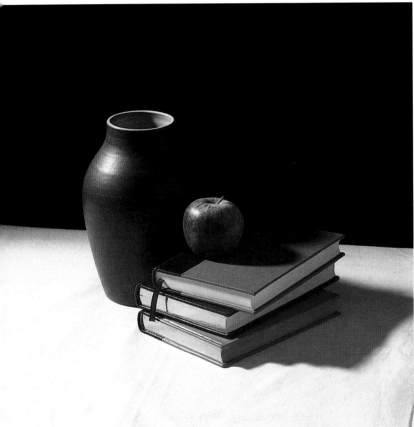

## MATERIALS

*Drawing paper (1), charcoal (2), eraser (3) and cloth (4).*

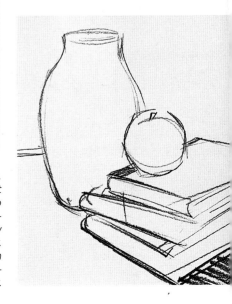

1. *The initial layout must be the most careful and detailed phase. The whole structure of the drawing depends on it. Therefore, it must be balanced and have the correct proportions, and there can be no errors in the lines - in this case the lines that construct the books - that call for greater precision. Before going on to the next stage, any necessary corrections must be made with the cloth and the eraser. Once the layout of the books has been decided upon, the direction of the shadow is marked in. All the shadows that are drawn will follow this direction, even though the plane of the objects may vary.*

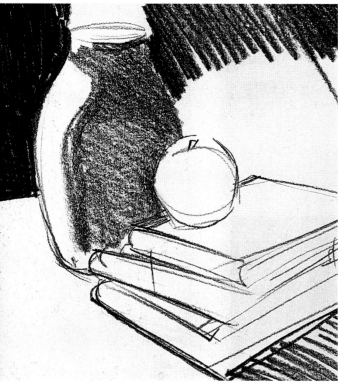

**2.** *Firstly, a strongly dark area is drawn around the vase. This completely black tone makes its shape stand out. Its first role is to establish the difference between light and dark, and, moreover, it is a reference point as it will be the most intense tone in the drawing. Starting from this straightforward tone the medium tones can be established. A study of the different tones will make it easier to draw the medium dark tone on the vase. This tone is much fainter than the one in the background. The difference is clear: when the dark area is drawn on the vase the shape of the highlight is marked out by the shadow plane.*

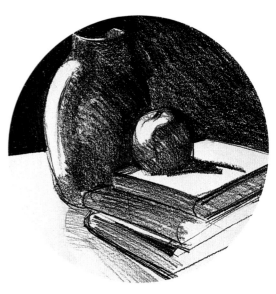

**3.** *The background is finished off by darkening completely in such a way that the foreground is made to stand out. Once the background is finished, draw the shadow of the apple. Here you can observe the difference between the light planes of the two curved objects. The shadow of the apple is laid down in the same way that the direction of the shadow was established in the first step. The edge of the books drawn with long, straight lines close together.*

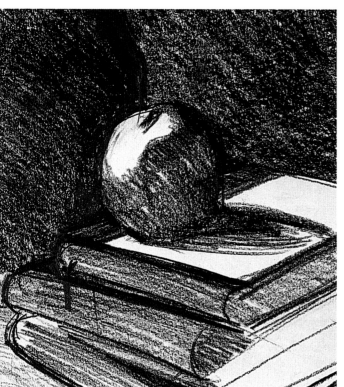

**4.** *Here the darkening of the planes in each area of the still life can be appreciated. Contrasts are created when two zones with different lighting come into contact. It is thus possible to differentiate the planes according to their position with respect to the light source. The contrasts are increased in the areas with less lighting. To make the darkness more intense, simply go over the area again.*

5. *Once the still life has been set out (the principal planes of each one of the lighted areas have been marked out) new dark areas, much more contrasted than before, can be superimposed on those drawn previously. The eraser allows you to clean the dirty zones, or to open up highlights where necessary. In this exercise the highlights do not have to be opened up. However, you may have to correct some areas or clean up traces of charcoal. Every zone is resolved with strokes that are suitable for its plane. The edge of the books has become darker. The darkness on the table is suggested with vertical lines.*

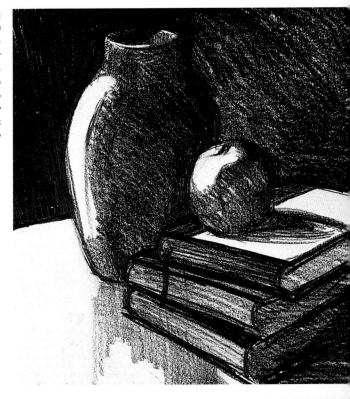

**6.** *In this close-up you can appreciate the development of the darkening of the shadowed part of the books. It is gradual and becomes denser towards the lower part, although the darkness is never as intense as in the background. Attention must be paid to the difference between the planes of all the edges of the books.*

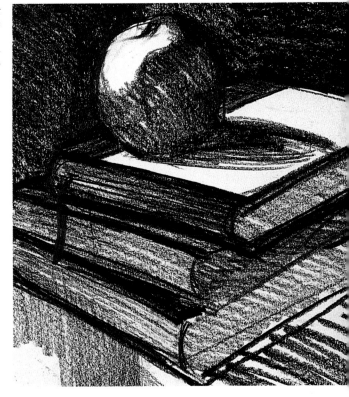

The less light falls on zones of the still life, the darker they become. Less light also means stronger contrasts.

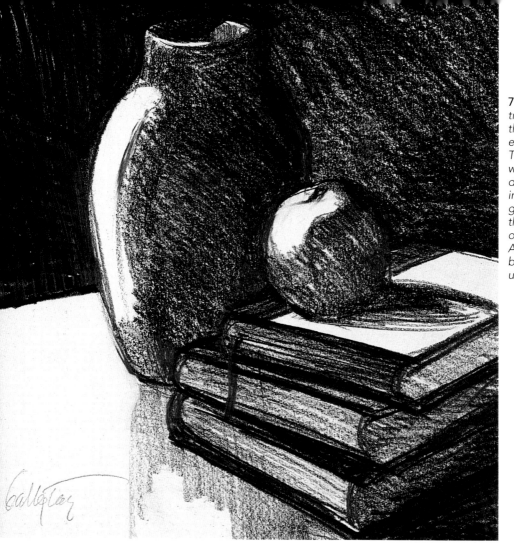

**7.** *Strengthen the contrasts which are defined by the shadows of the different objects of the still life. The large dark shadow which falls on the table is darkened to balance the intense black in the background. The thickness of the book cover is gone over with a darker line. Any areas that may have become dirty are cleaned up with the eraser.*

To learn to work more easily with lights and shadows, it is advisable to step up your still life with a single strong light to one side of it. This will make the different intensities perfectly clear.

## SUMMARY

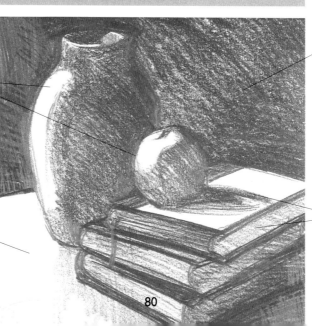

**The necessary highlights** are not opened with the eraser. Instead they are left standing out - in reserve - against the dark areas. As the drawing progresses, these white areas can be corrected.

Any parts of the shiny areas that may have become grubby can be cleaned with **the eraser**.

**The background,** which is the darkest part, is a reference point for the other dark areas of the picture.

**The light planes** are adapted to the forms of the objects. The shadow makes the bright zones stand out, and vice versa.

# 9 Shadows and gradation

## A STUDY OF GRAYS

Each drawing medium, depending on its hardness, allows different grays to be produced. Before studying the question of the ones that can be generated within shadows, it is a good idea to review briefly the tonal possibilities offered by different media.

In the last topic, we studied the way basic shadows and lights are applied to different planes of the model. We looked principally at those strong contrasts which contain few, if any, intermediate tones. In fact, it is possible to distinguish a wide range of tones which, when applied to the model, will allow us to portray many different intensities of light. Each of the media we shall use offers a variety of different strokes that can be gradated until they blend with the color of the paper or with the tones of the other media. Correct use of shadows allows the volume of an object to be more clearly shown.

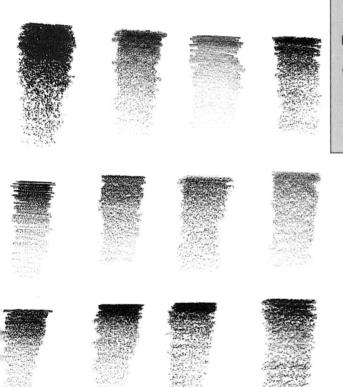

*This cylinder has been drawn with just a graphite pencil, number 6B, sufficiently soft to offer a wide variety of tones, which can later be enriched by numerous techniques or nuances. Once the cylinder has been drawn, put in the shadow on the darkest side with soft strokes before stumping it with your fingers. Finally, the eraser is used to clarify the upper section and open the highlight on the left.*

▲

▼ *This scale chart demonstrates how it is possible to produce extremely subtle variations between tones which are seemingly the same. Pencils and soft media give dark strokes, although the densest dark of each one is always distinct Both in the densest strokes and in the lightest there are notable tonal differences.*

## MODELING FORMS

For an accurate placement of the objects in the model, you must first learn to see the picture as a unified whole. The principles of layout are a great help here. As with the individual elements, the group of forms must be correctly proportioned. The following pages comprise a set of simple exercises involving a variety of objects, depicted first in schematized form. Draw these forms yourself. If you compare the three examples below you will notice two common features; they are neither symmetrical nor centered.

Why have fruits and still life elements been chosen to study modeling and shadows? The answer is clear: because they are straightforward to draw. More complicated objects would distract your attention away from the aim of the exercise. In addition, as such things are easy to obtain, the learner can begin studying natural objects.

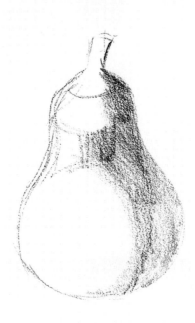

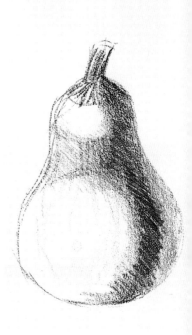

▼ 1. *A thorough study of light on an object requires a plan of the areas on which the light will fall most strongly, based on the initial scheme. Building on this, the intermediate tones can be filled in, and finally, the darkest shadows.*

▼ 2. *In the lost topic a clear difference was established between light and shadow zones by using only one tone. Here we are going to use two very distinct tones to establish the difference. Firstly, sanguine is used to fill in the whole shadow segment with a soft stroke. Do not go over into the light area. Sepia colored chalk is used for the main shadow zone, separating the two illuminated areas and following the plane of the fruit.*

▼ 3. *A soft sanguine stroke darkens all the shadow area. The stroke is slightly inclined and does not touch the lighter section. The same piece of sanguine is used to suggest the wrinkles of the pumpkin. More sepia is added to the shadow part this time with a much heavier contrast than in the last step.*

## GEOMETRIC OBJECTS AND ORGANIC FORMS

By analyzing the objects to be drawn in terms of simple geometric shapes (circle, square, triangle, rectangle etc.), combined or superimposed, you will always have a basis from which to resolve questions of lighting with greater ease and accuracy.

The organic forms that are all around us in nature are composed of elements that, when studied carefully, can be related to pure geometric forms or figures, like a sphere or a cylinder. These organic forms have the advantage that they are not subject to the demands of strict perfection or geometric exactness when they are represented. To model any object starting from the study of its tones, it is important to be aware that organic forms can be interpreted as simple interrelated elements.

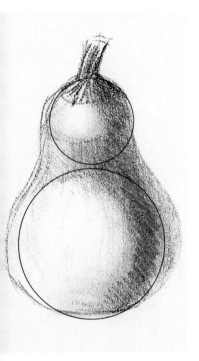

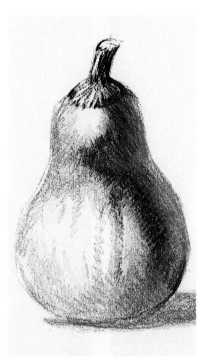

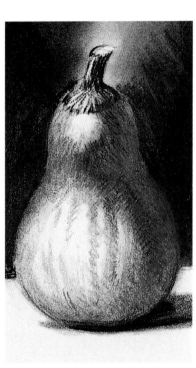

▼ 1. To model this pumpkin, start from the last exercise. As can be seen in the superimposed figure, the object could be represented perfectly by two almost identical spheres, as the light falls on the object from the same position and with the some intensity. To go on with this exercise in categorizing shadows, blend the tones of sepia and sanguine with your fingers in circular movements around your highlights.

▼ 2. The sanguine pencil starts the defining work on the shadows, beginning by superimposing fresh strokes on top of the recently blended tones. To attain quite a dark shadow tone and to completely define the volume of the pumpkin, a block conté crayon is used. The lines on the shadow are dense but not to the extent that they completely close the pores of the paper. The highlights are opened up with the eraser. The toning of black is completed with a soft stumping on the right-hand side.

▼ 3. To finish the defining of the shadows of the pumpkin it is essential to balance or adjust the darkness of the background. From now on this will be one of the most called-on techniques for defining objects. A highly dense darkness in the whole background will give emphasis to the paler tones of the object represented.

# Topic 9: Shadows and gradation

## SOFT LIGHT AND GENTLE STROKES

When you are combining several drawing media, you may alternate stages of modeling with stages of filling in detail. In this exercise we are going to use a variety of media for a subject which, though not difficult, demands a careful study of its shadows and of the lighted areas which are to be laid down with white chalk.

To ensure that the modeling is accurate and easy to check, it is advisable to begin with gentle strokes which will be intensified by others made on top of them in the process of adding nuances and defining details.

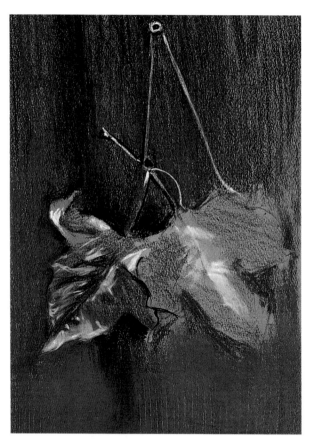

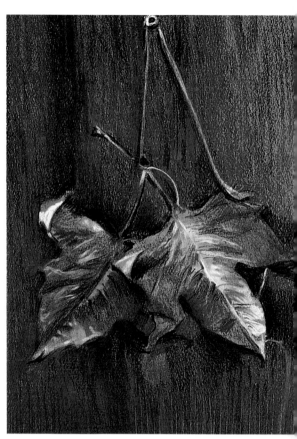

▼ 1. First, work with a wide stroke in sepia and carbon pencil. The leaves are perfectly marked out against the background. All the drawing in the area below the leaves is made bolder with the sanguine pencil. Putting a dark tone next to a clear one creates contrasts that enhance these tones. The leaves gain luminosity thanks to the darkening of the background. The texture of the leaf on the left is started by a soft stroke with sepia and sanguine on both sides of the central rib. The white chalk increases the lights of the texture: just a light touch of white is sufficient to achieve this rough, silvery aspect The thread from which the leaves hang is drawn in white chalk. On the lower left-hand side horizontal sepia strokes are put in; blend them with your fingers to enrich the tones on the paper.

▼ 2. On the leaf on the right, some dark areas, adapted to the shape of the veins, are drawn in sienna. On this leaf the modeling and the dark and light contrasts are perfectly defined. The brightest and lightest parts are drawn with white chalk. The background is contrasted with vertical strokes in carbon pencil. To contrast all the textures in the picture, the graining is drawn with long strokes in carbon and sepia. Also, the contrasts in the texture of the leaves are augmented by outlining in white and increasing the intensity of the darkness. All that remains to be done is to darken the shadow of the leaves on the wood.

# Step by step
# Birds

Tonal definition allows us to study the modeling of shadows with a tonal gradation that is progressively integrated with the white of the paper. Eventually, the model represented acquires an almost real volume. The image could seem complicated, but nothing is further from the truth. When you are doing it, you will realize that if you start from a sound base, it is much simpler than it appears. Afterwards, to ensure the greatest possible realism, it is imperative seek out the right tones for each lighted area of the model.

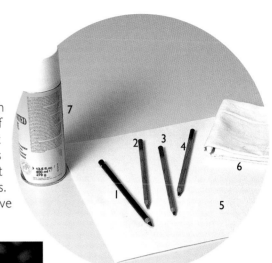

### MATERIALS

*Black conté crayon (1), sanguine pencil (2), light sepia pencil (3), hard sepia pencil (4), drawing paper (5), cloth (6), and fixative spray (7).*

**1.** *It is very important to know the form of the model before starting to lay out the distribution of the shadows, since their modeling must be accurately adapted to the scheme with which you began. If you look carefully at the model, it is easy to see that the two birds can be perfectly fitted into an elliptical scheme. This is the form that is going to be followed in the evaluation and modeling of the tones. Once the internal structure of the two birds has been established, their faces are drawn, starting from the placing of their beaks. A graphic scheme has been superimposed to make it easier to sketch this first and most important step.*

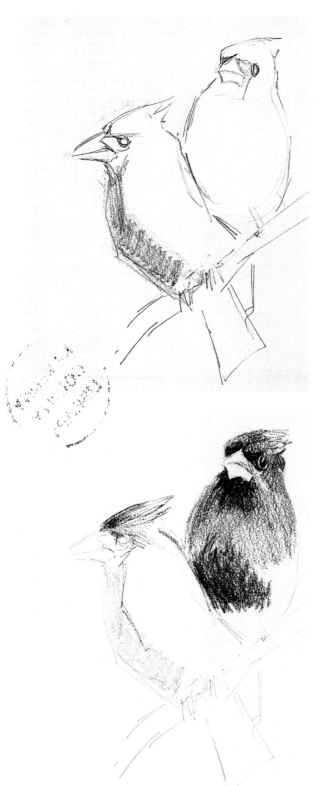

**2.** *Only when the line scheme is completely finished can you start to sketch the first shadow area on the model. With the same black color used for the layout, start the shading over the bird on the right. The stroke is soft and follows the tapering form of the bird's body perfectly. When this first dark area is being put in, all the rest of the body can be seen as a lighter part which includes the point of maximum light.*

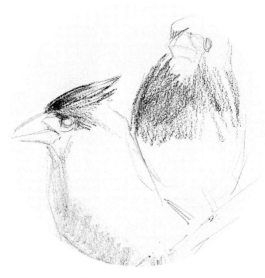

**3.** *Be careful with the pressure of the pencils on the paper, for the most delicate tones are obtained with a soft stroke. This pressure must be greater when you are after darker tones. To alleviate the lack of diffusion, pencils with different tones are used. Thus, if you want to darken a tone, the stroke can be made darker. In any case, as you can see in the bird on the right, the shading of the body can be carried out perfectly with a sanguine pencil.*

**4.** *The stroke with the sanguine pencil is made softly. The lines are short and rapid when you want the texture to be even without closing the pores of the paper. As you progress with the dark areas, you can intensify each zone, but without completely covering the white of the paper. In the lower part of the body of the bird on the right, the maximum tone obtainable with sanguine can be appreciated. When a darker tone is needed, for example on the face of the bird, the color sepia is used.*

**5.** *The modeling of the left-hand bird's body is done in the same way as it was set out in the beginning, but this time in sanguine pencil. First, the oval shape is softly marked. Once the plane is covered, intensify the area that must be darker. In the lower area, as with the bird on the right, the stroke is denser and firmer, so that light and shadowy areas are clearly distinguished by their tones. With the darkest sepia crayon, the shadows are superimposed on the dark sanguine tones. Now that the shadows have been outlined you can re-emphasize them with the sanguine pencil.*

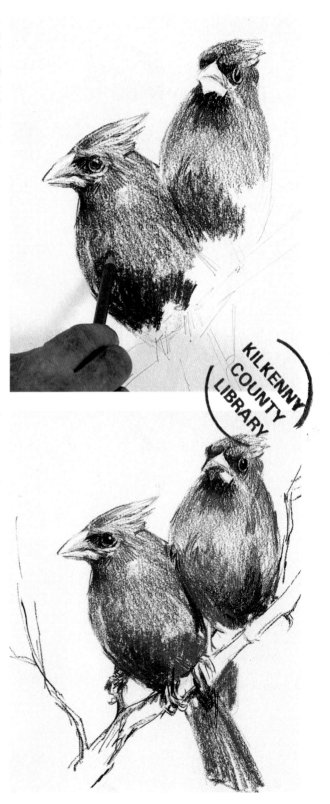

To get a satisfactory result with a work like this, it is imperative that the initial layout be constructed carefully and meticulously.

**6.** *The faces of the birds were completed almost at the beginning. Therefore, the bulk of the work lies in the modeling and tonal detailing of the bodies. Once the tone values have been decided, the drawing evolves according to the contrasts added to give shape to the shadows. Of course, the adjustment of tones that are too pale also plays a role.*

When you are defining the tones of the volume as a whole, if you darken a shadow too much, the earlier light tones can appear too. To correct this they will have to be made stronger so that the picture is balanced.

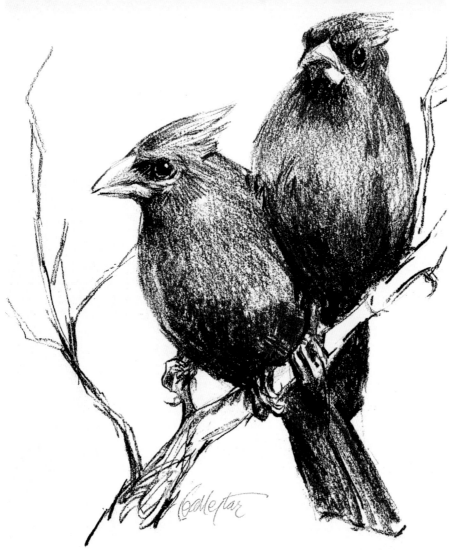

7. *The tonalities that model the two birds' bodies are progressive. The contrast is always increased as you move away from the shadow. The dark areas will always be placed in accordance with the lines that were done at the start. This is how the darkening of the lower part of the bird on the right is finished. The lighter zones are defined by this fresh intervention with dark tones.*

## SUMMARY

**The initial scheme** shows the form that the shadows must take in the modeling and tonal definition. In general, all the forms start out from simple elements, although later they can become more complicated as other elements are superimposed.

**The darkest tones** are carefully sketched over the perfect layout of the initial drawing.

**The whites and the lighted zones** are outlined by the dark tones.

**A darker tone** has to come into play when the previous tone can be darkened no further. Do not try to continue with the same tone.

# 10 Ink, pure whites and blacks

## STYLE AND THE USE OF THE PEN

In this topic we are going to practice one of the most classic drawing techniques, although currently it is not so widespread as other media. Using pen, brush and an ink stick allows a very versatile stroke, comparable to that of charcoal for its modeling results. The most important part of drawing with a pen is measuring the amount of ink that is incorporated into the stroke. In this chapter we have suggested a landscape which will enable you to start practicing the use of the bamboo pen, and to explore the different strokes made possible by its versatility.

A drawing can be executed with any medium that allows a mark to be made. Although, as a general rule, drawings are done with dry materials such as graphite, charcoal or sanguine, it is also possible to draw with ink. Pens and brushes are traditional drawing tools which give impressive results for they allow all types of drawing effects.

*. Before drawing with a pen, it has to be dipped in ink. The ink used can be either liquid or in stick form. When you start to draw, remember that the point of the cane leaves a gray mark even once the ink load is used up. The gray tone diminishes in intensity as the ink is consumed. If the pen is wetted in the ink you can start off by drawing a continuous black stroke for the horizon line. Do not wet the pen again until you have drawn several strokes. Once the ink begins to lose intensity, start to sketch in the sky with fading lines.*

*2. The bamboo pen allows a faded stroke which will produce grays of different intensities according to how much ink remains in the tip. Go over the entire sky area with the pen, and then outline the clouds. These latter grays will be more luminous, as the ink has almost run out. Take on more ink and draw in the dark areas of the horizon. Here we have a mixture of full and faded strokes, which produce a variety of grays for the background.*

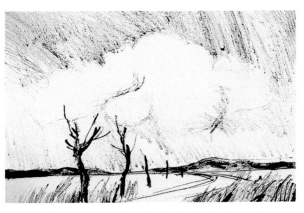

*▼ 3. The bamboo pen stroke is highly flexible: it allows both thick and thin lines to be produced according to the pressure exercised and the ink loaded. The tree trunks along the side of the road are drawn with a heavy ink load. Finer lines are then made by dragging the tip of the pen through the wet ink.*

## LAYOUT AND PLACEMENT OF LIGHTING

The ink tone should always be built up progressively because an ink stroke is quite difficult to correct. It is better, and safer, to start out with lighter tones that then lead into darker and denser areas. First, the clearest grays are drawn and then darker lines are added on top of these. The darkest areas are filled in at the end.

▶ **1.** *When elements of a similar height are combined, as is the case here, the composition is no longer triangular; instead it takes on a more complicated polygonal form. The composition scheme becomes more laborious, and, at the same time, the number of reference points increases. These are the vertices of the composition. When the measurements are transferred to the paper, it is important to bear in mind the distances between the edges of the objects, with respect both to each other and to the edge of the paper.*

Ink correction depends on the quality of the paper that is used for drawing. The most suitable for ink has a smooth finish. On normal paper, the ink penetrates through to the interior of the fiber: it is impossible to rub out. However, with a smooth finish the ink dries on the surface.

**3.** *The veins of the leaves then blend into the composition. Around these leaves, add patches of solid black, which will produce strong contrasts and set off the white areas.*

▲

▼ **2.** *When the main form has been schematized, the dark areas that outline the flower are put in. This dark zone is sketched continuously and rapidly towards the flower. The ink gives a dark effect, a very intense black when the lines are drawn very close together. The further apart they are, the greater the tendency towards a gray tone. Once the ink has dried, take a razor blade and scratch crosswise. Be careful not to tear the paper. You will discover that on this kind of paper, scratching the ink is no problem.*

1. *The principal lines of the drawing are laid out with the pen. The stroke is agile and rapid so that it is easier to make out the forms and their planes. Each of the landscape areas is drawn with a stroke adapted to the form of the plane. The strokes for the earth are curved and horizontal, while those of the mountain are long and diagonal. The way the stroke is made on the paper allows the different landscape textures to be suggested.*

## USING LIGHT TO SUGGEST SHAPE

When an extensive surface has to be covered, it is easier to do it with a brush than with a pen. In this new exercise we shall produce a landscape that requires pen and brush to be used alternatively. Pay attention to the way each stroke turns out, and how the ink responds to the use of the brush or the pen.

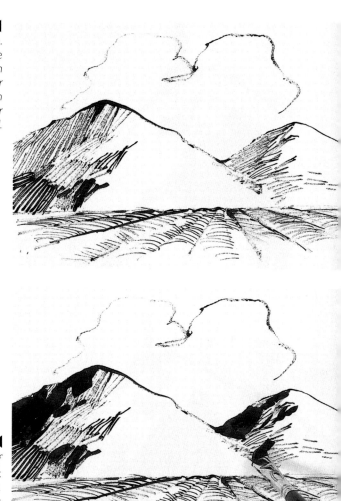

2. *The brush is dipped in ink to draw the darkest zones of the landscape with black blocks. This effect is called the block style because the darkness is made up of compact blocks. The block style makes it easy to create strong simultaneous contrasts between the light and dark areas. The brush must not be too soaked in ink because a little goes a long way.*

> The stroke of the bamboo pen with Chinese ink is not indelible. With a little practice, ink can be used like any other drawing medium.

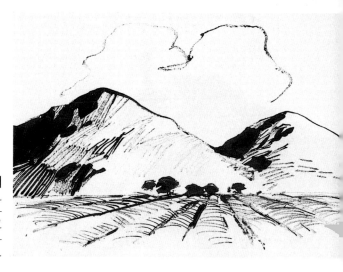

3. *The exercise concludes by alternating the two drawing tools. The brush is used to draw those zones that must be black and compact. The pen does the finer lines that are more drawn than painted. The landscape ends up looking like this. The strokes have been alternated to give a fine balance between dense stains and thin lines.*

▶ 1. *This is a straightforward exercise if the steps are followed carefully. The ink stick is wetted and rubbed over the stone a little so that the black is not too dark. The first lines are done finely. The edge of the stick neatly outlines the horse's head, starting from the straight part of the forehead down to the muzzle. The narrow part of the stick is used for the line of the mouth and the back part of the neck. Once the head has been completely set down, the darkest planes of the face are added.*

## TONAL SYNTHESIS

Once you have studied the model and discovered how the composition is structured and the way the planes are distributed, you then construct a scheme or outline before starting on the drawing itself. The construction process begins by considering the overall shape and then moving onto the elements and their proportions. This page offers an exercise based on the previous one, which consists simply of adding detail to the basic outline.

When one side of the stick has been worn away, the resulting texture can be taken advantage of to darken any medium grays that need to be finished off.

▶ 2. *Once the principal lines have been drawn, the darkest contrasts are worked on with the stick wetted and softened in water. To draw very intense blacks, the ink stick has to be rubbed, dragging sufficient water to moisten and soften it. On the horse's face, medium grays are drawn with an almost dry stick. The line produced by this medium is similar to those of other dry media such as pressed carbon.*

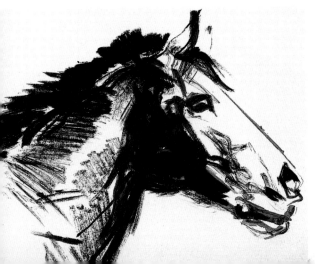

▶ 3. *The horse is elaborated gradually with the ink stick. The dark parts are drawn when the clearest parts have been sufficiently defined and structured. The first lines allow the dark parts of the shadows to be set in place. However, be careful not to stain more than necessary the areas that must remain white or reserved. After softening the ink stick, darken the horse's mane and the lower part of the neck.*

# *Step by step*
# A female figure

Drawing directly with an ink stick permits a great variety of strokes and makes for a more interesting graphic aspect. The example that we are going to do now includes most of the technical elements of this topic, especially those that refer to drawing with ink. As will be seen, the results of drawing directly with a stick are different from those of drawing with a pen or a brush, although the process is very similar. This is a good exercise to practice lines, stains and highly intense black zones. It is easier to draw a clothed figure than a nude one because the forms can be more generalized and straight.

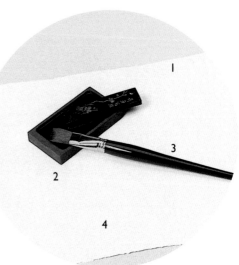

**1.** *The drawing is started with the ink stick, without any previous tracing. The stick is wetted with water and rubbed against the stone until it moves smoothly, then it is loaded with ink. The drawing is started with loose strokes which gradually blend together to complete the outline of the figure.*

# STEP BY STEP: A female figure

**2.** *Once the principal lines have been schematized, they are gone over with much firmer and darker strokes. The contrasts are put in with a very dense black tone; to do this the stick is wetted and rubbed until it is softened. This time the excess water is allowed to drain off, but the excess ink is not eliminated. Using the flat part of the stick, the figure's principal contrasts are marked out. They must be definitive areas to mark out the principal volumes. The lightest areas will stand out against these dark tones.*

**3.** *If you carefully examine the lines of the face, it ca[n] be seen that the forms must be as general as possibl[e] never invading the bright areas by so much as a sing[le] line. The work is done with the edge of the ink stic[k] which must not be allowed to drip. The ink's hardne[ss] allows a delicate stroke, although, as shown in th[e] image, it is impossible to work in too much deta[il].*

**4.** *The luminous zones of each of the figure's features must remain intact: keep in mind that Chinese ink is difficult to correct once you have drawn with it. This is why all of the strokes and stains put down on the picture must be as accurate as possible: the areas are built up bit by bit. The stroke must always be progressive, building on the lines already in place.*

**5.** *Now the brush is going to be used. To get this gray color, all you have to do is wet the brush with ink tone that is in the receptacle. If this tone is too clear, the ink will have to be rubbed until you get a darker gray. However, if the gray turns out too dark, it will have to be weakened by watering down.*

Depending on the temperature, the drying of the brush or stick can be a great hindrance to the artist. The drying time of the ink can be adjusted with alcohol, or with a few drops of glycerin. Alcohol accelerates water evaporation, while glycerin slows it down. These products must be added to the water which is used to mix the ink.

**6.** *In this close-up you can appreciate how the block style is used to isolate the whites with dense blacks. This is one of the techniques used by experts in working with ink.*

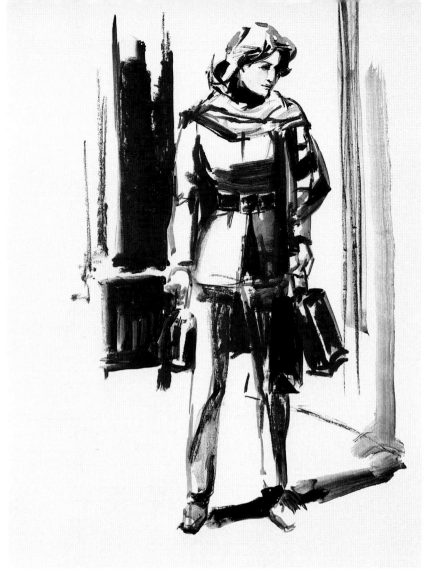

**7.** *Using the full width of the dampened stick, the dark column behind the model is drawn in. The white parts are perfectly outlined by such dense blacks. Finally, all that remains to be done are some medium grays in the shadow areas of the figure. Draw with the brush dipped in only water, dragging part of the ink tone from the figure. When this is finished, this ink work is complete.*

Every technique has its own special features and is especially suitable for certain types of drawings. Before deciding which type of technique is going to be used, it is necessary to think about which method is the best to achieve the effect that you are after.

## SUMMARY

**The features of the face** are done with the edge of the stick. Be especially careful with the synthesis of the lines to avoid staining the areas that must remain clear.

**The first lines** are done with a straightforward stroke, not too black, to outline the figure. Work with ink has to be very gradual, for it is more difficult to correct than pencil drawing.

**The dark parts of the figure** are applied with the stick held flat, outlining the form of the bright areas. This gives a blocked style which makes the highlights stand out.

An ink stick allows drawing with all its edges and surfaces. Different degrees of dampness offer **different shades of gray.**

# Copying with a grid

## USING A GRID

Beginners might feel that placing a grid over a piece of artwork to facilitate drawing is a form of cheating. This not true. Many famous artists have used this technique and continue to do so. Sketches can thus develope into finished work art.

**Drawing is not child's play: even the best artist may have trouble producing an accurate representation. Of course, artistic drawing does not aim at an exact copy; this is what photographs are for; but there is no need to abandon the quest for perfection. There are many ways to represent the model on paper, from enlarging and tracing a photocopy to using a slide projector. However, if you want to try and comprehend the model, which is an essential part of learning to draw, such methods should be ruled out. Using a grid to make a copy helps you to interpret the direction of the lines in the model and to structure the drawing on the paper.**

*To work with a grid you have to start with a photo, a drawing or a picture from magazine. The framing must match that of the model, in other words, the area which will contain your drawing must be proportional to that which contains the image to be copied. In this first exercise, the model has been divided along two axes, your paper must be similarly divided. Begin your drawing from the point of view presented by the model. Every area of the drawing must match its counterpart in the model, the central cross will help you to locate and place your reference points.*

▶ **1.** *The cross is a very useful system for the composition and for measuring the relative proportions of the objects. It allows a certain liberty in the drawing, since everyone sees things slightly differently. You should try to make the drawing coincide as much as possible with the model. Here the pear on the right coincides with the vertical axis. In the drawing, too, it must coincide.*

## THE GRAYS

The copying method with a little cross is the least exact grid copying method. However, it is the most common; for it permits a freer and more artistic interpretation of the original model. The little cross is only a guide that allows the layout to be done more accurately. Once the layout has been finalized, you must forget about the little cross and finish off the drawing in the traditional way.

▶ **2.** *When the drawing is completely outlined, the way the grays and half tones are going to be dealt with can be considered. At this stage you can stop copying and get down to the artistic work. The first grays are drawn with the stick flat: it is just a question of showing the differences between the light and shadow tones. Once the dark parts of the shadows have been sketched, the contrasts can be strengthened.*

> The grid must be drawn in an easily erasable medium, such as a graphite 6B pencil. Only the lightest pressure is needed.

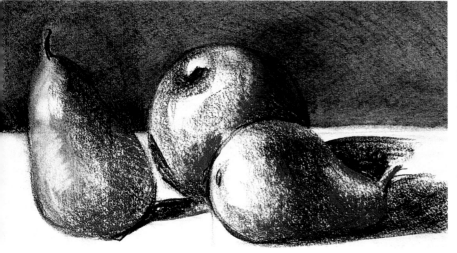

▶ **3.** *Once the shadows have been accurately located, the grid can be rubbed out. An everyday eraser can be used. It does not matter if you rub out part of the drawing for it can be redone at any moment. The grays are drawn progressively. As was seen in the last step, the first grays are outlined in sanguine. Afterwards the darker parts are emphasized with charcoal. Finally, the highlights are opened up with an eraser.*

**I.** *When you are trying to make an accurate copy, it is important to use a ruler.*

## ENLARGEMENT AND COPYING

opying with a grid can give very exact results. The more finely divided the odel is, the better the guide will be and e lower the possibility that the drawing ontains errors. Besides being a perfect pying method, the grid also permits the odel to be enlarged in proportion. This fers the possibility of working from small hages, "blowing them up": the end prod- t is a larger size.

**2.** *Enlarging the grid depends on the format of the drawing paper. The most straight forward method is the following: Measure the width and the height of the model and go far an exact division. If the model is 8 cm high, dividing it by four makes 2 cm. The width of the image is also divided into 2 cm sections. To enlarge the model on the paper it must be divided into the same number of parts as the original, but increasing the size of the sections: for example, the squares could now be 5 cm large. The grid must have the same number of squares as the original model.*

**3.** *When you use a grid, the profiles of the forms have to match those of the model. This means that the part inside every little square must be identical to that shown in the photo.*

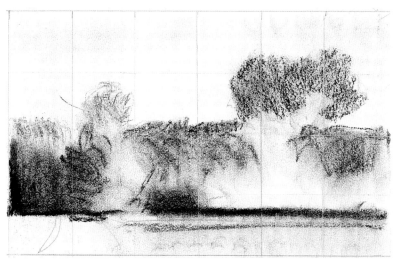

▶ **1.** *The basis of this exercise is a perfect structuring of the drawing by using the grid to enlarge it. First, the most tenuous grays are done with the flat charcoal. Lightly smudge it with your fingers to produce a stumped background, and then start drawing with the charcoal again, but this time with the tip, using only a very faint pressure for the tree on the right and in the background. On the left the contrasts are stronger, as is the starting line of the forest in the lower part.*

## COPYING PHOTOGRAPHS

This procedure can be used to draw any image: this means that any sketch or photo can be enlarged. The elaboration process can be as perfectionist as the artist wishes. In this exercise we are going to finish what we began on the previous page. As can be seen, using a photocopy as a model is a great help in doing the grays.

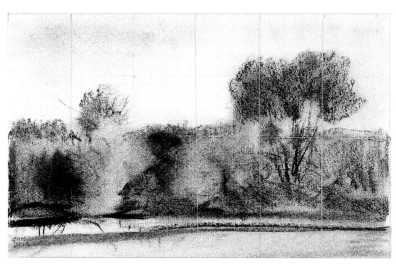

▶ **2.** *Use your fingertips to do some more stumping and thus smudge all the trees in the background. On top of this medium gray background you can start to do the dark parts of the trees. Follow the grid and try to make the different intensities of gray coincide with those of the model. The shadowy areas are gradually darkened and the most prominent branches are drawn in.*

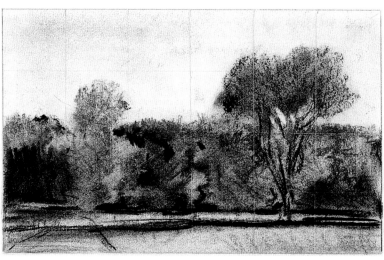

▶ **3.** *Contrasts ore added to the different tones. Stump the contours of the most solid stains with your fingers. Use the eraser to clean up those zones which may have been dirtied inadvertently, and then the exercise is finished.*

# Step by step
# An urban landscape

Using a grid is especially useful when representing a complex model. A complex model is made up of lines that are difficult to understand. A good example are the leaning planes in this urban landscape. With a grid these problems can be solved simply by measuring. The exercise is not difficult; it ll turn out to be a lot easier than many you have already done, but it mands a lot of attention when planning the lines and the slopes.

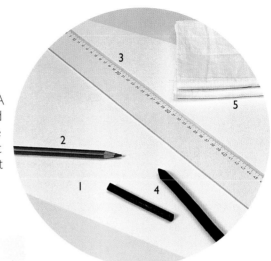

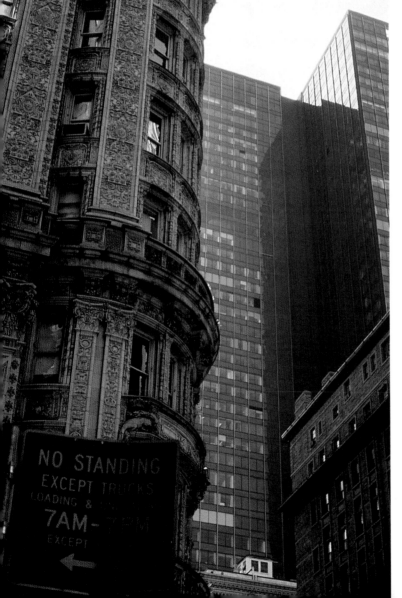

| MATERIALS |
| --- |
| Drawing paper (1), pencil (2), a ruler (3), charcoal (4), and a cloth (5). |

**1.** To divide the model, do a photocopy on top of which you can draw freely. The initial lines are the most complicated, as you have to observe where they start and finish on the model and then reproduce them on the paper. If your hand is not steady, you can use any straight edge as a guide, like a book or a ruler.

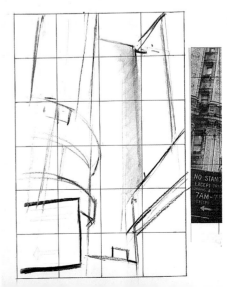

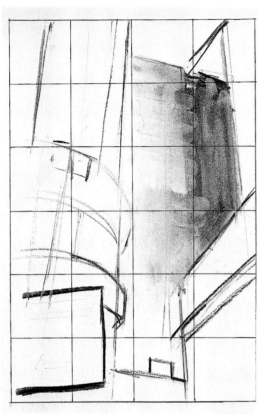

**2.** Once the principal lines and planes of the model have been laid down, you can begin on the grays. Start with the buildings in the background, first with a flat stroke, gradually darkening a the reflection. Then use your fingertips to smudge the whole area and the left-hand side of the building is covered in gray. Take a look at one detail of the drawing: the sign in the foreground has deliberately been done badly so that the correctio can be made afterwards. As can be seen, the inclination of its lines does not correspond to that of the model.

> The grid permits the model to be accurately transferred to the paper: the line and plane composition can be exact. By using a grid, the model can easily be enlarged.

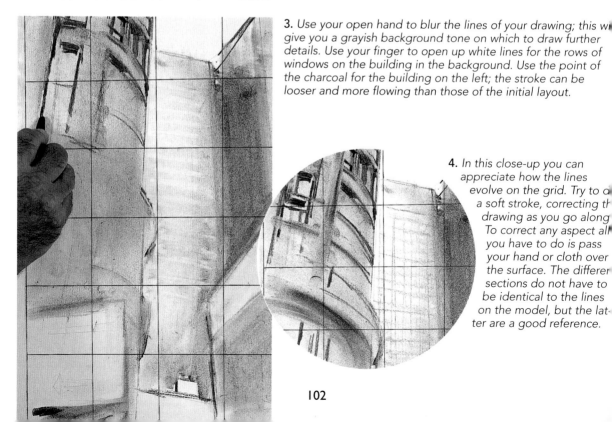

**3.** Use your open hand to blur the lines of your drawing; this w give you a grayish background tone on which to draw further details. Use your finger to open up white lines for the rows of windows on the building in the background. Use the point of the charcoal for the building on the left; the stroke can be looser and more flowing than those of the initial layout.

**4.** In this close-up you can appreciate how the lines evolve on the grid. Try to a a soft stroke, correcting th drawing as you go along To correct any aspect all you have to do is pass your hand or cloth over the surface. The differer sections do not have to be identical to the lines on the model, but the latter are a good reference.

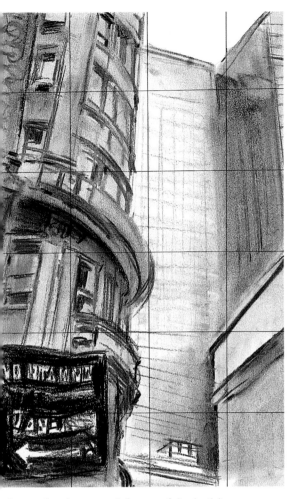

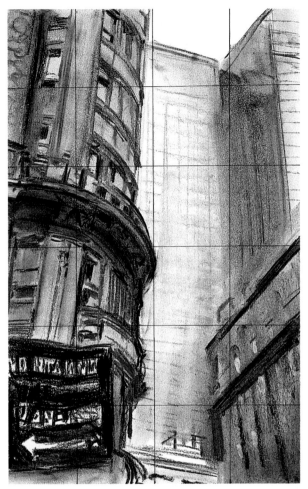

Just as for the upper left part of the building, use ~~e~~ strokes to sketch out the windows and cornices of ~~e~~ lower part. Where darkness and shadows are going ~~ be~~ mixed, press the charcoal a little harder and ~~ump~~ it with your fingers. Look at the main cornice on ~~e~~ left. Now the sign is completely corrected and the ~~gle~~ of its lines is adjusted to fit in with the grid ~~odel~~. The letters are formed by the dark patches that ~~ut~~lined them: they should not be legible, however.

**6.** The cornice work on the left is done with much greater precision with the charcoal point. The rest of the architectural features are drawn using the schemes already marked in. The low building on the right has its contrasts darkened, and a row of windows is outlined. The impression of depth and plane separation between the buildings in the foreground and background will remain if the latter are left as a sketch.

The grid is the perfect method for replicating any subject exactly. To guarantee the quality of the drawing and to avoid unnecessary corrections, the wisest thing is to make the strokes bit by bit so that they are easy to erase. As the drawing progresses, it will become obvious which lines are correct and can be appropriately intensified.

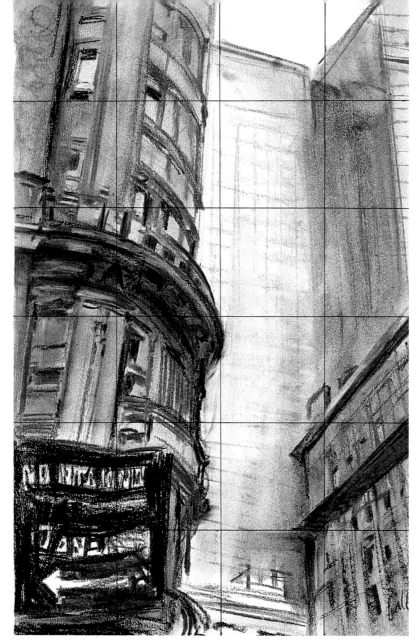

**7.** *The contrasts in the windows and cornices of the building on the right are the final touches to finish off this grid assisted drawing. You need not take up too much time in excessive details nor in making the lines exactly match the model. A stain to suggest a shadow, or a small area of white for a highlight, are more than sufficient.*

Although it is a perfectly legitimate option, in principle a drawing does not have to be an exact replica of what a camera would see. As an artistic production, it should express what its creator perceives and feels when looking at the original view.

## SUMMARY

**The first lines** must be the most structured of the drawing: to do this you must identify the fundamental lines.

**Start applying grays in medium tones.** If they are later smudged with the hand, a base is obtained on top of which you can fill in darker tones. The background buildings are hardly sketched at all.

**The contrasts and the foreground building lines** are redrawn freehand.

**The sign in the foreground** is corrected once the dark tone inside has been done.

# Figure drawing

## FUNDAMENTAL PROPORTIONS

Proportions are nothing more than the balance of the measurements which establish harmony between the objects: in this case the parts of the body. A drawing is said to be out of proportion when, for example, the head is too big, the arms too long or too short, whenever the model deviates from the norm. This is an exercise in observation, which can be applied to pictures in magazines, photos or drawings.

*A central point in the figure must be established. If a standing figure is divided into two, the top half must go from the pubis up to the top of the head. The legs start just below the pubis line.*

**The figure is one of the most interesting themes that can be tackled by an artist. It is a bigger challenge than other subjects because the proportions, the coordination between the forms, and the lines reveal a reality that is very close to the spectator and the artist. While an error in another subject may go unnoticed, here it will be very obvious. Drawing a figure is no easy task: it requires a great capacity for observation, and a lot of practice. Do not lose patience. In this chapter we shall explain some of the fundamental keys to drawing a well-proportioned figure.**

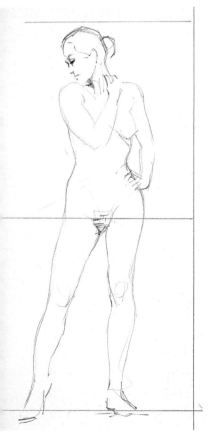

*In drawing, and therefore in all artistic representation, the human body must always conform to the canons. A canon is a series of measurements that balance the proportions of the different parts of the body. The canon has not remained unchanged. Each epoch has had different aesthetic preferences in the matter of representation. Today, generally, the figure is made up of eight heads: that is to say, from the chin to the top of the head is one eighth the length of the whole body. As can be seen, this figure corresponds to the canon stated. However, small children have different measurements depending on their age, starting at three and a half heads for a newborn baby and with the proportions changing as they grow.*

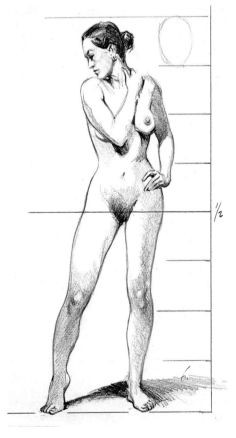

▶ **1.** *The axis of the body is the spinal column. This will be the symmetry line that will establish the basic measurements. The distance from the shoulders to the spine must be the same, although the girl is leaning. First, the line of the spinal column is drawn in. It does not have to be straight, as it is flexible to permit movement. In the upper part, below the base of the neck, the collarbones are marked inclined and symmetrical. Observe how the torso and chest outline is drawn: it coincides with the start of the arms.*

# PRINCIPAL STRUCTURES: DRAWING THE TORSO

Although total symmetry does not exist in the human body since everybody varies slightly on one side or the other, it useful to consider the human body as perfectly symmetrical. This makes it easier to represent seemingly complicated elements like the torso. If you go over the previous chapters you will see the natural elements can be represented starting from the synthesis of their lines. It is important to establish a principal axis, and from there to elaborate the appropiate forms.

▶ **2.** *When the scheme is constructed, and the proportions corrected you can start on a more profound study of the anatomy. A suggestion of volume will make the forms in the drawing easier to comprehend. Here the neck is twisted due to the tilting of the head. This tilting causes a tensing of the right deltoid muscles. Also, the shading on the breasts gives volume to the figure.*

▶ **3.** *The neck gives more expression to the torso; the muscles give a sense of the flexibility to the head, which is represented by deviating the symmetry of the spinal column. Once the principal volumes of the torso have been decided upon, it will be seen that the abdominal muscles fall into place.*

1. The hips must be considered as a straight line, a line that corresponds to the upper part of the pelvis and the fictitious union between the two hips. The inclination of the hips starts at the spinal column, coinciding with the flexing point, also called the tension point, of the legs in this area. When the hips line is inclined, the spinal column does not remain totally straight but rather takes on a soft curve at the base. As can be seen, the hips support the weight of the body, one hipbone being lower than the other. You can see the inflection of the lower hipbone because the weight is supported on the one opposite. As the weight rests on the higher hipbone, the leg that supports the weight must remain straight.

## PRINCIPAL STRUCTURES: DRAWING THE HIPS

The hips are one of the principal elements when drawing the human body. In this area the femur joint enters the hipbone, while the spinal column also comes into play. Rarely are the hips totally horizontal. Almost always, especially in resting poses, they are slightly inclined, meaning that the weight is supported on one leg while the other remains bent and relaxed. This pose is called contrapposto (the figure has an asymmetrical balance).

2. The layout allows a profounder study of the anatomy by considering the volumes of the body. Whenever a figure is drawn, each of the parts has to be analyzed so that the model is natural. The thighs must not be drawn like tubes. The muscles are thicker in the upper part. The shapeliness of the legs starts in the darker zones, here light comes into play with the gradation of the shadows. The abdomen is not totally flat: as it is dark in the drawing it can be separated from the upper abdomen and from the curve of the hips.

3. It is important to do a good study of the volume. In this exercise the drawing has been modeled in sanguine until the tones are gradated according to the body planes. Finally, an eraser has been used to open up the most prominent highlights.

▶ 1. *This is a simple exercise in which the most straightforward method of doing a joint, such as the shoulder, is explained. If you pay close attention to the initial scheme, you can make out simple forms such as the elements that make up the joint. If you ever have any doubts about the internal structure, it is advisable to study it in terms of elementary forms. The circles allow the wide curves that are formed between neck and the shoulder to be schematized. The smallest circle allows the joint muscles to be structured. From this simple scheme, it appears as if the drawing emerges on its own.*

## DRAWING THE SHOULDER. THE SPINAL COLUMN

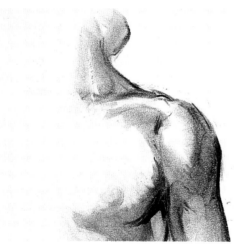

The joints can be complicated to draw because they are the poi where two elements come together. In reality, difficult aspects do n exist: there is only a lack of understanding about their representation. It important to comprehend the internal form of the joint, so that there w be no problem in contrasting the scheme and the drawing. A key factor that the spinal column is the axis of the body and, therefore, gives it mob ity. If you learn to use this line as the center of the figure, you will ha made a large step in drawing.

▶ 2. *Starting from the previous scheme, a new study of the modeling enables us to analyze the musculature. The shoulder is basically a sphere, slightly oval-shaped. The chest muscle is much flatter, and therefore receives light more directly, although it is softened near the ribs. The musculature of the arms is long, as is its shadow.*

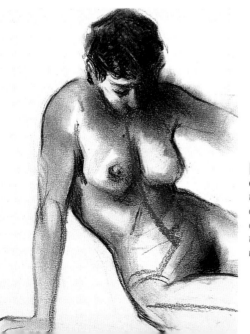

> The source of the light is fundamental when it comes to approaching the shadows of the important parts of the body. The shadows give form to each limb and part. The direction of the light must be studied so that all the shadows fall in a logical way: behind the corresponding part with respect to the principal light source.

▶ *The spinal column gives the figure its flexibility. This exercise can be extended to as many models as you can find, either photos or drawings in this book or in any other. Look for figures sitting down, standing up, naked or clothed, then put tracing paper over them, and try to place the spinal column and the hips. Then, make an effort to draw the figure, even if only by tracing. If this exercise is carried out with several figures you will gain a much better understanding of the importance of the internal bone structure.*

# Step by step
## A nude

A nude is the most beautiful and complex subject that can be attempt-
ed. It is a great challenge for the artist, and consequently pulling it off gives
a great deal of satisfaction. In this topic we have been able to study a few
notions of anatomy that will be continued in this exercise. This drawing is
of a girl kneeling. A layout has been superimposed, taking the head as a unit
of measurement. In the first step, this layout has once again been superim-
posed so that it can be used to guide your study of the proportions.

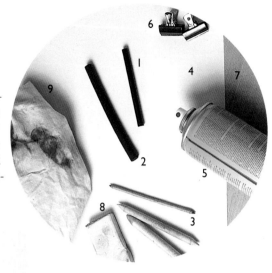

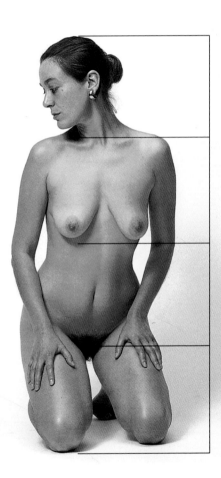

### MATERIALS

*Carbon (1), pressed carbon (2),
stumpings (3), paper (4), fixative
spray (5), pegs (6), board (7),
eraser (8), and a cloth (9).*

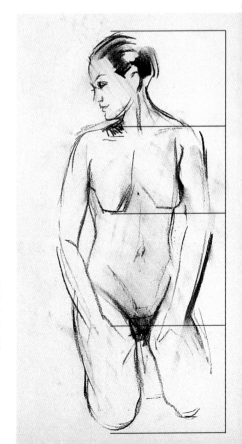

**1.** *As you remember from the earlier lesson, the canon for drawing a figure
is eight heads. The first four correspond to the torso as far as the pubis
line. In this drawing the measurement is very approximate because the fig-
ure is kneeling, so that part of the body is leaning slightly backwards, also
displacing the pubis line. The figure has to be schematized with simple
lines to place the head, the shoulder line, and the hip line. Once these first
strokes have been sketched in, the shoulder and arm joints can be started.*

**2.** *The most complex stage is the first because after the initial scheme you have to start modeling the shadows. However, first the elements of the figure have to be perfectly defined and set in proportion with the rest. Once the drawing is clear, the first dark parts can be tackled. The dark parts allow the anatomical study to be deepened and give prominence to the light zones. All this first stage of the drawing is done with charcoal so that any corrections are simple to make. By gently darkening the background, all the left side of the figure is made to stand out. The main light source is on this side. When that is done, the dark parts on the right can be started.*

**3.** *When the first dark parts have been set in plac the lines of the head and left shoulder are gor over. The inclining and twisting of the head mal the neck muscles stand out. Contrast is added wi a light stumping. As the contrasts progress, the da parts can be further accentuated. Observe that tr shadow of the head falls on the right shoulde*

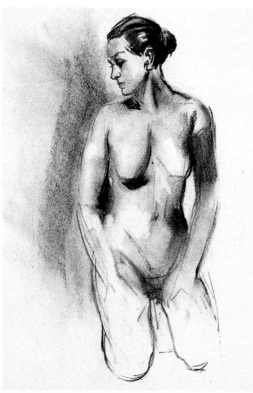

**4.** *Using the charcoal point, you should intensify considerably the contrasts of the figure. Now do the modeling with your fingers because the areas concerned are more extensive. Where there is a strong illumination, as on the breasts, the shoulders and the forearms, the highlights are opened with the eraser. The lines that show the contours of the figure are then emphasized with a clean, dark line. Start to draw the hands.*

. Up until now, charcoal has been used to lay out the drawing. The darkest tones that can be achieved with charcoal are not so contrasted as those of pressed carbon. Using a bar of pressed carbon, start to go over some of the lines and dark parts, although you must remember that the stability of this medium is much greater than that of charcoal, and therefore it is harder to correct. Draw the leg line as far as the right hipbone, and then darken the background. Pressed carbon is used to darken the left side, but without pressing too hard so that a stumped stroke can be created on top of the earlier charcoal shadow.

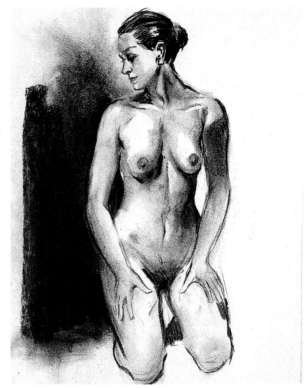

. The progress of the modeling can now be appreciated. In reality it is not difficult, since the areas of light and shadow are well indicated in the model. Eraser work is very important, as it gives the depth that the forms require after having been stumped. The highlight zones on the abdomen and on the arm have been opened up with the eraser, without aiming for total whiteness.

Stumping allows the stroke to be faded and blended on the paper. However, stumping with your finger offers far more sensitivity. Stumping allows you to attain more concrete areas: you can even go as far as drawing with it.

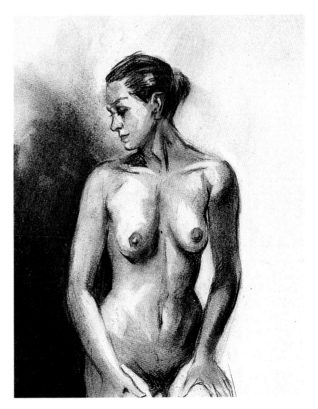

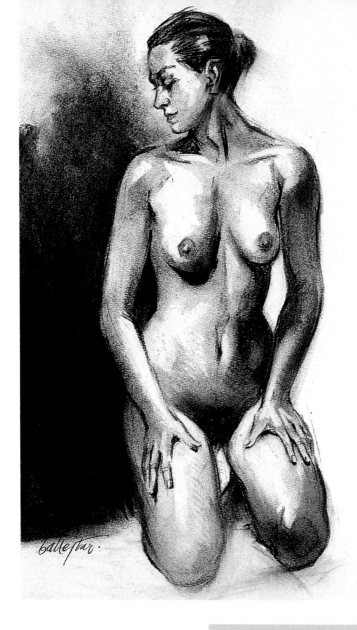

7. *The final contrasts and blendings are done on the side and on the arms. Redo any shapes that may have been damaged in the elaboration process. The eraser is used to clean up any grubby areas and to open up highlights where the light requires them. All that remains to be done is fix the drawing with the spray.*

For the volume of the figure to be well defined and resolved, it is necessary that the light on it should come from a single source. A figure must never receive intense light from both sides.

## SUMMARY

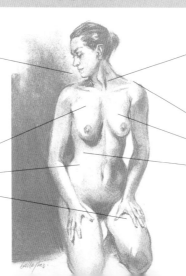

After the initial layout, **the forms are outlined with the aid of the grays** that surround them. The first grays are laid down in the background and indicate the direction of the light.

It is important to place **the highlights** correctly so that the volume of the figure is well defined.

The spinal column is **the center of the anatomy**. From this axis the shoulder line and the hip line originate.

**The highlights of the anatomy** are opened up with the eraser, on the chest, on the flanks and on the shoulders.

# Figure sketches

## SIMPLICIFYING FORMS

There are no complex forms that cannot be simplified into others. In the same way, to get a more complex form, such an awkward kneeling pose or one such as the seated girl below, you can start from a simple form, like a triangle. This basic truth has been repeated throughout the book, because drawing is not complex if it is built up from basic shapes, as was suggested by Cezanne.

One of the most difficult subjects in drawing, and one which requires a great deal of application by the learner, is doing figure sketchs. Studying the figure by sketching is a slow, but vital, process for the learner. Sketches are brief notes, done as quickly as possible. Constant practice gives the hand sureness, and at the same time finds solutions for all sorts of anatomical questions.

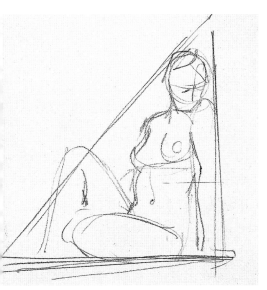

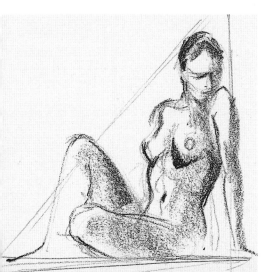

▶ Starting from the initial layout, it will not be too difficult to construct this figure, bearing in mind the fundamental proportions. Using a drawing medium like charcoal, or in this case sanguine, makes the work a lot easier; as the stick can be either flat or transverse, the shadow planes can be done efficiently, at the some time outlining the highlights.

▼ These sketches have been done in graphite. Try to construct them starting from basic forms. First the external forms have to be done, and then the internal forms fitted in.

## STAIN TO FORM

To get into the swing of drawing it is useful to do a few quick sketches before each session. The aim is merely to warm up the hand. In these preliminary drawings you must try to lay down the principal strokes in as few lines as possible. It does not matter that the drawing is unfinished. The finished aspect of a sketch is unimportant. This is why many quick sketches are nothing more than scribbles. Many body parts do not even have to be drawn.

> As the very term indicates, a sketch must only represent what is essential, the basic elements that make up the figure. Sketching demands a great capacity for synthesis. Any aspect focusing on details or corrections goes against the nature of the sketch.

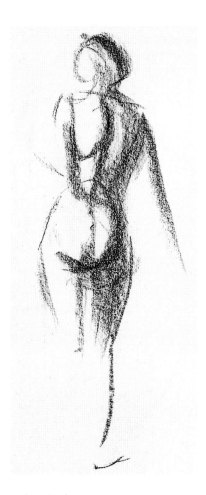

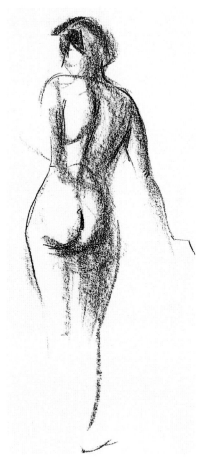

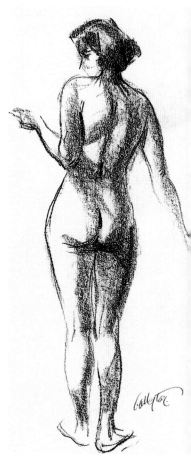

▼ *1. In this first outline, the main shapes that make up the figure are combined almost mechanically, using a pressed carbon stick held flat with occasional strokes made with the point to ensure comprehension. The fewer the lines and stains, the less there will be to correct.*

▼ *2. Once the rough figure is down, not all the drawing need be done with the same intensity. Some areas need a strong pressure: this allows a principal line to be reinforced. On other parts of the anatomy the line almost fades away. The form is suggested by other lines. This technique allows you to hint at what cannot be seen.*

▼ *3. Sometimes an area that would usually demand greater attention is left undrawn, although it is perfectly suggested by the strong and decided strokes around it. As can be seen in this sketch, what is important is constructing a whole: the details do not matter. What counts are the stains and the immediate study of the pose.*

# SKETCHING IN SANGUINE

One of the most attractive ways to begin figure drawing is by using the flat stain produced by any of the dry media, example charcoal and sanguine. Once you have tried a few ick action sketches, you can start on the more extended ses; the reason for this approach is that some poses are ore complicated than others. An upright figure is much simer to understand and sketch than a reclining one.

The easiest sketches to do are those when you are under no time pressure. In these drawings it is easy to correct the errors, although it is better not to use the eraser: instead, make the correction on top of the badly placed line. You will thus acquire an understanding of which reference points should not be used. In the exercises on this page, you should set yourself a time limit for doing the sketch, and not use the eraser. When doing figure sketches bear in mind the following questions: the proportions of the head and the body, the shape of the spinal column, the inclination of the shoulders with respect to the hips, and the position of the legs and feet on the floor.

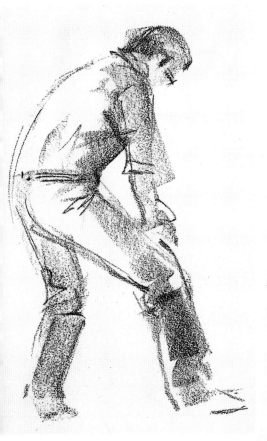

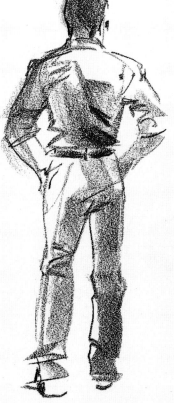

▶ Using the flat bar correctly allows you to lay down relatively complex forms in a few moments. The point of the bar is handy for finishing off the last lines that define the fig-ure. In a figure sketch, give the same importance to the dark parts as to the highlight areas.

In doing this sketch the line of the spinal lumn has been taken into account: everything se has been constructed starting from this rve. A stain with the bar flat helps to set wn the dark parts of the body. The details of e hands and face are done only roughly.

# Topic 13: Figure sketches

▶ *Sketches of a model should be done in such a way that the drawing technique does not detract from the dynamics of the work; you have to ignore tone values and modeling. One of the best ways to begin the rapid drawing required by a sketch is to outline the most strongly lit areas of the figure with a fine, clear line and then to use a graphite stick or a piece of charcoal held flat to fill in the shadowy areas with a single stroke.*

## HOW TO LOOK AT THE MODEL

Whether you are sketching still or moving figures, it always interesting to do so from more than one poi of view, moving around the figure as each sketch is complete Each viewpoint offers you a change of pose, as the same po appears different from different angles. Although this book c offer only exercises based on static poses, you can experien these rapid changes of viewpoint by quickly moving from o drawing to the next.

*The complexities of a seated figure differ from those of upright figure: the joints and limbs are not an extension of th body. They are seen as different planes that have to be co nected by lines or by shadows. Pay attention to the form of th joints and the concealed parts, which must be considered whe deciding where each limb begins. The left leg is hidden, b thanks to the position of the right leg it is perfectly implie*

▼ *The figure of a person who is not upright presents a series of problems which can be complex, above all in the legs and the body parts that are hidden from view. You have to observe the starting point of each line you draw, where they meet, and where they fit into the structure of the body.*

# Step by step
# Sketches of a model

A sketch is produced almost spontaneously, which makes it quite complex to work on throughout a whole session. This is why in this exercise two different poses are offered: one standing up, and the other lying on the ground. They must be in a few lines. As we are working from photographs, this exercise will be similar to a session with a model. A tip before you begin: firstly observe how the weight of the figure is distributed, and also its principal lines.

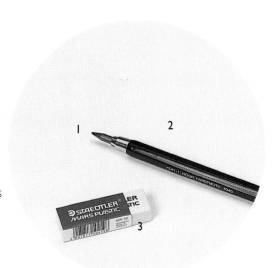

### MATERIALS
*Drawing paper (1), graphite lead propelling pencil (2), and eraser (3).*

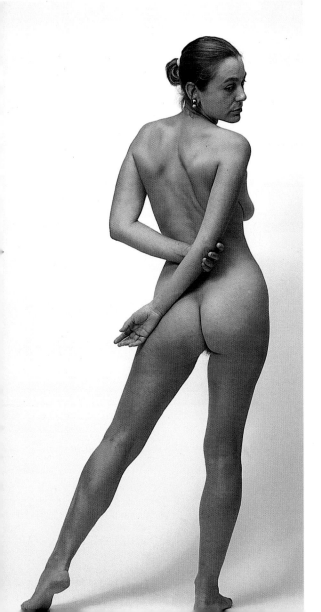

**1.** *The layout is started very quickly, beginning with the head and then the line of the back. If necessary the form of the model can be schematized within a triangle. The head coincides with the upper angle and the two feet with the lower corners. The shoulders decide the pose of the body. The shoulder line is slightly inclined, which results in the back being gently twisted. This is why the shoulder curve is not symmetrical: on the right the curve is more acute than on the left. The elbows have not been drawn; they are implied by the forearm and the upper arm.*

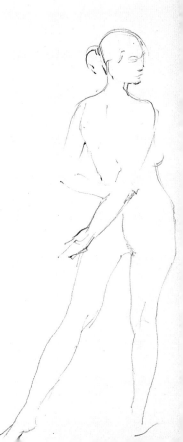

**3.** *To finish off, the dark areas of the legs are done in the same way as the upper torso. On the right calf muscle the highlight is left in reserve, just like the buttocks. The dark parts around them make them seem more luminous. All that remains to be done is reinforce the lines of the figure, without going into detail on unimportant bits like the fingers.*

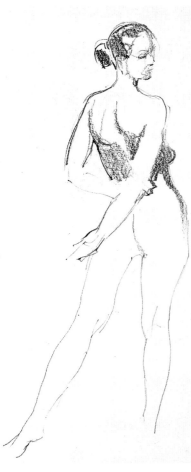

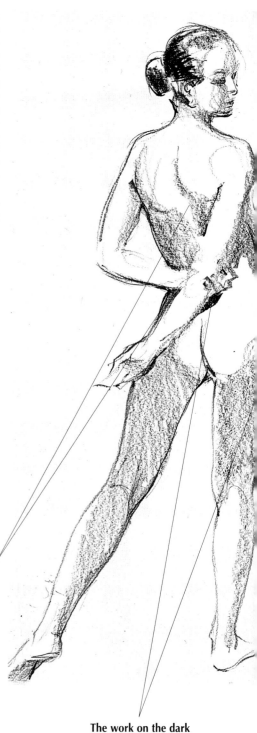

*2. The shadows are only added when the initial scheme is perfectly set out. The presence of dark areas in a rapid sketch has only one end: to separate the light planes in the anatomy from the shadow planes. The figure's main dark areas are drawn so that the luminous sections become more prominent. The dark work is quickly finished off with the edge of the graphite stick, or by taking the lead out of the propelling pencil and drawing with its flat surface. How you decide to represent the shadows will depend on the size of the drawing.*

**The layout** is created with clear, continous lines, once the placement of the shoulders, the spinal column and the hip have been studied.

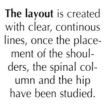

**The work on the dark parts** is quickly carried out with the edge of the graphite stick.

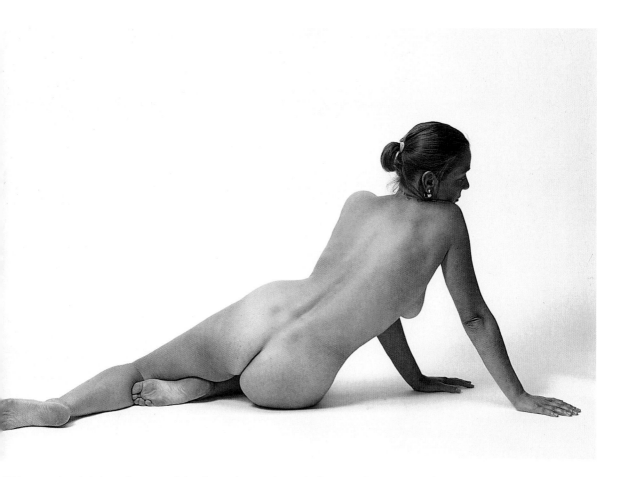

This next sketch is based on a reclining figure. Just as the ~~st~~ pose could be schematized inside a triangle, this one ~~~uld~~ be fitted into another. Try to synthesize your scheme before starting to draw. You will see how in this way the placing and the shapes of the figure become much more straightforward and self-evident.

**1.** The drawing is begun with the head, which is a reference point for the shoulder line. The model's pose shows quite clearly the form and the curve of the spinal column. In this sketch it is easier than in the last to schematize the plane of the back for there are no visual impediments, like the arms, that get in the way. It can be appreciated that the hip line is inclined to the right at a very acute angle, as the girl is leaning towards the ground. The left leg is slightly bent, which means that it is drawn much shorter than the outstretched leg.

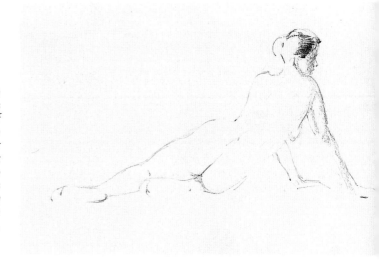

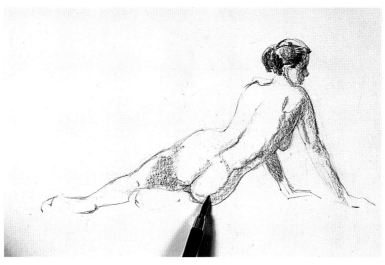

*2. The layout of the pose has been resolved almost immediately. Do not worry if you have to make corrections, because to get a sketch right the very first time you need a lot of practice. In this phase of the sketch the most complex anatomic questions are perfectly resolved. On top of the clean drawing, free of any accessory line, the contrasts that suggest the volumes of the body are put in. To show the flectio of the leg, a dark area has to be put in on the rear of the left thigh. The right side of the figure is darkened with a rapid stroke. On the arms the lighted areas are hardly marked.*

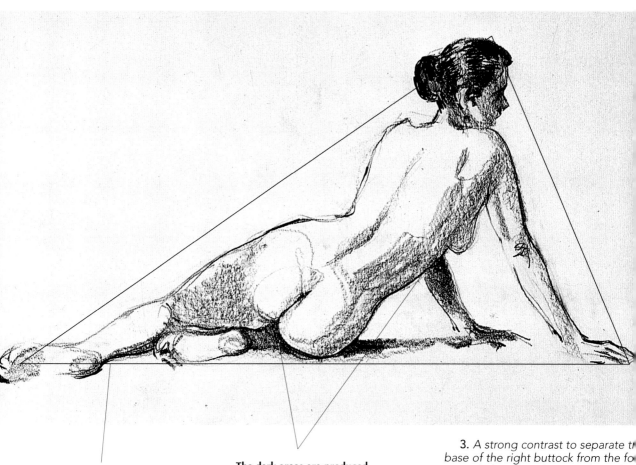

**The figure** can be fitted into a perfectly defined triangle.

**The dark areas are produced** with a thick, uniform line, without tone variation. What is aimed at is the separation of the lighted and shadowy zones, and to give more emphasis to the areas suggested by the darkness.

*3. A strong contrast to separate th base of the right buttock from the fo is needed to draw the complex volum of the legs. This intensely dark are gives a perfect effect of depth. Wh the dark parts are too intense, they ter to destroy the balance in areas of inte mediate tones. Therefore, the left arm also darkened, whereas the wrist an the hand are barely implied by the ligh*

# The face

## STUDYING THE SHAPE OF THE FACE

A drawing must always be done progressively, starting out from forms sufficiently simple to permit it to evolve steadily. The study of the face is no different. All the features that make up a face have to be correctly placed within the structure of its elementary lines.

The face is, beyond doubt, one of the parts of the human body that attracts the most attention, and therefore special care must be taken when drawing it. The features and the proportions must obey a number of well defined rules, although afterwards, in practice, these rules and measurements can be varied to a greater or lesser extent according to the person.

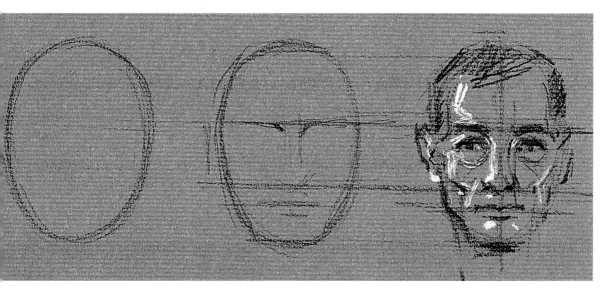

1. *Viewed from the front, the shape of the face fits into an oval which will vary for each individual. These examples do not aim to put forward a definite canon; they only offer a guide which can be adapted to many faces and proportions.*

▼ 2. *The oval is divided into three similarly sized parts. However, the upper part can be somewhat bigger as it will include the forehead. The middle area will be occupied by the eyes and nose. The lower part is for the mouth and chin.*

▼ 3. *This image shows the proportions that the features can have with respect to each other. The vertical line that divides the face forms a symmetrical axis which is used to situate the features proportionally. Of course, this only works when drawing from the front. Try this scheme on top of photos; this will help you to understand better the importance of the basic lines.*

# THE EYES AND THE NOSE

On the previous page we studied the layout of the face. From now on each of the individual parts will have to be studied on its own to create an accurate representation of the features.

If you master the features you will be able to do a perfect front and profile portrait. The eyes light up the face with their expression; the nose instils character.

The central part of the oval which makes up the face consists of the eyes and the nose. It is unwise to start a drawing without having first observed the subject carefully. An eye is only well drawn if it expresses feeling.

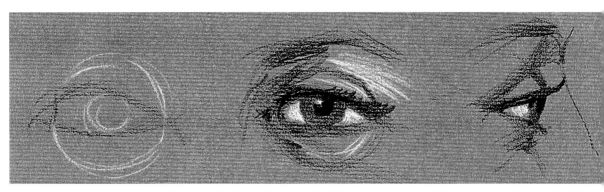

▼ 1 . An eye fits perfectly into a neat circle, which corresponds to the eye socket. Within this shape the eyelids are added: the upper one is slightly more almond-shaped than the lower. The lacrimal gland is on the inside of the eye, next to the nasal septum.

▼ 2. Observe how the eyelids are laid down thanks to the anterior circle fit. The upper eyelid is drawn with eyelashes, but do not overdo them. Female lashes are made thicke.r The curve only has to be shown on the outer side, as can be seen in the image.

▼ 3. Seen from the side, the for of the eye also fits into a circle. The eyelids are now drawn with two lines at a quite acute angle.

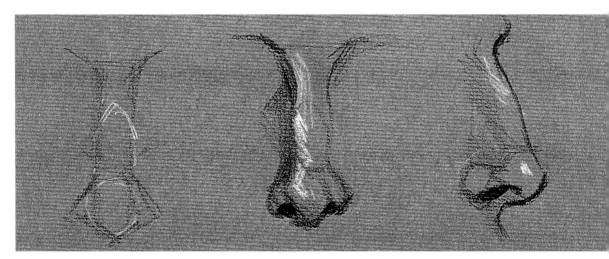

▼ 1 . The nose can be fitted into an elongated rectangle. In this scheme the tip has been emphasized, drawing it in a circular form. The bridge has a slight bulge. If everything fits into a rectangle, the nostrils must stick out a little.

▼ 2. Starting from the previous scheme, just a hint of darkness is sufficient to give the nose the necessary volume. As always, white reliefs odd volume.

▼ 3. From the side, the nose can be fitte into a right-angled triangle, this angle bei formed by the height and the base.

## THE MOUTH

Despite of the appearances, the mouth is quite difficult to draw because the lips cannot be represented with a simple straight line. It is important to pay special attention to the continuous curves around the central axis and also to the corners.

◀

*1. Symmetry is very important in all the facial features. To achieve perfect symmetry, start from the vertical axis and add a horizontal line that enables you to do the principal curves of the lips. The lower lip is more prominent and leads into the chin. The lip corners are a small, but important detail: they are two fine lines that softly cut the line of the mouth.*

*2. The central little dip is equally important to give shape to the upper lip by comparison with the lower one. The upper lip is drawn with a soft curve, symmetrical on both sides. It is darker than the lower lip, which is not defined with a closed stroke. The desired effect is achieved by a shadow where the lip meets the chin. White reliefs allow the lips to be separated.*

Although the drawing of a mouth seen from the front starts with two crossed straight lines, when all is finished there is no longer even one straight line.

▼ *3. If you look closely at this drawing, you will see that a lateral view of the mouth can be schematized as half of the previous scheme. Getting the corners right is very important in giving naturalness and realism to the mouth.*

## THE EAR

Curiously, the ear is a part of the face that is very easy draw. However, it is often the least well done. The schem is based on two very elementary geometric forms. Ears va from person to person: some hardly have an ear lobe, wh others have a large one. This feature has to be made clear in t initial layout.

▶ **1.** As can be seen here, the initial scheme consists of two circ lar forms. The larger one permits all the upper part of the ear to be detailed. The smaller circle facilitates the placement of the ec lobe. The two circles allow the outline of the ear to be drawn.

▼ **2.** Starting from the initial scheme, the construction of the ear can be completed. As can be seen, it is not too difficult to achieve the definitive form. The internal folds are drawn from the internal cavity and the middle of the ear lobe. The dark parts are set off against the palest highlights.

▼ **3.** The three-quarter view of the ear is not complex, although is advisable to practice in different positions to be able to mast the changing planes when the head moves. You will discover tha when the internal ear cavity is viewed from behind, it takes on a spherical form.

# Step by step
# A portrait in sanguine

Studying the face allows an accurate portrait. There is no doubt that it
[.] complex subject, for the resemblance between the model and the final
[.]ult will be obvious. Knowing how to represent the facial features is one
[.]g; achieving a likeness is another. It is no good being able to draw if
[.]se features are not well constructed within the overall layout. As has
[.]en seen in this lesson, the examples that have been studied are not the
[.]ne for all the faces. In this model we can see that the structure is not an
[.]l one, but rather, due to the beard, takes on a rectangular appearance.

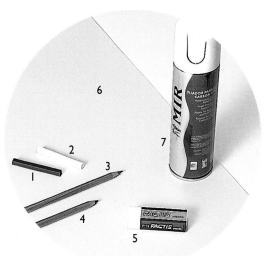

## MATERIALS

*Sanguine stick (1), white chalk (2),
sanguine crayon (3), sepia pencil
(4), eraser (5), cream colored paper
(6), and fixative spray (7).*

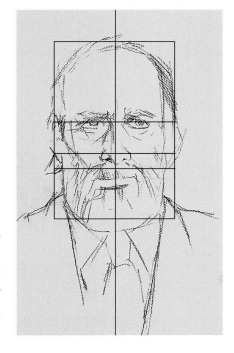

**1.** *The drawing is begun with the sepia pencil. Although it is a very
dark tone, its stroke is sufficiently soft and fine so that a schematic lay-
out of the principal lines can be constructed. The scheme consists of a
rectangular form in which a symmetrical axis is established. The
scheme is divided into three parts: the upper one is somewhat larger
than the others. The dividing lines coincide with the height of the
mouth and the eyes. Over the mouth line the base of the nose is
marked. The principal features are put in on top of this basic scheme.*

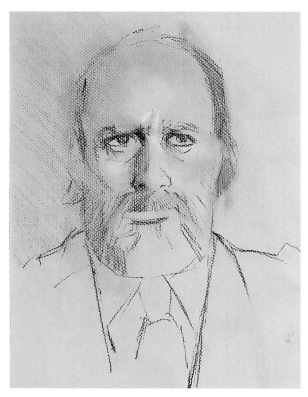

**2.** Once the principal lines of the face have been set ou
the facial features are drawn in sanguine. This time a sa
guine crayon is used to draw the principal contrasts of
the face. Start with the hair, which defines the shape of
the cranium. On top of the sketched drawing, you can
start to set out the principal contrasts in the tone that
sanguine offers you. This tone helps you to build up the
features gradually, the corrections can be done as you
along. White chalk is used to do the first highlights in the
lightest parts of the forehead and between the eyebrou

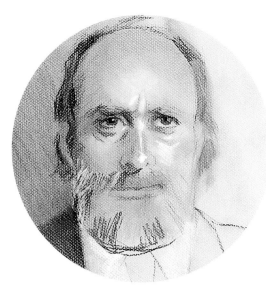

**3.** The contrasts of the face must be built up slov
always trying to graduate the planes in terms of h
much light falls on them. In any portrait it is essen
that the placing of the features and the quest
expressivity are based on the proportions betwe
them. Firstly, the eye area is detailed. As can
seen, the arch of the upper eyelid is much m
curved than that of the lower. The relief of the n
means that more volume can be given to the na
septum and to the tip. The fingertips are used
smudge the tones and add volume to the fa

**4.** Once the features are fully defined, it is important to
continue working on them on the basis of the contrasts
offered by the different media used for this exercise. A
sepia pencil intensifies the most strongly contrasted
tones of the face. The paper color, combined with the
luminous tones of sanguine and the white highlights,
enhances the forehead, nose and cheek hues.

*5. Use your fingertips to blend in some of the dark parts of the face, and add new contrasts with sepia on top of the shadows. The dark parts of the beard add a lot of expressiveness to the face. When these dark parts are drawn, the lighting of the model has to be taken into account. Here it can be seen that the principal light source comes from the right, and therefore the shadows are mainly on the left of the picture. The light on the lower lip is enhanced with white chalk. The jacket is considerably darkened on the shadow side, and the shirt is completely covered in white. The shadow side is left smudged with the sanguine color.*

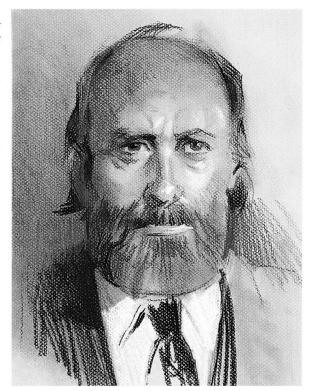

If you have achieved a good preliminary sketch which you do not want to lose, even though there may be erasures and corrections to be made, you must fix your work before proceeding. Remember, though, that any errors will also be fixed and unerasable.

*6. It is important to build up the contrasts progressively, so that false volume effects are not produced. And it is also essential to gradate the highlights according to the contrasts that they offer. The work on the beard is done with long, loose strokes which give texture to the hair. The excessively luminous highlights, like those of the lower lip, are stumped with the fingers and blended with the color of the paper.*

Be careful when smudging an area that contains a highlight. White can be converted into a dirty gray color.

7. *All that remains to be done is stump some of the sepia zones that are too contrasted, and to redo any areas that have been spoilt the work progressed. The final white chalk highlights are applied, some blending with the other tones.*

## SUMMARY

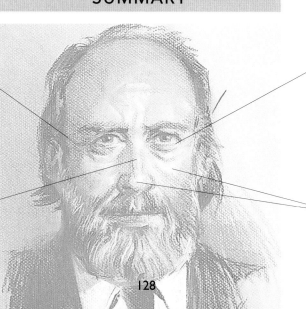

**The facial structure** must be fitted into a very simple and linear format in order to study the proportions and measurements.

**The nose** starts out from a symmetrical, rectangular shape. Afterwards, the nostrils are added.

**The eyes** are constructed within the circular framework of their orbits. The upper arch is more curved than the lower one.

**White reliefs** allow the lighted areas of all the face parts to be enhanced.

# Landscape

## THE BASIC STRUCTURE OF MOUNTAIN LANDSCAPES

mountain landscape is attractive and not very complex, especially when it is set out as if it were several different nes superimposed on each other. With a little practice autiful landscapes can be done in any of the media and hniques known to drawing. For this landscape we are ng to use a brush and the technique known as a wash. All t is necessary are watercolors, in whatever tone you like, a ss of water and a brush. This is one of the most classic pro-dures in drawing.

**The landscape is one of the favorite subjects of artists. On the one hand it gives great latitude to the artist's creativity, and, on the other hand, it is not subject to strict canons of measurement and form like the figure, the still life, or a portrait. Representing landscape in a drawing offers a great number of options, whose limits are only decided by the creative capacity of the artist. Throughout this topic we are going to look at very general questions related to landscape.**

▶ 1. *The initial outline is used to situate accurately each plane of the landscape. This example is going to be executed with a wash, or, coiled by another name, a single shade of watercolor. As will be seen, it is not difficult to carry out as the technique is the same as for any other drawing procedure. However, here it is done with a brush and watercolor.*

▶ **2.** *On top of the initial scheme the sky is painted in a dark tone, leaving the cloud space white. The ground is drawn in the same way, the most luminous zones being left unpainted. This is what is called a reserve. The different planes ore separated by reserved zones.*

▼

*3. Once the separate areas of the landscape have been painted, and the most luminous zones left in reserve, the dark parts of the trees are drawn. To avoid mixing the dark tone with the lighter ones, the latter must be completely dry.*

# THE URBAN LANDSCAPE

For many artists, landscape becomes especially interest when it is practiced in the city. Although the scenery is r natural, it is no less enticing or engrossing because of the co plexity of the buildings, and because little views can be add which give more flavor to the composition. The artist will sel the areas he or she wishes to represent. The final choi reflects the artist's feelings and is used to represent on pap his or her vision of the city.

▶ *Perspective can be included or foregone when setting out on urban landscape based on positional planes as in this example. However, it is important to bear in mind some notions of perspective, like, for example, the way the shadows of the buildings fall on the walls.*

▶ *Urban landscapes also provide most attractive subjects in hidden corners like this one. Here the most important aspect is the difference between the contrasts in the foreground, produced by the very dark details of the vegetation and the structure of this work and the background plane. This tone difference allows a strong backlight to be developed.*

*This view is comple without perspective. It p sents the town buildi from the front. Here principal work is done the multiple details of windows and the contr among the ro*

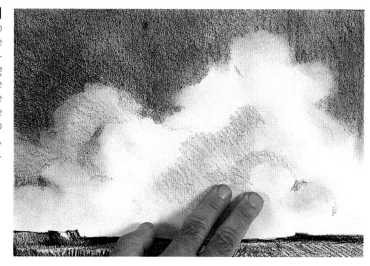

1. The position of the clouds has to be decided on before starting them with medium tones. To make the clouds' white stand out all the rest of the sky is darkened. If necessary, the whites can be reinforced by using the eraser to outline the form. Inside the clouds the tones that give them volume are added, and then the edges are stumped with the fingers. Depending on the medium used, the stumping will be more or less easy to do. If they are drawn in charcoal, graphite, or sanguine, they will be easy to stump.

## CLOUDS

Clouds are an important feature of any landscape, regardless of the subject. You do not have to be in the country to see a fabulous cloudy sky. Looking out of the window will allow you to appreciate all types of sky, depending on the climate and the time of day. The techniques of drawing clouds are many and varied. Here a simple example is shown that can be taken as a starting point for a host of landscapes. Moreover, clouds alone can be an appealing subject.

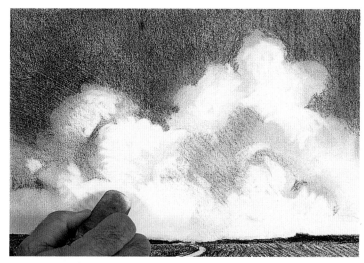

2. The white luminous spaces of the clouds are opened up with on eraser. The whites are worked with the stroke because the eraser allows us to work on top of surfaces that have already been covered. The white parts correspond to the most luminous highlights of the clouds. This effect has to be balanced by putting in dark areas.

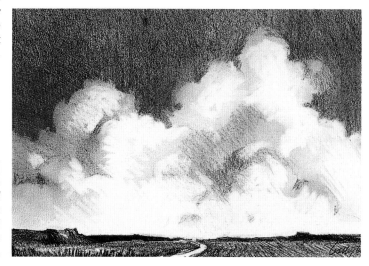

3. It is easy to get clouds like these if you combine drawing, techniques with the eraser and finger-smudged grays. Drawing clouds, although straightforward, always has more impact when you are working from a real model or a photo. If you invent them they can lack the contrasts and the viewpoint of the real thing.

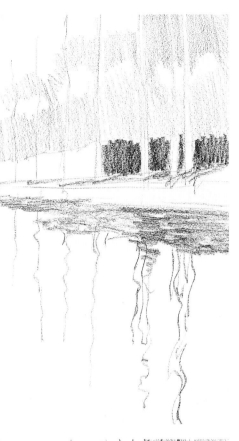

▶ 1. This exercise shows a river scene in which the surface of the water is still, allowing the river bank to be perfectly reflected. The water acts as a mirror, reflecting the objects on the surface. Enough space must be left to be able to draw the water surface. First, the shore is drawn, then the trees, and, finally, the slightly distorted reflections of the shore and the trees are put in.

## WATER

Another theme which can be used in isolation as the subject of a landscape is water in all its aspects. Many artists are reluctant to draw water because they consider it too complicated. In this straightforward exercise it will be seen that it is much simpler than it appears at first. The techniques called upon in this topic can be applied to any subject in which water is present.

> Water can display many forms, varying with its surface, which is largely determined by the current, the wind and the sky.

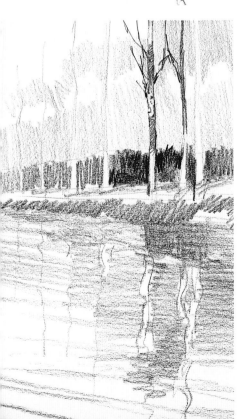

▶ 2. The calmer the water surface is, the clearer the reflections will be in it. These reflections are always more contrasted than the original images and must be drawn with less precision than what they are reflecting. The ripples on the water are created with horizontal strokes that become less intense as they move away from the shore.

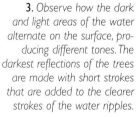

3. Observe how the dark and light areas of the water alternate on the surface, producing different tones. The darkest reflections of the trees are made with short strokes that are added to the clearer strokes of the water ripples.

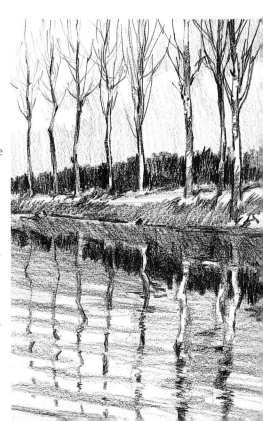

# Step by step
# A corner in the forest

Landscape is one of the most rewarding subjects in drawing because the result does not have to be an exact copy of the model, as is the case with a portrait or a figure. Moreover, all the drawing media can be used sucessfully for this subject.

A forest landscape has been chosen to practice the techniques of ink and pen. The strokes and lines depend on the amount of ink loaded on the pen. Heavily loaded, it will make them nearly completely black, although as the ink runs out it will offer a variety of grays. The greatest difficulty of this exercise lies in keeping the whites clean it is not possible to correct them except by scraping with a razor blade.

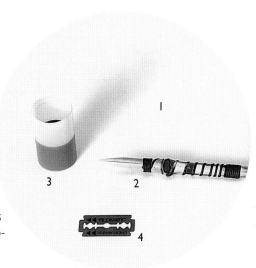

You can draw with a bamboo pen, with a sharpened stick, or with an ostrich feather. However, the results achieved will be very different in terms of the characteristiques of the stroke.

**1.** *The sketch is begun directly with ink, without any other procedure coming into play, even though you may have to make corrections later. This is why the first lines must be soft and not too heavily inked. Firstly, the two big planes of the foreground are put in. On top of this, the trees in the midground and in the rocky background are sketched in. The pen must not be overloaded with ink. To get the right intensity in the stroke you must do a test line on identical paper. Every time that the ink runs out, this operation must be repeated.*

# STEP BY STEP: A corner in the forest

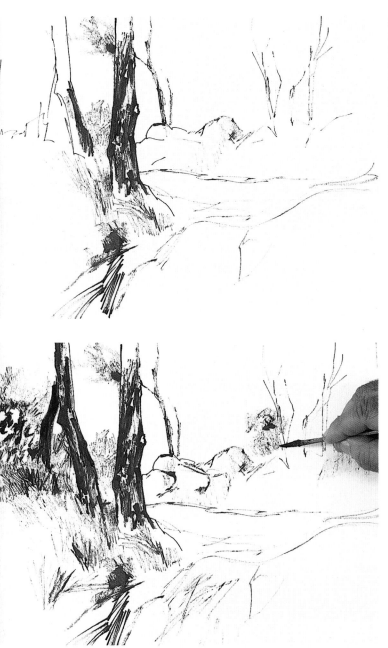

**2.** *The drawing is started with the left side of the waterfall. The first strokes are long and parallel t try out the way the pen responds. On top of this zone, a dark stain is made without too much ink With the ink remaining on the pen - do not loac more - put in the first grays of the grass below the trees on the left. Once the pen has been reloaded, the dark parts of the trunks are startec leaving the light parts in reserve. Only when the ink is running out are the grays drawn in.*

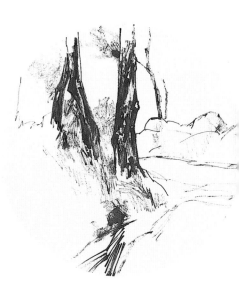

**3.** *The ink work continues on the trees o the left, always leaving the most luminou parts in reserve. As the ink is used up, an before reloading the pen, some stroke are made in the lighter gray areas, such a the upper left part of the tree.*

**4.** *The trees on the left in the background are much more contrasted than those in the foreground. The trunks are completely black. In this way the separation planes between the foreground and background are established, as was explained in the first part of the lesson. Before the ink runs out completely, the background grasses are put in. The rocks in the background are made to stand out and their contrasts are begun. The vegetation in the background is drawn with the pen almost out of ink.*

To obtain gray tones the pen must have hardly any ink on it. It must be dragged firmly over the zone that is to be grayed. The result is a stroke that reminds us of some of the dry media, like pencil or charcoal.

**5.** *To get the very soft grays in the background the pen must be almost out of ink, although it will have to be rubbed firmly over each of the areas to be grayed. Whenever you reload the pen, use the first, inkier strokes in areas that require a greater contrast or a clean line. In the bush on the right above the rocky zone, some dark stains are made, and when the ink is running out the graying of the background is started again. In the foreground, on top of the rocks, you should use long strokes.*

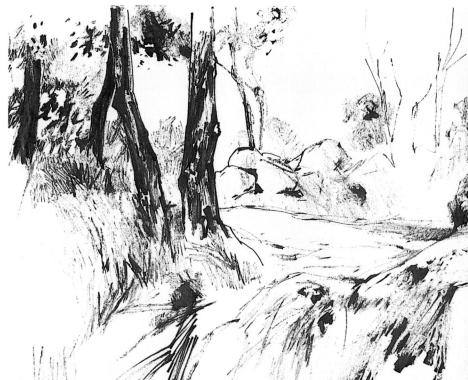

To correct any error made in ink, you have to wait until it is completely dry and then scrape it with a razor blade, taking care not to tear the paper.

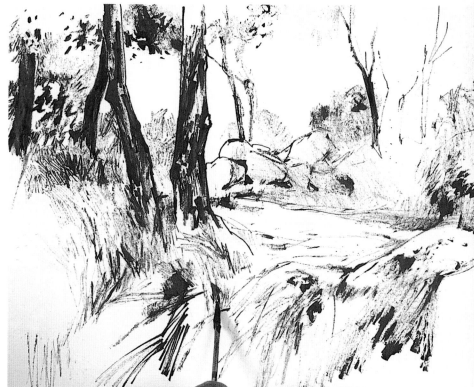

**6.** *In the foreground numerous crossed lines are put in, but without completely obliterating what is underneath. This will give texture to the grass. When this plane is finished, it will have a stronger contrast than the midground, which has many white areas that act as pure highlights.*

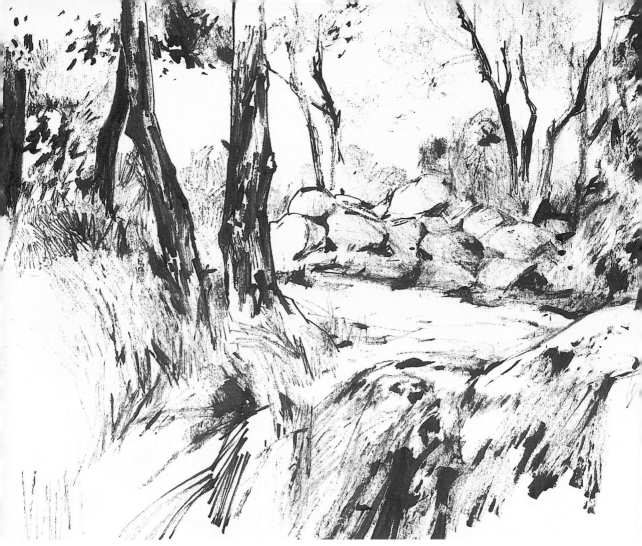

7. *The drawing of the trees in the background is finished, the upper part of the trunks being darker due to the shadows. Also the most strongly contrasted dark parts of the vegetation are drawn in. Once the pen is almost out of ink, the clear grays of the background are put in.* *A rich variety of grays is included, the different intensities depend on the degree of superimposition. This concludes this pen and ink landscape, in which one can appreciate numerous similarities with the other dry media.*

## SUMMARY

**The initial drawing** is realized directly in ink. Only the outline of the trees and the situation planes of each area are laid down.

**On top of the trees** on the left the first contrasts are painted, leaving blank the most luminous zones.

**The first stroke** experiments are made in the foreground.

**In the rocks on the right** you can create the contrasts by dragging the pen across earlier lines, thus streaking the ink.

**The grays in the foreground** are obtained when the ink has nearly run out by dragging the almost dry tip across the paper.

# 16 Landscape features

## THE TEXTURE OF THE TRUNK

You may find that you have to represent a tree situated in the foreground. This is an important part of landscape composition, though it may not always be as prominent as that in the next exercise. You should bear in mind that what you are putting on paper is an interpretation of the actual object, in which some aspects are implied rather than specified.

> In the last chapter we looked at how different aspects of the landscape can be worked on. In fact, the principal elements vary according to the artist's interests. One person may create a landscape in which no single element predominates, such as a wide expanse of countryside; another may focus on one principal object whose texture is observed and reproduced in detail.

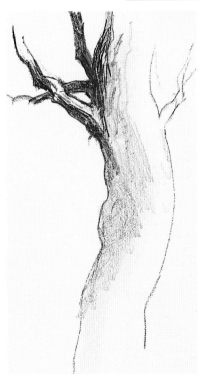

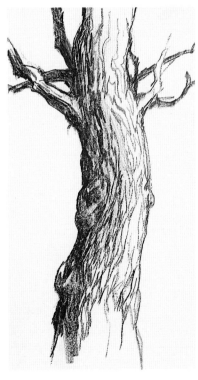

▼ 1. The exercise is carried out in graphite. The layout is always important because it is the basis of all the later work The trunk is set down with a very simple drawing; a couple of strokes are sufficient for its entire outline.

▼ 2. The darkest parts, like the branches, are drawn as dark as the medium allows. Dark areas are added on to the trunk and then stumped with the finger in a gradation that blends into the brightest area.

▼ 3. On the basis of the previous tone, the work on the texture is begun. The bark is structured with short strokes that follow the cylindrical plane. It is important to leave some luminous patches in the shadows to show the volume of this area. As you move towards the lighter area of this bark, the stroke becomes softer and more defined.

# WORKING ON TREES

In the previous chapter we saw how the use of pen and ink can produce a characteristic effect, similar to those achieved with other common dry media. The combination of detailed areas with others that are barely suggested is a technique often used for landscape elements such as trees; it gives the drawing freshness and expressiveness and will therefore be practiced fur-ther in this topic. It can be used in drawing with charcoal, graphite or sanguine.

▶ 1. *As we have seen, drawing with ink can be done directly, without any preliminary work pencil. However, if you wish you can first sketch in the form of the tree, although it is not necessary. In this drawing the layout is done with a faded line: sketch in only the tree top and trunk. Once the whole tree is sketched, put in a firm and contrasted stroke on the right side of the trunk The ink will nearly run out while doing this stroke, and then you can start to draw the texture of the tree top, using quick and continuous lines.*

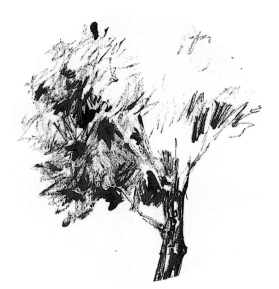

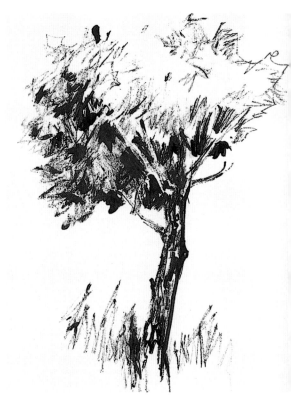

◀

*2 & 3. The maximum contrast work is centered on only one side of the tree, without making the separation between the two halves so obvious. The stroke used depends on the texture that you are after. A faded stroke allows you to draw a gray texture on the trunk. A cleaner stroke is more suitable for the densest dark parts. When the pen is fully loaded, you obtain patches that imply shadows, shown as strong black areas.*

1. *As always, the initial layout of the drawing is crucially important for the development of the landscape. Each area to be worked on must be fully defined in order to understand its importance to the whole. In this exercise first draw the horizon line and the mountains in the background. In the foreground sketch the forms of the rocks. A soft stroke will outline the shapes of the grass. The first dark area is drawn on the stone on the right. Thus, the shadow is defined and the lighted area is reserved.*

## DRAWING TEXTURES

Even simple textures like grass or rocks are a challenge for beginners because they do not understand that details need not imply complexity. Grass does not consist of lines alone; it includes areas of light and shade which affect the way it is structured in the drawing. Rocks do no need to be difficult; a simple darkening is enough to suggest their texture.

2. *The background above the mountains is covered with a darkness to establish the reference tones for the landscape. The contrast of the stones in the foreground is begun with crossed strokes. Observe how the texture of the stone is suggested by the crack in the light area. The work on the grass is begun by darkening its shadowy area. These strokes should define its texture in a general way.*

3. *The rocks in the foreground are finished by working on the dark parts; we do not want the lines to be very obvious. To achieve this end, the graphite is applied continuously, but gently. The grass clumps are drawn by combining the dark shadows with lighter areas to outline their shapes.*

▶ **1.** *In this exercise all that interests us is the texture of the rocks in the foreground, but we are also going to draw their surrounding so that they are seen in their element. The horizon is drawn high up so that there remains a large expanse in which the rocks can be worked on. The first scheme is done in pencil. The strokes are done quickly; the aim is only to set the planes of the drawing. On top of this sketch, draw with a flat charcoal stick. All we want to do is to lay down the dark parts of the background mountains and of the rocks in the foreground.*

# ROCKS ON A CLIFF

In the last exercise we studied how to represent rocks among grass. The rock on a cliff can be darker and have a more abrasive texture. In this exercise we are going to see how some drawing media, like carbon and pressed carbon, can be exploited in a simple piece of work that produces the required texture to these landscape elements.

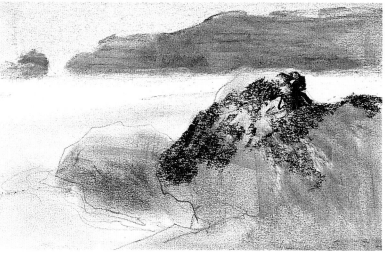

▶ **2.** *The charcoal is blended with the fingertips. This tone is perfect as a base for the rock texture. The rocks in the foreground are gone over with the pressed carbon bar flat between the fingers. The point of the bar can also be used, without pressing too much: what counts is getting the right texture from the combination of the grain of the paper and the dragging trace of the medium.*

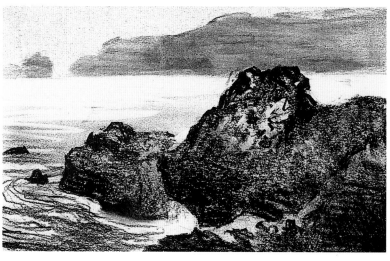

▶ **3.** *The lightest zones are not white. In these areas the dragging of the pressed carbon is very important as it shows the rock texture. Pressed carbon allows a very intense tone that is used for the densest shadows. To achieve this result it is vital to think of the grain and the dragging as fundamental elements of drawing.*

# Step by step
# A landscape with rocks

Very rarely are the elements of a landscape represented in isolation from their context, although their texture can often be shown in detail. The texture of the elements varies according to their distance from the spectator. The further away they are, the more uniform their texture is. The tone of the texture is another question to bear in mind. For example, if you observe this model the trees appear much darker, while there are more contrasts in the rocks. This exercise is based on the rocks, and although other features are worked on, they do not require so much attention.

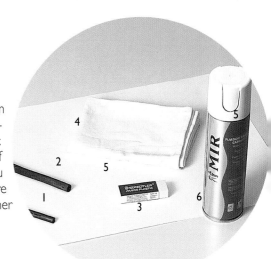

## MATERIALS
*Charcoal (1), pressed carbon (2), eraser (3), cloth (4), drawing paper (5), and fixative spray (6).*

**1.** *The initial layout involves sketching the general outlines which will contain the different areas of the landscape. As you see, this first sketch is very elementary, almost geometric, although it includes some of the basic lines of the landscape features. A lengthways charcoal stroke is used for the outlines and a transverse one for the first gray shading.*

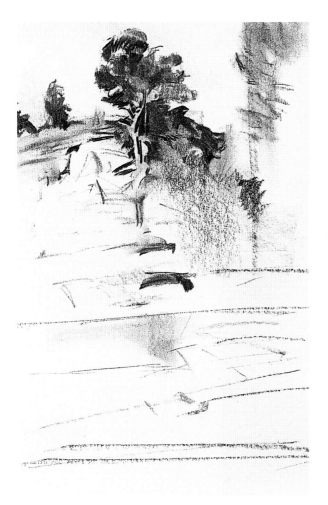

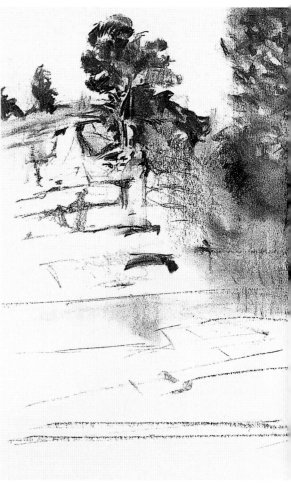

**2.** *First, the dark parts of the landscape have to be set down, especially those which outline the most luminous areas. The trees on top of the rock face permit this area to remain isolated. The top of the pine tree is drawn with the charcoal flat and in short movements that allow this zone to be rapidly darkened. The tree trunk is defined by the dark parts that surround it. Use your fingertips to gently blend the charcoal grays. The densest contrasts of the rock strata are worked on with the charcoal point.*

**3.** *The area of vegetation on the right of the picture is quickly darkened with the charcoal flat. To unify the tone pass a hand over the whole area. The upper part is finished with little charcoal dashes which give texture to the fallen leaves. On the rock face the separation between the rocks is drawn with much more detail.*

Although it is essential to consider every piece of work as a unified whole, it is also important to observe and reproduce carefully the details of each individual element. The textures must vary according to what is most appropiate in each case.

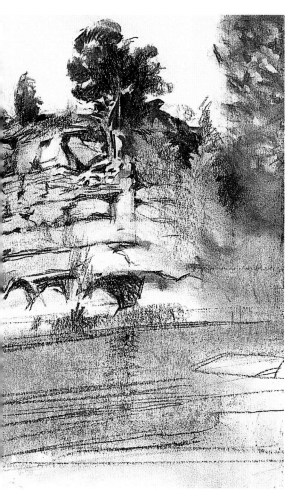

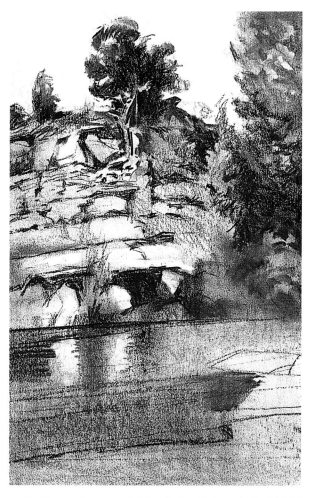

Now the pressed carbon is used to draw the gaps between the rocks in a more definitive way. A study of e lighting is an essential step so that the landscape kes on the necessary realism. All of the rocks are out-ed by the dark shadows cast by the rocks above em. This detail can be seen clearly in the triangular ck next to the tree. Note how the rock face acquires a rong effect of volume when the left side is darkened.

**5.** The entire water is blended and the principal highlights are opened up with the eraser. On top of the right side of the rock face the corresponding rocks are drawn. The gray put in previously becomes the texture of these rocks, while the central rocks are much more luminous. The densest dark parts of the trees, and of the shrubs in the lower part, are drawn with pressed carbon. What were previously the darkest tones of this area now become medium shadows.

Pressed carbon is not easy to rub out. You must therefore gauge the tone intensity carefully before drawing the definitive dark areas.

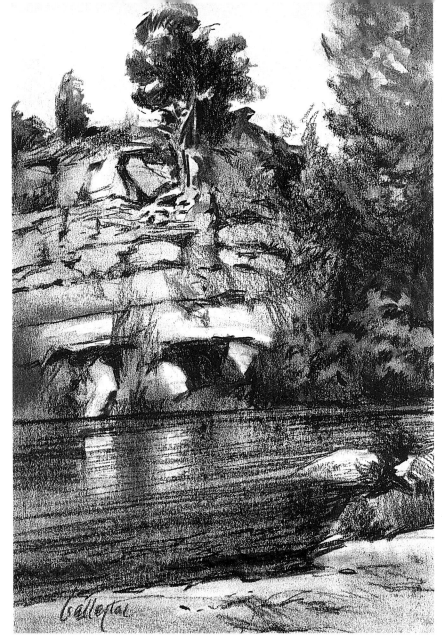

**6.** *The strongest contrasts of the tre on the right are finished off. This makes the medium tones much brighter due to the contrast. The water surface is worked on with an intense stroke that is superimposed on the previous grays. The rocks in the foreground are drawn. The draw ing is fixed, but do not apply too much fixative. A light spray is enouc*

To control the intensity of the strokes and to avoid having to lighten any excessively dark parts, start with the gray tones and as you progress darken those areas or elements that it require.

## SUMMARY

**The layout** is the essential basis of all landscape elements. Without it any texture that is drawn will lack structure.

**The upper tree** is drawn with very precise touches of charcoal. The trunk is perfectly defined by the dark zones that surround it.

**The rocks** are defined by the dark outlines. The quality of the texture depends on the base tone.

**The densest dark parts,** produced with pressed carbon, allow the grass at the bottom to be highlighted.

# Drawing animals

## SCHEMATIZING ANIMALS

However complex the animals observed may be, when you use them as a model you must try to see in them their basic shapes, their movement, and their static pose: everything that gives a clue to their structure. Understanding the internal structure of the animals helps us to represent their external form more exactly. Once it is clear whether an animal can be schematized within a sphere or a square, or if its back is defined by a particular line, it will without doubt be easier to represent.

Since the birth of humanity, people have been irresistibly attracted to images of animals; other species fascinate us. Drawings of animals may spring from wonder, curiosity or fear, but no artist can remain unmoved by them. Each species has its own particular anatomical configuration; these vary so greatly that we cannot study them all in detail. Nevertheless, this chapter will look at several different species, not step by step but rather as an introduction to the marvels of nature drawing.

As you have seen in the previous topics all the forms, however complex they may be, can be represented much better when they are simplified into basic shapes like triangles, circles, or squares. To begin the study of animals, you must bear in mind that the most difficult parts to understand and to draw are the legs. Apart from this question, the rest of the body only needs a straightforward geometric sketch that must be laid down before starting the definitive drawing, or even the scheme. If you look at this elephant carefully, you will see that the line scheme is almost a perfect circle.

▼ Once a you have a geometric scheme which includes all the parts has been realized, you can get down to doing the individual limbs. This system of representation is valid for any animal, however complex it may be. When drawing an animal, once the general scheme and form are finished, you have to place the head accurately. The line which marks the spinal column is vitally important as it gives shape to the entire upper part of the animal. A good exercise in observation would be to reproduce this example, considering the form of the spinal column. Moving the spinal column allows different aspects of the animal to be shown.

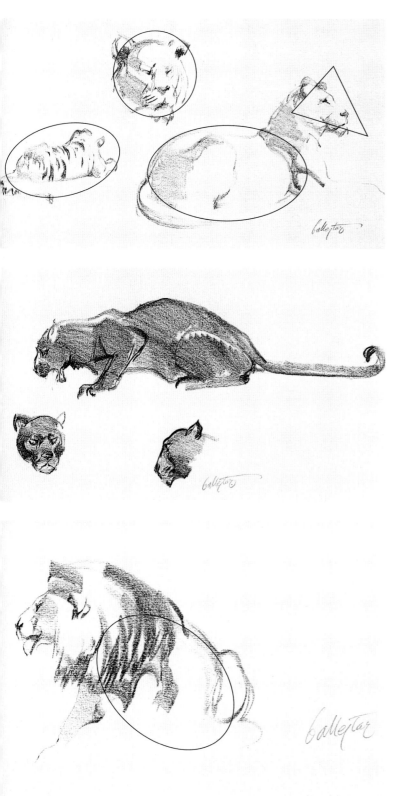

## BIG CATS

Wild animals are not easy to draw because, f
tunately, the chances of one crossing y
path are low, especially if it is one of the big cats
spite of this, it is not impossible to find models. T
best place is the zoo, but anybody who has be
there will have realized that the big cats like to r
during the day, and therefore they hide in the sha
One option is to fall back on photos.

▶ *This relaxed lioness offers a perfect study of the
form of her body in repose; as can be seen, it can be
fitted into a completely elliptical form, and the head
can be worked on within a triangle. Next to the fig-
ure a study of her head has been done from another
point of view. Draw the images that are shown on
this page, starting from geometric schemes. The
lioness' head can be schematized inside a circle.*

▶ *All the members of the cat family have very
characteristic bones and musculature. Just by looking
at a domestic cat you can see that it is very similar
to this panther. The front legs raise the animal off
the ground while the hind ones are resting, and the
back is completely curved. Next to the figure there
are two studies of the head. Try to schematize the
forms with simple geometrical elements.*

▶ *The structure of this lion is very similar
to a lioness. It is drawn with the same
elements, although the lion is somewhat
taller and the mane makes him seem
much bigger. In all these drawings it is
important to do the truly vital lines only.*

A stag is a stunningly beautiful animal that can be in forests and in the countryside. Drawing this fine animal calls for special attention because, unlike the cats on the previous page, it is almost always seen standing and therefore does not hide its legs. This can be a problem for beginners. This piece has been realized with felt tip pens. Try to schematize and draw the legs of this majestic animal.

## THE LEGS OF DIFFERENT ANIMALS

On these pages the forms shown are not excessively complex, especially if the draw- that illustrate the explanations are taken as a reference. When the animal is lying down, as we with the cats drawn before, the legs are out of t, which makes life easier for the artist. Things more complicated when the animal is upright. this page we are going to study some exam- of legs. As can be seen, each species has its distinct anatomy.

Depending on the animal being drawn, the leg structure can vary notably, although in general each species has characteristics that vary very little from one family to another. Let's take as an example two bovine types, the Indian ox from India, and the bison. Both are animals which appear very different but if you look closely at their legs you will find points in common between the two species. Both, the hind and front quarters are similar. Look at the joints and the flexing points, and compare them with those of the stag.

## RAPID SKETCHES

Many drawings of the same animal will be necessary. In beginning it will be difficult, but as you progress understanding of forms will improve. When you draw live mals, you must have plenty of paper to hand so that you ca as many sketches as possible in a short period of time. To r ter the art of drawing animals it is necessary to pay cons attention to the form. This is why, once you have finished c ing the models on these pages, it is advisable to do others photos, or even better, from live models.

▶ *Drawing animals is one of the best exercises for perfecting t line and increasing the speed of your drawing. Above all, what is required is careful attention, and a lot of patience. In the beginn it is sensible to choose calm animals that do not change their p ture too much. Always start out from simple general forms, like c circle, an ellipse, or a square.*

▶ *The anatomy must be understood in terms of synthesis. This implies doing only the lines which are indispensable to your drawing. For example, if you want to draw a giraffe, its anatomy can be simplified greatly if the fundamental features are described with a few strokes. Each one of the strokes must define a complete part of the animal with a simple line. Try to reproduce the sketches that accompany this text The strokes are continuous. They do not close off these forms; they are left open.*

*Animals often lie and hide their legs u neath their body. This co very useful to the beg as it means that the s of the animal can be up without the need fc profound a knowlea anatomy. This may not, ever, be very easy; e the legs are hidder need to observe e how they are hidder how the folding of the affects the line of the*

# Step by step
# A lion

this exercise the aim is to amplify the notions that we have been learn-
throughout the exercises. We have shown only finished examples, not
process that created them.

is difficult to draw an animal that is moving, so you can resort to a
to. Nevertheless, it is advisable to do live sketches because the effort
they require increases the artist's capacity for both drawing and syn-
is.

efore starting to draw, it is a good idea to look at the model carefully, and
cessary, to trace a scheme so that the elementary forms of the head, torso
limbs can be studied.

**MATERIALS**

*Drawing paper (1),
pure graphite (2),
and eraser (3).*

A library of
images is an
excellent
resource for the
learner. Such a
stock of photos
can be obtained
from magazines,
postcards, etc.

**1.** *If you have done a rough outline over the photo
model, it will be much easier to set out the
schematic forms of the lion. Do not be confused by
the thick mane when you are setting out the initial
drawing. Its volume could mislead you. The lion's
mane is a covering that makes its head seem much
bigger. In this first scheme, it can be seen that the
head, in reality, is only what is visible on the face,
which can be synthesized within a triangle.*

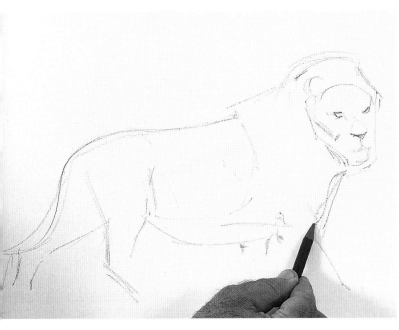

**2.** *Once the structure of the external lines ha[s] been accurately set out, the fundamental strokes can be emphasized. Now the curve [of] the back and the shape of the leg are define[d]. The features of the lion's face are laid down. [If] you look closely at the lion's face, you will se[e] that an equilateral triangle, slightly inclined [at] eye level, can be fitted between the eyes an[d] the nose. You can now begin the definitive [outline] line of the mane. It starts on the side of the [face] and goes down to the lower part of the neck[,] where the front leg begins.*

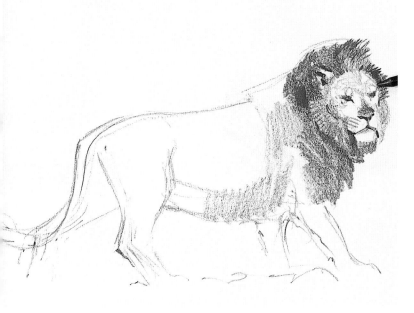

**3.** *Start to put in the contrasts on top o[f] line sketch. First, do the head, increa[se] the tonal differences between the mane and the forehead. This same s[tyle] continues down one side, and finally u[nder]neath. The facial features are defin[ed] more detail, including a soft gray ton[e] the nose to suggest the angle of the m[uzzle]*

**4.** *It seems that the lion's shape is now quite similar to the model, and therefore the dark parts that underline facial details and the fur texture can be started. Looking for contrasts enables the lighter areas that represent volume, as on the animal's muzzle, to be isolated. These dark parts have to be laid down very gradually so that the grays can balance each other, and the densest tones can be situated in the right place: in this case in the mane. The direction of the stroke is very important in representing the skin on the face or the different planes of the animal.*

To draw the scheme of the lion, it is necessary to start from basic elementary forms. This enables all the parts of the body to be correctly placed together.

**5.** In this step all the principal dark parts will be placed and will then be the base for all the medium tones and reserved highlights. The form of the mane is finished off, by using different stroke intensities. The lines that give the animal its expression are also contrasted. The hind legs require a double contrast. An intense dark zone is drawn on the inside of the rear leg. Then a darker gray is used to place the more luminous area. The form of the highlight indicates the muscula-ture of the animal's leg. A much more definite stroke is used to finish off the mop of hair underneath the animal.

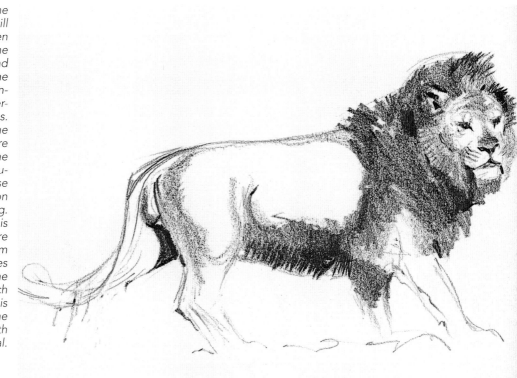

**6.** In this exercise special attention is paid to the form of the legs. As can be seen, to simplify the lion's stance, and to increase the naturalness of its movement, the paws are not drawn completely. Instead, in the same plane as the earth, they are left undefined. The darkest lines are reinforced. On the leg at the front a soft gray is used to outline the principal highlights.

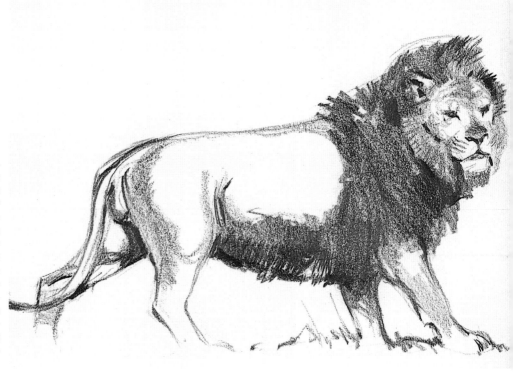

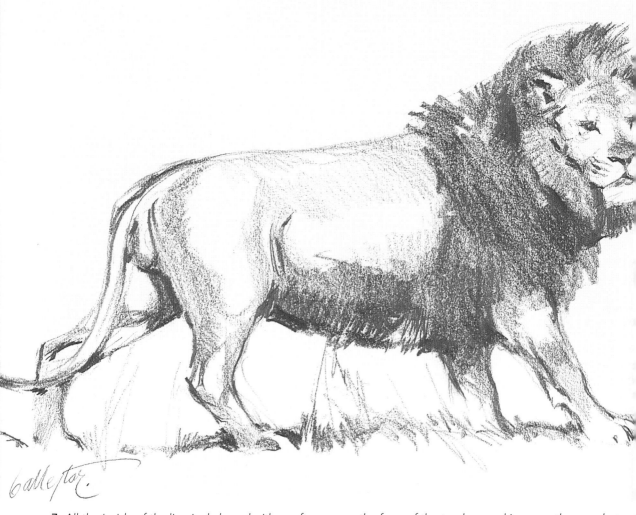

6alle/tae.

**7.** *All the inside of the lion is darkened with a soft stroke. The direction of the line is important because it suggests the volume of the torso. The hind leg, supported on the floor, is finished off in the same way as the others, without closing the paw. The final contrasts show* *the form of the tendons and increase the muscle ton[e] the animal. The eraser cleans up the principal highlig[hts] both on the legs and on the body. Loose strokes on t[he] ground suggest the grass.*

## SUMMARY

To draw **the outline of the lion** it is necessary to start from basic elementary forms that allow each body part to be fitted in.

**The essential shape [of] the animal** is dictate[d] by the line that goe[s] from the head to th[e] hindquarters. The ar[c] of the back is vitall[y] important for the placement of the tor[so] and the head.

**The legs** are drawn from the flexion points. The dark parts provide the necessary volume.

With the eraser, th[e] definitive **highlight[s]** are opened up on t[he] legs and torso.

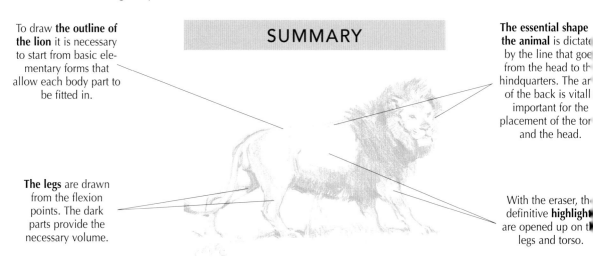

152

# The way they painted:
## Claude Lorraine
(Chamagne, Toul diocese 1600-Rome 1682)

# The Tiber seen from Mount Mario

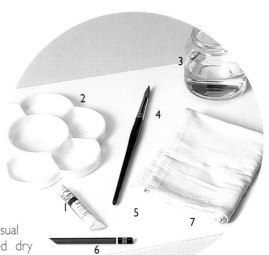

Lorraine knew Poussin and was a member of the international painters circle of his time. His fame spread all across Europe thanks to the only subject that he worked on: landscape. He was only interested in the light. Lorraine's work influenced Turner and the Impressionists and is now included in some of the best collections in the world.

Although nowadays the most usual drawing media are the so-called dry media, we must not exclude the use of the watercolor or ink wash, to practice reproducing beautiful works like those of Lorraine.

The interest that Lorraine took in the composition of the landscape is very evident. The trees are represented by simple dark stains which become smaller with distance, while the luminosity of the river stands out from the foreground with stunning effect.

## MATERIALS

*Sienna or burnt umber watercolor (1), ceramic palette or a plate (2), water (3), watercolor brush (4), watercolor paper (5), pencil (6), and a cloth (7).*

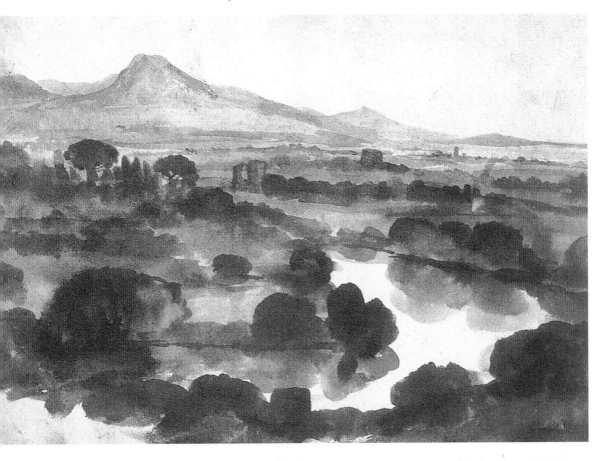

# STEP BY STEP: *The Tiber seen from Mount Mario* by Claude Lorraine

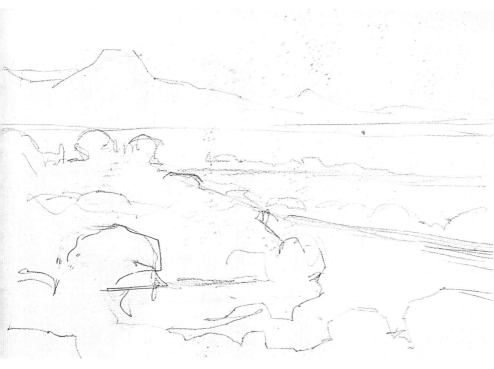

**1.** The initial drawing is goi
to play a key role: it will
place the essential elemen
within the picture. The first
lines, made in pencil, are
never definitive. The lines
left on the paper must be
fine enough so that if they
have to be corrected, you
not have to rub too hard.
Just as in any other work,
principal lines are only a
preparation for later work.
the different tones are goi
to be created in wash, in t
initial drawing we need no
worry about tonalities: we
will simply draw the lines.

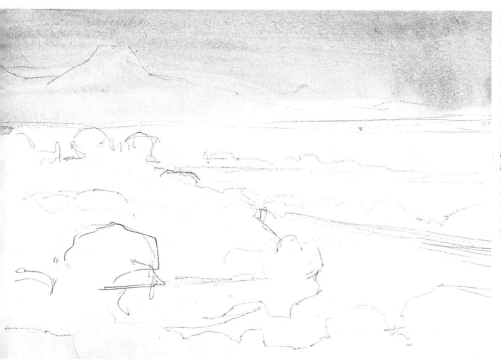

**2.** The watercolor wash, ju
like the ink wash, uses the
medium with different
amounts of water in such a
way that the color can be
more or less transparent, a
desired. Bearing this in mi
the first sky tone is laid
down. It is worth remembe
ing that, as in other paintir
processes, when one layer
put on top of another, the
result is the sum of both, a
a darker tone is produced.
this process is repeated, th
initial tone will darken pro-
gressively.

Once the background tone is dry, you can start to draw the mountain in the distance. The tone used in this is slightly darker than the sky. The line of the mountain is faint, but it shows a very controlled brushstroke to be used for its outline. When working with the wash technique, you always have to put lighter tones on top of dark ones as it is not possible to erase paint. This is why clearer and more luminous tones are the base for light reserves. Below the horizon line, a somewhat darker tone is painted in, until you reach the river bank, which must remain reserved during this drawing process, as it is the brightest one. On top of the wash by the shore the first dark parts are drawn in, though the wet base will cause them to blend into the background.

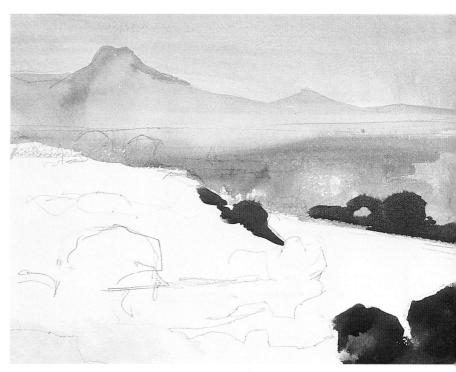

**4.** While the last step was being carried out, the wash over the mountain has dried out. Now, a new and more luminous (transparent) tone can be added. As can be seen, whenever two tones are combined, the result is always darker than either component. The mountain base color becomes one of the most luminous colors in the areas where it is visible between the later strokes.

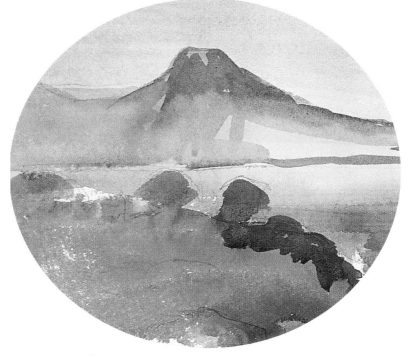

155

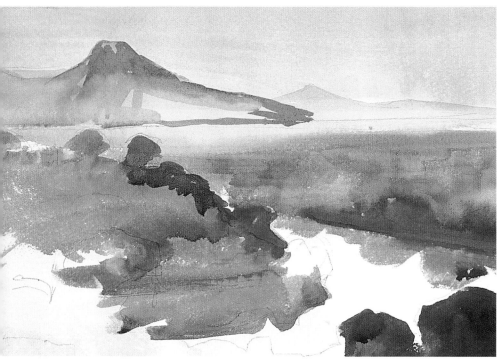

**5.** *As can be seen in this step, the dark parts of the right bank of the river that were laid down earlier ha merged into the backgro so that the edges are diffused. A medium tone is used to paint over the pla again in such a way that i separated off from the mountainous backgrounc On the left side you can s to draw the dark areas th will form a base for the la tones. The shapes of the trees that outline the hillc are drawn against the bac ground tone with precise brushstrokes. The reflecti along the right bank of th river are once again draw a luminous tone.*

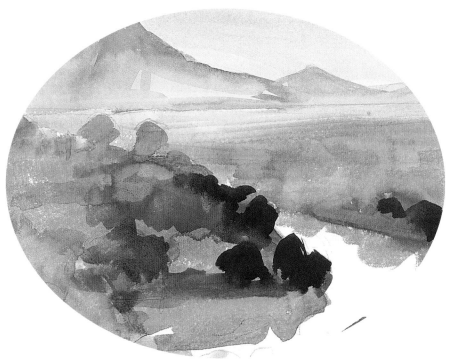

**6.** *The tones that are goin create a base for the rest the painting are now dow on the paper. This allows stains, that will represent trees in the landscape, to put in against the slightly darkened background. Th new color additions are much darker than the pre ous ones and therefore th contrasts are stronger. If y look at the model, you wi see that the darkest trees the ones along the river bank, since areas further back have been left alone and retain their original brightness.*

The contrasts on the trees the background must be accurately detailed. In this close-up you can see how the forms of the trees on outline of the hill have evolved. If you look at the last step, you can see the very evident darkening of this zone. The tone that before was the darkest is now once again the most luminous.

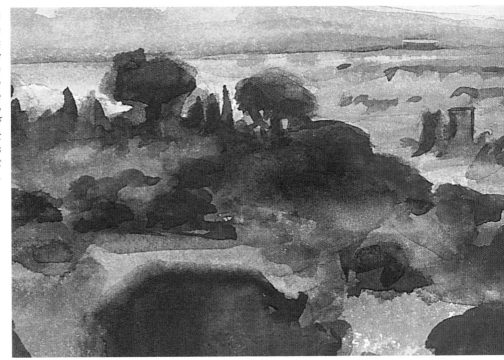

When using the wash technique, you should bear in mind the drying time for each layer or tone. If you painted while the lower tone was still wet, the humidity would cause the two tones to blend together.

The dark parts in the foreground on the right take on the form of trees. Here the background tone becomes the brightest color in this area. It is important to work on a dry base in order to avoid that the dark parts blend together, or the brushstrokes become distorted. If you are working on a dry background, the brushstroke can be controlled like any other drawing medium. While the form of the trees the foreground is wet, you can open up highlights by absorbing the wash with a clean, dry brush. On the right bank of the river some patches are inserted as a base for the final shapes.

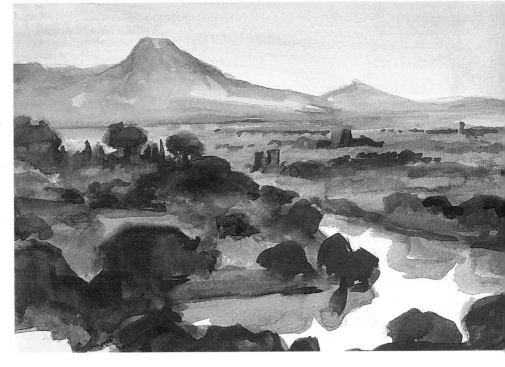

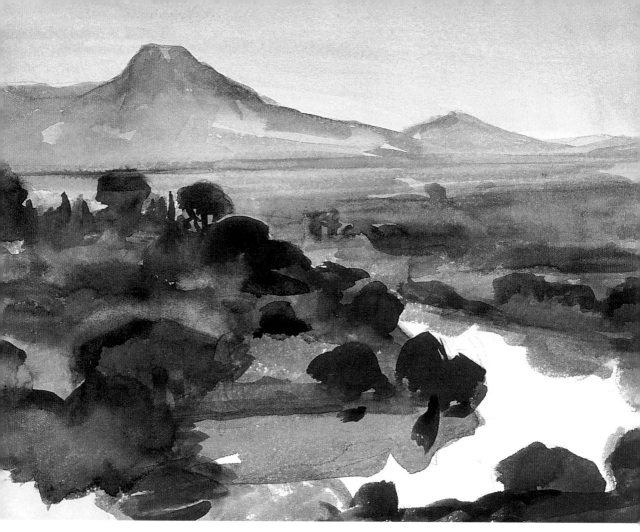

**9.** *In this last step all that remains is to do the dark parts that give shape to the trees on the right bank of the river. These trees are quite distant, so the shades are very small and make up horizontal groups.*

*On the left bank put down new layers of color so that* t *darkest tones are completely contrasted. The work in* t *central area can also be perfected and the details enhanced.*

## SUMMARY

**The initial sketch** lays down the forms and the important planes.

**The first wash,** whic is very transparent, is applied to the background.

**The mountains** are painted in two stages The first is on top of t dry sky. The second applied after the firs layer is dry.

**Most of the and the contrasts** are placed on the left bank. In the first phase the background tones are put in.

**The whites of the riv** will remain luminou throughout all the process: it must be carefully reserved.

# The way they painted:
## Leonardo da Vinci
(Vinci, Tuscany 1452-Le Clos-Luce, Amboise 1519)

# A kneeling figure

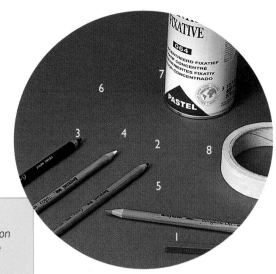

## MATERIALS

*Sanguine stick (1), sanguine crayon (2), black conté crayon (3), white chalk crayon (4), sepia chalk crayon (5), color paper (6), fixative spray (7), and tape (8).*

Leonardo de Vinci is without doubt one of the most prodigious figures of history. He possessed all the possible qualities of the artist and excelled in everything: as poet, scientist, musician, anatomist... No single label can do more than define a part of what he was. As an artist he was outstanding in everything he did, but his drawing technique in particular marks him as one of the greatest of the Renaissance realists.

This chapter proposes a study of thing. This type of exercise was undertaken by the artist to produce three-dimensional aspect to the image on the paper by studying the ts, the shadows, and the white lights that allow the drawing to contemplated as if it were the real g. Leonardo used these studies as basis for later works in oil. Before ting to lay out the drawing it is ortant to study the model. This analysis must be meticulous and rough because it will be the basis placing the folds, the creases, and structure that is formed by the t and the shadow.

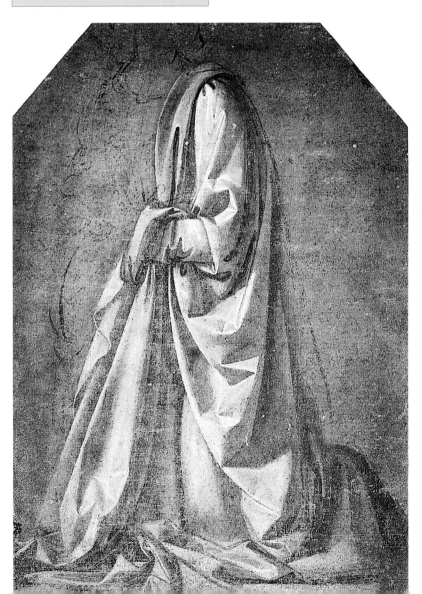

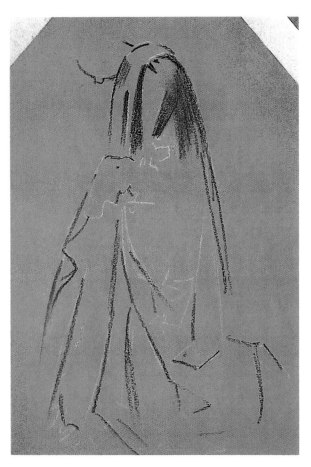

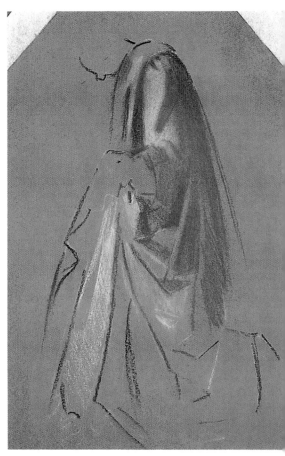

1. *Use the tape to frame the space that the drawing is going to occupy. Once it is framed, cover the entire background in sanguine so that the brown tone of the paper is slightly altered. Moreover, there is another advantage: on top of the sanguine-stained base the other media will show up better and the tones will blend well. On this background, use the white chalk crayon to draw the general form of the cloth and then the principal lines of the folds. Go over the drawing with the conte crayon, making the lines that must appear definitive more solid and putting in the first dark areas in the upper part.*

2. *The right side of the drawing is darkened with a stroke with the black conte crayon. Only the shadow the folds are dark, the parts that must be somew more luminous are left alone. Not all the dark p have the same tone. The sienna crayon is used to down the shadow areas in the folds where the arm to be. Once the dark parts have been drawn, you start to make the brighter contrasts. When the white strokes are added, the cloth appears to take c very realistic volume. In the upper fold the whit blended with the fingers dragging part of the gray surrounds it. Make an effort to give each stroke same direction as the plane of its f*

You must bear in mind the tonal value produced
when two simultaneous contrasts are in contact.
That is to say, when a very dark contrast is next to
a lighter one, the medium tones tend to disappear
due to the strength of the new tones.

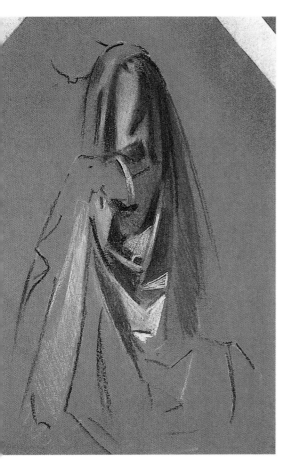

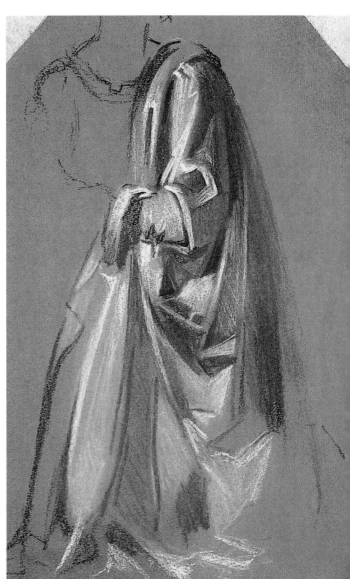

The whites are drawn gradually, augmenting the intensity as the need for brightness increases. In the center of the clothing the presence of the whites becomes more accentuated. They do not necessarily have to be touching a dark shadow zone. The shadow bulge sometimes coincides with the background paper tone seen in the detail below.

**4.** The contrasts are increased gradually. They go from the subtle tones in the background right through to bright, direct highlights. In the upper part of the clothing, you can start to accentuate the sharp contrasts between the black tone of the conté crayon and the luminous white of the chalk. When you are drawing a area with a strong dark tone, the whites of the highlight must be balanced so that the dark part does not dominate. At the moment the medium tones are not so important. This structure of this drawing allows a precise study of the light, thanks to the way the dark contrasts have already been incorporated.

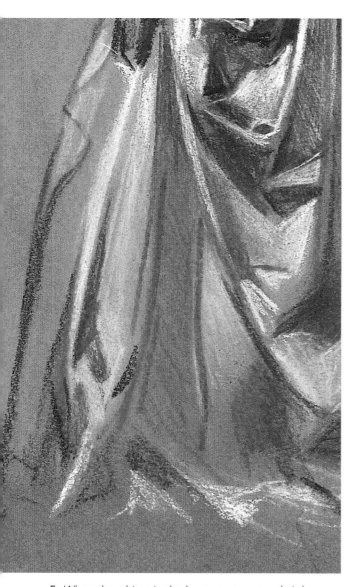

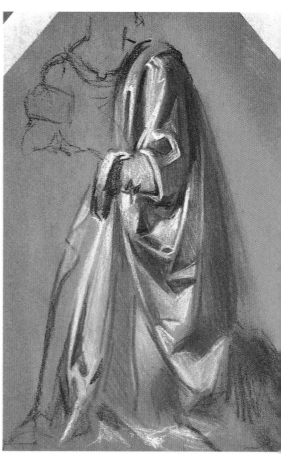

**6.** *Once again the contrasts on the right
increased and the drawing of the cloth is finish
This large dark area is produced with a soft stro
avoiding the most luminous areas and blenc
into the background. The dark tone in the corne
the fold on the lower right side is laid down v
more contrast in order to give it greater depth.
kneeling figure itself is sketched with a few lir*

**5.** *When the whites in the lower part are too bright,
it is necessary to tone them down with a cloth, softly
flicking until the white comes off in the area of the
central fold. This will be one of the most often
repeated actions while working on this drawing:
mute or intensify the tones depending on the overall
effect that you want to produce. Use the black conté
crayon to produce the medium tones of the vertical
fold. The stroke will be soft so that the paper is not
marked. After the shadow has been drawn in, gently
stump it with the sanguine of the background.*

Pressing down on the paper with
the different media can complete-
ly block up the pores, making it
impossible to gradate the tones
correctly or to erase any mistakes.
The shading must always progress
gradually thus enabling many
tonal values to contribute to the
richness of the drawing.

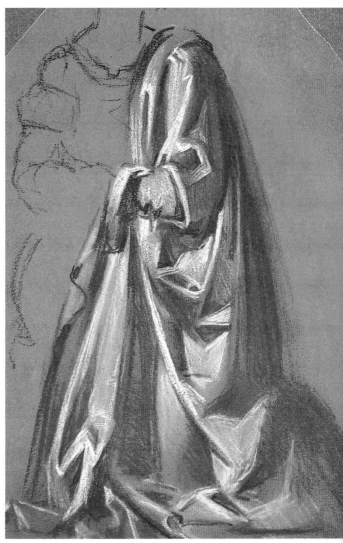

n this close-up you can see how a few firm,
t strokes perfectly render the long fine, creas-
on the left side of the fabric.

**8.** *The medium tones of the shadows that must not be gray, are gone over with the sienna chalk crayon. This tone integrates completely the hard contrasts produced by the conte crayon with the background paper hue. The shadows on the right of the drawing are softly blended into the background: their presence fades away.*

White chalk responds different-
ly when it is used on top of a
sanguine background, or when,
as in this example, it is used
on a black background.

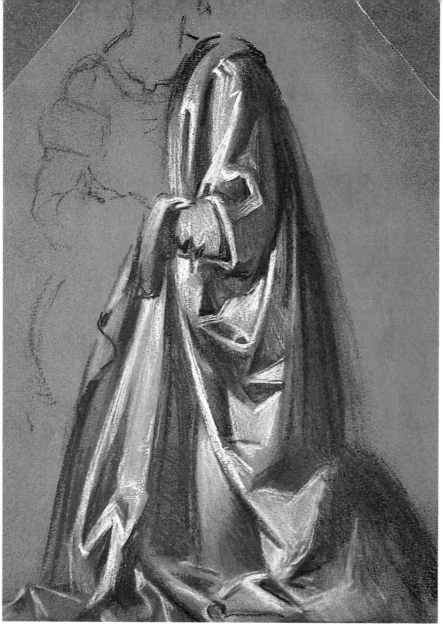

**9.** *The white highlights are drawn on top of zones that have been previously stumped. This creates different position planes of the fabric with respect to the light. Finally, some of the densest shadows are drawn with very defined strokes. that remains to be done is take away some of the presence from the outline of the kneeling figure. The drawing is sprayed at a distance of about 30 cm in order to fix without the tones sticking together. This is the final touch to this study of clothing, an intense, but interesting, work for which we have applied a method not very different from that used by da Vinci himself.*

## SUMMARY

**The background is covered** with the sanguine stick which produces a tone that only varies within certain limits.

The strokes are gone over in **black conté crayon.**

**The study of the creases** is begun in the upper shadow zone.

The half shadows are outlined in **sepia crayon.**

**The white highlights** give the right light to the creases and folds

164

# The way they painted:

## Michelangelo
(Caprese, Tuscany 1475-Rome 1564)

# Studies for Sibila libia

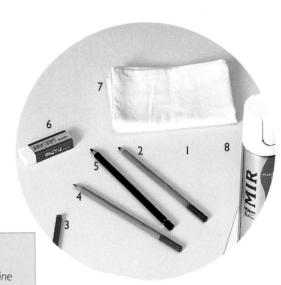

Like Leonardo da Vinci, Michelangelo was a principal figure in the European Renaissance. Without him, our modern concepts of art would have been very different. Drawing is a basic way of studying and approaching an understanding of the world, as is evidenced throughout his artistic career. There is no limit to the magnificence of his work; in a true Renaissance spirit, his hunger for knowledge led him to explore both the arts and the sciences, in all of which he excelled. The culmination of his great work was the Sistine Chapel, which he completed in the space of four years.

## MATERIALS

Cream-colored paper (1), sanguine crayon (2), sanguine stick (3), sepia crayon (4), carbon pencil (5), eraser (6), cloth (7), and fixative spray (8).

Drawing the anatomy is one of the [pri]mordial interests of all the [Re]naissance artists. Studying the [bo]dy and defying the visual laws are [ch]allenges that only artists like [Mi]chelangelo have overcome. The [for]eshortening of the body consists [in] the presentation of a risky pose, in [wh]ich it can be seen how part of the [dr]awing defies the paper plane and [be]comes a three dimensional vol[um]e. If you observe the arm of this [fig]ure, you can easily see this effect. [It] is a complex study that requires [de]dication and analysis of the model, [bu]t it is, without doubt, one of the [be]st exercises that can be realized.

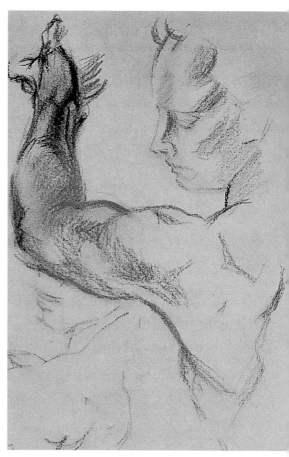

1. *The layout is the most important stage of any drawing. This is even more true for an exercise like this one whose main concern is the anatomy. The initial scheme can be analysed in terms of simple, elementary forms. This is always a useful technique for sketching even the most complex poses. Here, the head is fitted into a circle. The line of the spinal column extends out from the neck: it definitively determines the form of the back. The joints of the shoulder and the elbow can be schematized starting from circles. On top of this scheme the entire outline of the figure can be constructed. Observe the pose of the arm: the forearm is further away. The foreshortening effect means that it appears smaller.*

2. *Once the initial outline has been laid down principal lines of the anatomy can be reinforced. S with the external lines in such a way that the struct of the figure becomes clearer. The deltoid musc are drawn above the neck line. The shoulder blad also solidified. The face is done with soft lines, first objective of which is to mark out the princi dark areas. The aim is not so much to place shadows as to outline the most illuminated zon*

You should never start drawing without having first done the layout. This is especially indispensable when you are working on the human anatomy. The first step is always building up a coherent whole on the basis of simple geometrical shapes.

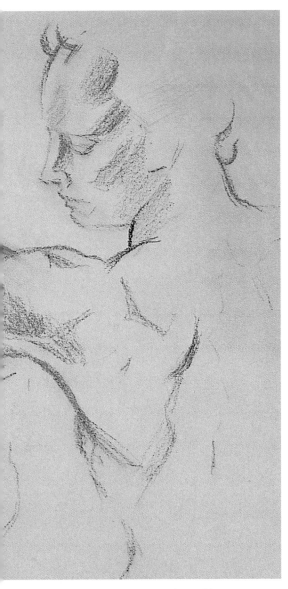

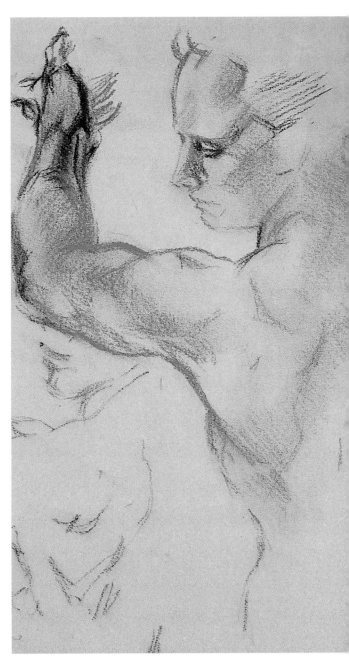

The dark parts of the face are softened by stumping th the fingertips. The tone is integrated into the color the paper. You should now concentrate on develop-g the arm. In fact, the arm will be the center of atten-n of this study. The musculature of the shoulder is odeled as if it were spherical, slightly tapering cause it is tensed. The shoulder muscle is between e biceps and the triceps. This area is finished off by rkening the hollow between the muscles, while the rts with the greatest volume are left more luminous. e first contrasts are accentuated in the face, giving e to the half-closed eye and the form of the nose.

4. Draw each area of the forearm in turn. The side section that runs to the wrist tendons is grayed. The muscle is rounded and given its characteristic form. The wrist tendon is drawn much darker. You must pay special attention to this zone because it gives real profundity to the foreshortening by defining an important separation between the lighted planes of the figure. The luminosity reappears in the work done on the hand, the fingers of which are barely outlined.

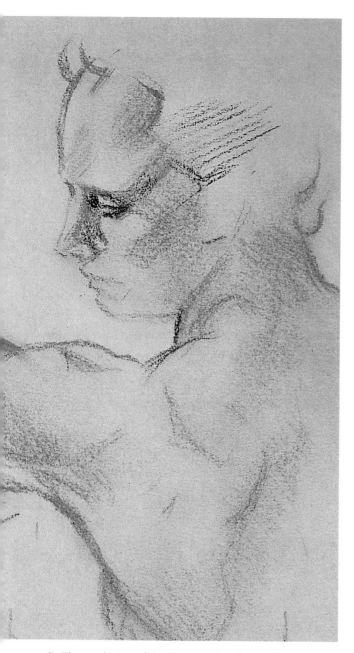

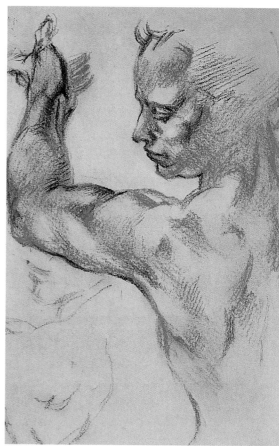

**6.** *Once the features of the face have been drawn, the shadows that define the different muscle groups of the back are realized. The spinal column is placed with a soft line representing its shadow. The same sanguine tone is used to draw the shadows of the shoulder and the shoulder blade. The darkest areas of the arm are reinforced with the sienna crayon, softening its tone so that it blends in with the sanguine tone and with the paper color which is now one of the most prominent hues.*

**5.** *The evolution of the face can be clearly observed. At this stage you should concentrate on the lights as defined by the shadows. The forehead is darkened with sanguine, leaving a highlight on the eyebrow. Another bright line is left on the nasal septum. The darkest parts of the face are worked with the sepia crayon, without pressing too hard. Soft strokes will allow you to match the tone perfectly. Deeper shadows are put in around the mouth, on the cheek and on the right side of the eyebrow.*

Complementary contrasts make shadows next to more luminous tones appear much denser. The same effect occurs with the luminous tones: if they are set next to shadows they seem more brilliant.

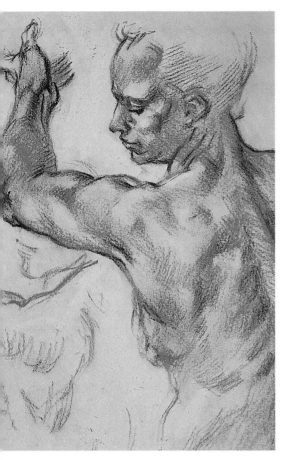

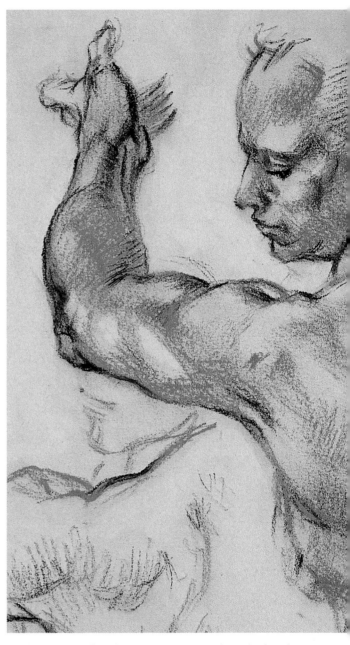

When the principal muscle groups are accurately ...ed, you can go on to put in the rib forms that start ...n the spinal column and thus finish the anatomical ...k of the back. Before drawing them, schematize ...r curved shapes. Starting from this scheme, it is ...h easier to place the shadows, which have to define ...volume. First, draw soft strokes in sanguine. ...ce the principal mass is in place, you can use the ...ia crayon. The carbon pencil is used for the dark ...efs in the most intense shadow zones. The function ...he carbon pencil in this drawing is to round off the ...e scale of the sepia crayon.

**8.** In this close-up you can see how the hand is dealt with. The dark tones are alternated with the more luminous parts. As can be seen, the fingers are not drawn completely, instead, they are hardly outlined. In this area the stroke is particularly important, as only by varying the pressure can you make different aspects stand out.

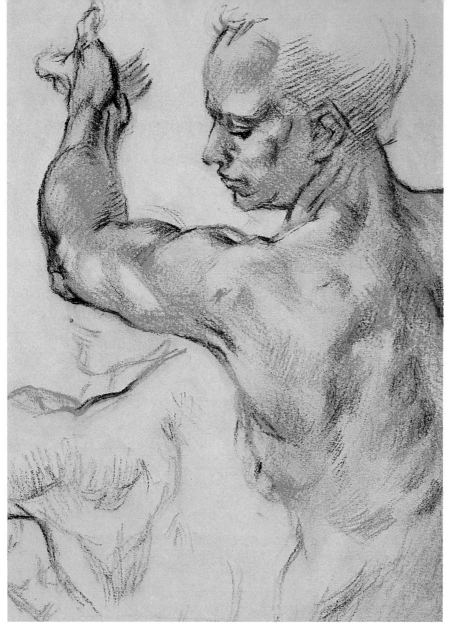

**9.** *The eraser is used to op[en] up the most prominent hig[h] lights on the musculature; during the earlier work, th[e] gray layers have been crea[t] ed. The work with the eras[er] has to be very accurate, si[nce] too much highlighting will lessen its effect more than necessary. To finish this stu[dy] of Michelangelo's drawing[,] that remains is to fix it. Spr[ay] it lightly once from a dista[nce] of about 30 cm.*

## SUMMARY

**The outline sketch** plays a crucial role. It is best to base it on very simple geometric forms.

**The shoulder muscula-ture** is a slightly elon-gated spherical shape.

**The hand** is only define[d] in its nearest plane. The fingers are merel[y] sketched.

**The darks of the fac[e]** outline the principal highlights and contra[st] strongly with them.

Starting from **the dra[w] ing of the spinal colum[n]** the ribs are added. Th[ey] are defined primarily by their shadows.

# The way they painted:

## Georges Seurat
(París 1859-1891)

# A Summer Sunday at Grande-Jatte

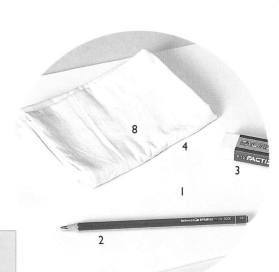

Georges Seurat, together with
ignac, created Neoimpres-
ionism: It was he who devel-
ped the pointillist technique, as
ell as an extensive treatise on
ie theory of color. The work of
eurat was a decisive influence
n masters like Pissarro or Van
iogh: they worked according to
is theories. He had many imita-
rs, although none of them
ould match his mastery. He
ied young, aged only 32.
lowever, his pictorial legacy
as made a great impact on later
enerations of artists.

## MATERIALS

*Paper (1), graphite pencil (2),
eraser (3), and a cloth (4).*

can be claimed that the pointillist
nnique was born from this piece.
ntillism consists of using tiny dots
lifferent colors which combine at
retina to make up the hues per-
ed by the viewer. In preparation
this canvas Seurat carried out
iy experimental sketches, in
ch he examined the physical
cts of light on each of the elem-
s which would make up the com-
ition.
his exercise is based on one of
se preliminary notes for this most
cal work. He was not aiming for
great realism, his principal con-
ns being the composition and the
t.

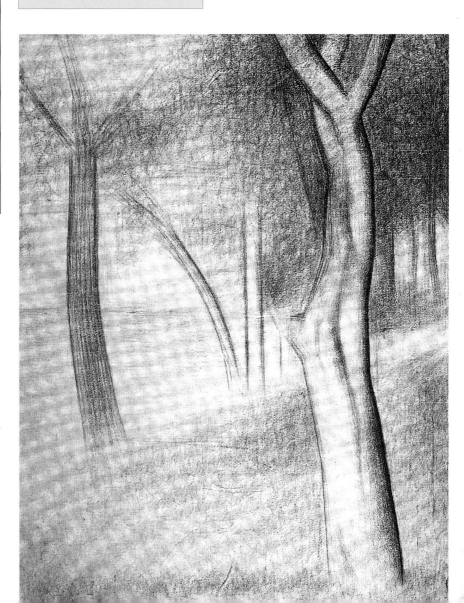

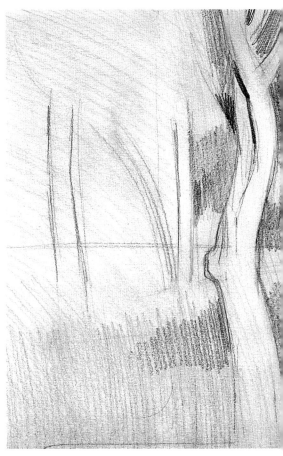

**1.** *To begin with, the principal sections of the drawing have to be defined on the basis of the horizon line. The first stage of the drawing is decisive for the rest of the composition because everything is going to be balanced around the horizon; it will be the equilibrium point. Once the horizon line has been marked, the trees are drawn in. They are laid down at first in a very schematic way. When their placing is correct the drawing is reinforced with a much firmer stroke.*

**2.** *In this drawing the shadows must always added progressively. Never forget the way Se built up his original study. When the tree tru are perfectly laid down, you can start on the shadows. First comes the grass, with a long, vertical stroke. In this area a triangular shado created by increasing the intensity of the li There is a strong shadow in the upper part. It c trasts with the much brighter shape of the t*

When setting out a piece of work, instead of niggling over the details and the nuances, you must consider the overall effect of the elements and the light and shadow zones that combine together, sometimes juxtaposed. This will condition the way the work starts out and will mark the path to be followed to decide the forms, establish the volumes and resolve the details.

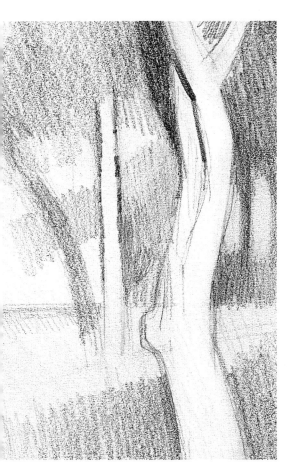

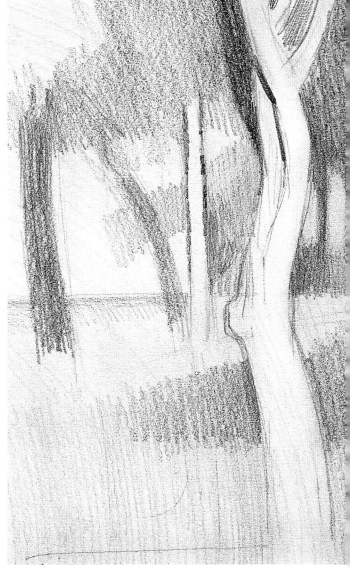

n this close-up you can see one of Seurat's funda-
ntal interests: his constant reference to the effects
duced among the contrasts in the drawing.
rat studied in depth each one of the phases of
drawings. To this end he did many studies and
tches which he used for visual experiments, like
interplay between complementary and simultan-
s contrasts. Observe the way this section evolves
ughout the drawing process. The darker the
e around the tree is, the brighter it will appear.

4. The shadows made with the graphite pencil can be
very deep grays, depending, of course, on the grade
of pencil that is used, and its pressure on the paper.
In the early stages of the drawing we do not want the
dark areas to be too intense. What is much more
important is that the gray areas are laid down pro-
gressively. The trunk on the right is drawn in a dark
tone, but without blocking the pores of the paper.
The lines have to follow the shape of the trunk exactly.

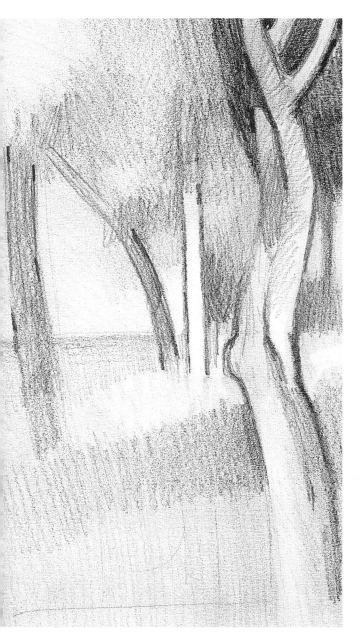

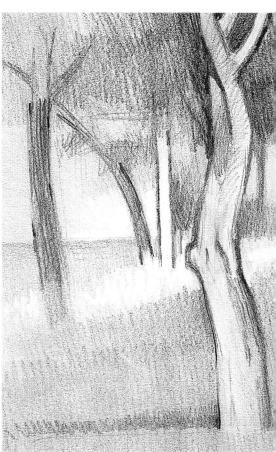

**6.** *The pencil stroke becomes more intense in upper area. The result is a quite intense med tone. Now all the intermediate section, and the in the middle, are the brightest parts. Before cont ing, lightly smudge over the drawing with your gers. As you are using a soft pencil you can achiev very soft stumping. Avoid pressing down too har that the lines do not fade away. The tree on the le drawn more firmly to suggest the texture of the b*

**5.** *The outlines of the trees are gone over with a soft but firm stroke. It can be repeated as often as necessary, until the desired tone is achieved. Not all the trees are outlined equally firmly: the one in the foreground is the most put in. On this tree the first contrasts are realized, starting the stroke from the upper part. As this area is darkened, the contrast with the background decreases. This means that it is necessary to add more background to re-establish the contrast between it and the tree. The eraser is used to open up a lighter area on the grass.*

You should always use the appropiate materials for any drawing. For example, hard pencils do not allow stumping and the marks are difficult to erase.

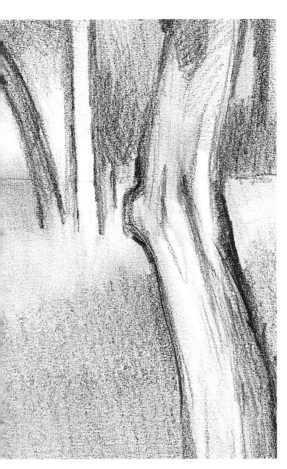

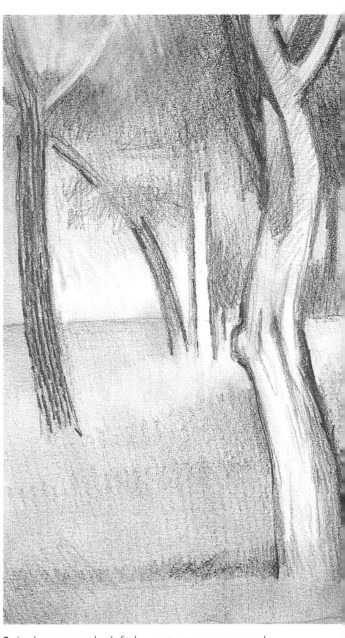

*n this close-up you can appreciate how the bark tex-
of the foreground tree has been produced. The
trast is essential to achieve the required effects of
t and shade in this area. The bark is drawn with dark
kes, not pressing too much. They are then gently
ead with the fingers, and then immediately next to
n stroke a highlight is opened up with the eraser.*

Using sandpaper on the point of
your pencil will keep it sharp
without constant recourse to the
sharpener.

**8.** *In the tree on the left the contrasts are now made
much more obvious. The strokes are more linear and
darker. The contrasts must be applied to the whole pic-
ture. The upper area is darkened noticeably and then
stumped with the fingertips. Also the texture of the
foreground tree is begun. The shadow that this tree
casts on the ground is drawn softly and firmly: the stroke
should be steady.*

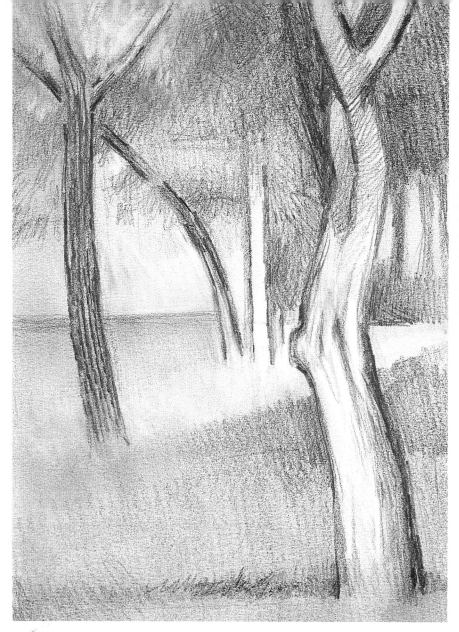

**9.** *The contrasts in the for*
*ground tree are augmente*
*The highest branch is out*
*lined strongly until a rathe*
*intense black is obtained,*
*without completely obscu*
*the white of the paper. Th*
*right-hand side of this tre*
*also darkened. The highlig*
*on the bark are made mo*
*luminous with the eraser.*
*add the final touches, con*
*tinue perfecting the contr*
*in all the area of the pictu*
*on the grass, on the back*
*ground trees, and, very sc*
*on the left in the foregrou*

## SUMMARY

**The composition study**
is started by separating
the principal areas of
the picture, which is then
started with the horizon
line and the trees.

When **the grays of the
grass** have been dif-
fused, the contrasts are
again readjusted until a
balanced interplay is
achieved.

**The first shadows** outl
the shape of the tree
in the foreground.

**The tree in the midd**
is an interesting study
simultaneous contras

**The brightest white**
are achieved with th
aid of
an eraser.